MICHELANGELO

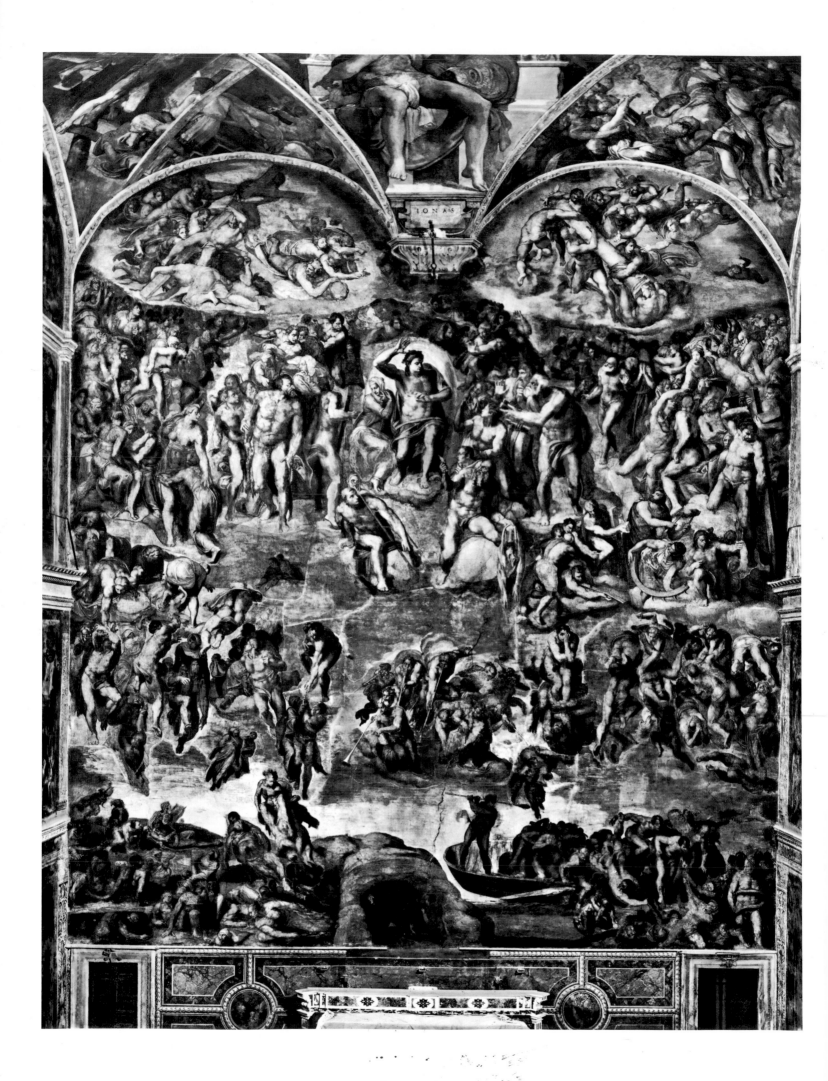

MICHELANGELO BUONARROTI

Michelangelo

FREDERICK HARTT

Paul Goodloe McIntire Professor of the History of Art, University of Virginia

HARRY N. ABRAMS, INC., *Publishers*

FRONTISPIECE: THE LAST JUDGMENT. 1536–41
Fresco, approximately 48 × 44'
Sistine Chapel, Vatican, Rome

ISBN 0-8109-1335-6
Library of Congress Catalog Card Number: 83-72131

Published in 1984 by HARRY N. ABRAMS, INCORPORATED, New York.
Also published in a leatherbound edition for The Easton Press,
Norwalk, Connecticut. All rights reserved. This is a concise
edition of Frederick Hartt's *Michelangelo*, originally published
in 1964. No part of the contents of this book may be reproduced
without the written permission of the publisher.

Printed and bound in Japan

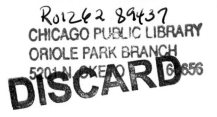
CONTENTS

COLORPLATES

La mia pittura morta
difendi orma' Giovanni, e'l mio onore
non sendo in loco bon nè io pittore.

Defend my dead painting
now, Giovanni, and my honor
not being in a good place nor I a painter.

(From a poem written by Michelangelo during the painting of the Sistine Ceiling)

All his life Michelangelo professed to think of himself as a sculptor rather than a painter. In fact he was not a painter in the sense of such colorists as the great Venetians, or the Dutch and Flemish painters of the seventeenth century. His paintings generally resemble polychromed sculpture. In his seventies he wrote to Benedetto Varchi, a humanist who was polling the Florentine artists on the relative merits of painting and sculpture, that "painting seems to me more to be held good the more it approaches relief, and relief to be held bad the more it approaches painting: and therefore I used to think that sculpture was the lantern of painting, and that between the one and the other was that difference which there is between the sun and the moon." Despite elaborate courtesies toward Varchi, the aged artist made clear that he still held to his opinion (he even recommended that all painters keep their work in line by doing some sculpture), and that he felt little inclination to waste his time in such polls. The painter of the Sistine Ceiling and the _Last Judgment_ regarded sculpture as the art requiring more judgment and harder work, and, until in his extreme old age when he grew contemptuous of all manual arts, he generally signed his letters and even contracts for important works of painting as "Michelangelo the sculptor." Time and again he spoke of his distaste for painting, which he claimed was not his profession.

Yet, of all Michelangelo's more ambitious projects only those in painting were completed by his own hand, while his vast sculptural designs either survive in fragmentary state or were never even started. And, despite his steadfast disregard of so many of what painters like to consider the fundamentals of their craft, he was one of the greatest painters who ever lived. In content and in form, in piercing intensity of feeling and striking beauty of mass and line, in sublimity of imagination and newness of vision, even in delicacy of color (as the colorplates show), few professional painters in the history of art can remotely approach him.

In this strange dichotomy between Michelangelo's words and his achievements we can glimpse something essential in a character riven by conflict. Disparate and warring motives shape his thoughts and actions. He had to break with his family's gentility and adopt the most laborious and sweaty of the arts, yet he prided himself on his noble ancestry (partly mythical) and lived for years in extreme privation in order to devote almost the entire income from his stonecarving to the re-establishment of the family fortunes and honor. He loved his father and his brothers desperately and poured out his earnings for their well-being, yet berated them savagely and at times unjustly. He was a courageous republican and challenged even his papal patrons with scant respect, yet when the chips were down he fled or hid, and in political danger recommended the strictest concealment of political opinion. He professed undying love for Tommaso Cavalieri, yet entertained other emotional interests. He

was rudely masculine in his behavior and in the strength of his style and conceptions, yet could allow his line and surface to caress a form with a lingering feminine sweetness. He used male models for his monumental female figures (fig. 31), yet time and again in his intimate drawings it is almost impossible to decide whether the beautiful subject is a young man or a young woman. He was always a pious Christian, devoted to God and to the Church and scornful of false priests (of whom there were many in high places), yet no artist has ever celebrated more movingly either the heroic grandeur or the melodious sensuality of the nude human body. His actions and his works overflow with vitality, yet when his life was scarcely half over he considered himself old and for forty years he meditated on death.

Perhaps the secret of Michelangelo's well-nigh universal appeal lies partly in the very poignancy of this spiritual conflict. The Christian Psychomachia, or warfare in the soul, the subject of so much thought, writing, and elaborate imagery in the Middle Ages, becomes a personal struggle in the Renaissance. On the limitless battlefield of Michelangelo's mind the opposing armies move with pride and ferocity and greatness. From the sacrifice, the terror, the suffering, the courage, the compassion of this inner war, emerges the beauty that makes every stroke of his chisel, his pen, or his brush an unforgettable witness to the powers of the human spirit.

There is, undeniably, a certain grandiosity about Michelangelo, illustrative perhaps of the tragic gap between all human aims and human achievements. Think of the contracts he signed—the Piccolomini altar with its fifteen statuettes to be executed in three years, of which none was ever done by Michelangelo himself; the twelve large-scale apostles to be executed in as many years for the Cathedral of Florence, of which only one was even blocked in; the huge fresco painting of the *Battle of Cascina* barely started (figs. 15–17); the first designs for the Tomb of Julius II, which would have had approximately forty over-lifesize statues and several reliefs (fig. 40), not to speak of the architectural details, all to be delivered in five years (in forty years only ten statues were ever done, of which four are unfinished, and only three actually found their way to the tomb); the façade for San Lorenzo (fig. 41), which was to have displayed twelve colossal statues, eleven large and three small reliefs (not one was ever undertaken); the unfinished and

sometimes uncommenced statues and architectural details for the Medici Chapel; the numerous splendid architectural commissions undertaken and allowed to languish. True, Michelangelo was always able to appeal to external circumstances to justify the delay, truncation, or abandonment of a project, but the fact remains that he kept on signing contracts that were unrealistic from the start and frequently conflicted with each other. Judging by the speed at which he generally worked, the first project for the Tomb of Julius II, if it had been allowed to proceed without interruption, would have taken him about twenty years, during which time, of course, his style would inevitably have so changed that the earliest work would have harmonized badly with the latest. Surely both Michelangelo and his patrons were intelligent enough to have realized this. That they did not tells us something

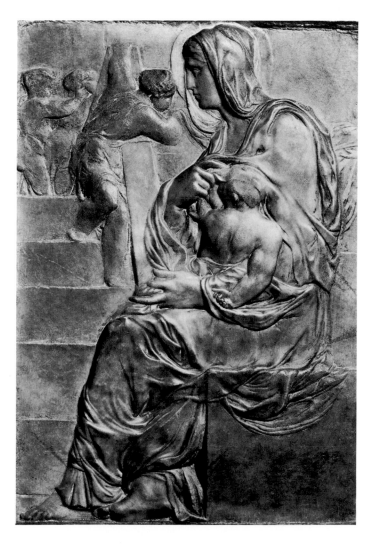

I. MADONNA OF THE STAIRS. C. 1491
Marble, 22 × 15¾″
Casa Buonarroti, Florence

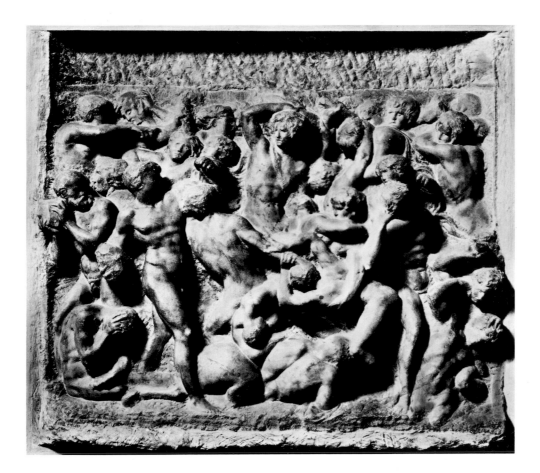

2. BATTLE OF LAPITHS AND
CENTAURS. C. 1491–92
Marble, 33 ¼ × 35 ⅝"
Casa Buonarroti, Florence

significant not only about the artist but about the period from which he struck so responsive a chord.

Grandiosity was the disease of early sixteenth-century Italy. The political life of contemporary Italy then suffered, by and large, from a discrepancy between ambition and reality, doubtless due to the alarm of the separate Italian states before the unified monarchies developing elsewhere in Europe. The French invasion of Italy in the 1490s, when Michelangelo was an adolescent in Florence, made the fact of Italian impotence abundantly and painfully clear. In the opening decades of the fifteenth century the republics, under the lead of Florence, had staved off threats of conquest by one or two Italian despotisms, and in this atmosphere of struggle for human liberty the humanistic style of the early Renaissance had been born. Now, however, these same humanistic values of courage and self-reliance, under the government of guilds of merchants and artisans, had become anachronistic, yet had created an atmosphere in which willing unity on a national scale —the only possibility of defense against foreign domination—was impossible.

The first and least praiseworthy Italian reaction to the foreign threat was the gangster regime of the Borgia family, possibly directed toward making the papacy itself a hereditary monarchy. But there were more heroic responses. The Florentine Republic, dedicated to the re-establishment of its ancient freedoms, expelled the Medici family and consolidated republican rule by means of a leader elected for life. Under Julius II the papacy assumed a peninsular leadership, resulting in the expulsion of the French from Italy in 1512, the submission of Venice, and the subjugation of Florence. But in spite of their enthusiasm and courage there is something fantastic about both the attempt of the Florentines to revive a republic long corroded from within and the old Pope's aim to melt single-handed the rivalries of a millennium and forge such intractable metals into anything approaching a nation.

Michelangelo was the perfect artist for such heroic dreamers, for he could provide them with glorious images of a triumphant and perfect humanity, endowed with superhuman powers before which all obstacles would disappear. Under Soderini's republic and even more under the theocratic empire of Julius II, Michelangelo's new race of titans was born and grew to gigantic stature. But they, their creator, and their patrons were doomed, as some had long realized they would be. The grim reality

9

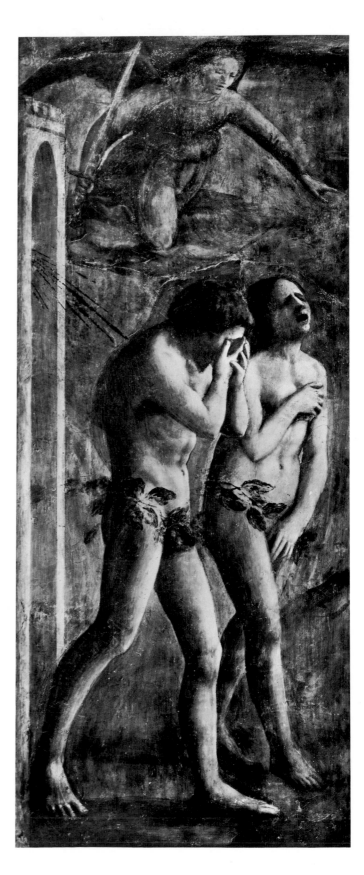

of the Italian predicament became only too apparent once death had checked the dynamic impetus of Julius II and the excitement had died down. Under his successors Leo X, Hadrian VI, and Clement VII, Italy proved incapable of holding off invasion, even as the papacy was powerless to keep Western Christendom united. After the ultimate humiliation of the Sack of Rome in 1527 and the imprisonment of Clement VII, only a new absolutism, temporal under the Empire, spiritual under the Counter Reformation papacy, could maintain the appearance of stability in Italy. Defeated and discredited, the glorious giants of Michelangelo's imagination at first writhed in

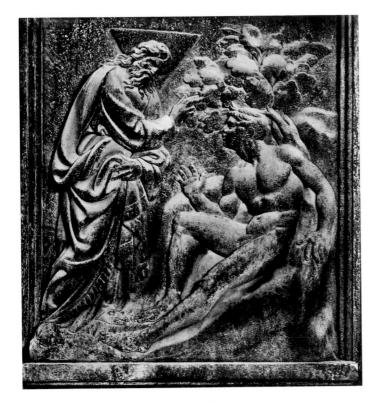

5. Jacopo della Quercia: CREATION OF ADAM
1425–38. *San Petronio, Bologna*

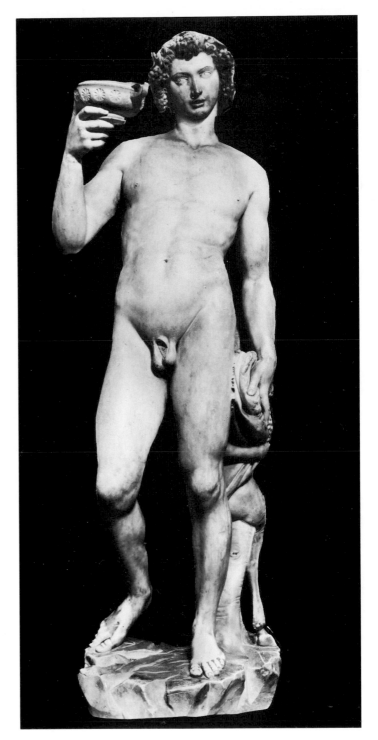

6. BACCHUS. 1496–97. Marble, height 6′ 8″
Bargello, Florence

subjection and eventually retreated into an inner world of phantoms and private religious solace. The dreams had evaporated; the Renaissance ideal of human supremacy was over.

Michelangelo Buonarroti was born on Sunday, March 6, 1475, at Caprese, a cluster of stone hovels clinging like barnacles to the gutted hulk of a medieval castle, high in the Apennines. Only a few miles away stood the vast mountain forest of fir trees at Camaldoli where, in the eleventh century, St. Romuald experienced his vision of the heavens opening, and where, in those very years, Lorenzo de'Medici walked on summer days with the members of his Neoplatonic Academy. Even nearer, on the lonely peak of La Verna, St. Francis of Assisi in the thirteenth century had received the wounds of Christ in his hands and feet and side. We do not know whether Michelangelo ever returned to Caprese, of which he can have had no conscious memories (he was only a month old when he left), but at one time he jokingly told Giorgio Vasari, the painter, architect, and art historian, on whose *Lives of the Painters, Sculptors, and Architects* we depend for so much of our knowledge of the Renaissance, that his genius was first nourished in the rarefied air of the

mountains of Arezzo. And the few landscapes appearing in his work (page 127; figs. 60, 62) show the same barren hummocks and stony ridges that ring Caprese. He also let Vasari know that he drew in the love of stone with his wet-nurse's milk, since outside Settignano, a town of stonecutters near Florence, he had been given over to the care of a stonecutter's wife. It is interesting in this regard to note that Michelangelo's only signature on any work

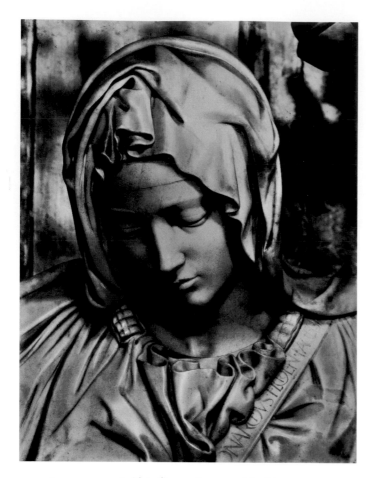

7. PIETÀ (detail). 1498–1500. Marble,
height 69". St. Peter's, Rome

of art is carved into a band over the breast of the Madonna in the marble *Pietà* in St. Peter's.

He seems to have grown up, however, with remarkably little feminine influence. The enormous mass of documents and sixteenth-century literary sources concerning the artist contain not a single reference—beyond their mere names—either to his mother or to the woman his father married when the boy was ten. From the very beginning Michelangelo's character seems to have been shaped by the constant stresses of a family of men—his father Lodovico Buonarroti, his uncle, and four brothers, all but one of whom were younger. Not until the artist's old age is there evidence of a single attachment to a woman, and that an impregnable one, the pious, elderly, widowed, and aristocratic Vittoria Colonna, who had retired to a convent and for whom Michelangelo could find no higher praise than to say that she had the soul of a man. The alternating phases of unbounded generosity and affection toward men and sullen, silent suspicion seem

to reflect the rivalries of a male-dominated environment.

At the grammar school to which his father sent him, as a preparation for a career in business, the boy seems to have spent more time drawing than learning, to the despair of his father and uncle, who considered art a social disgrace. No punishments could deter the child, however, and less than a month after his thirteenth birthday he was placed by Lodovico in the shop of the painter Domenico del Ghirlandaio and his son David. We have no evidence as to Michelangelo's own preference in the matter, but if Lodovico had to apprentice his son to a painter, Ghirlandaio was certainly the most acceptable candidate. He enjoyed a tremendous business success. In fact he may be thought of as the ideal painter for the Florentine businessmen of the late fifteenth century —sound, conservative, and literal; not plagued by imagination, Ghirlandaio was a competent craftsman where the work would show and unwilling to waste his time where it would not; he was the head of the busiest picture-factory in the city, with an army of assistants and apprentices. It is scarcely conceivable that Lodovico Buonarroti would entrust his boy's future to a lanquid romantic like Sandro Botticelli, or to so mercurial a genius as Antonio del Pollaiuolo; and of course the greatest Florentine artist of the time, Leonardo da Vinci, was then working in Milan, and thus unavailable. Michelangelo must have struck Ghirlandaio as already a useful member of his shop, for he was willing to offer a salary rather than exact the usual parental payment for the indenture. About the boy's own attitude we know only what he told his biographer Ascanio Condivi at a much later date, and memory was one of Michelangelo's most creative faculties. We read about his painting a *Temptation of St. Anthony* on panel after an engraving by Schongauer, with all the monstrous details heightened by careful study of the Florentine fish market. We also learn that Ghirlandaio was so jealous that he refused to show his pupil his sketchbook filled with heads, dogs, sheep, and the like.

Attempts have been made, with slight success, to identify the hand of the thirteen-year-old Michelangelo in the vast series of frescoes painted by Ghirlandaio and his shop in the chancel of Santa Maria Novella. What is certain is that the boy was exposed in Ghirlandaio's shop to the time-honored methods of Florentine painting, which had scarcely changed since the days of Giotto. Fresco and tempera techniques could scarcely have been absorbed

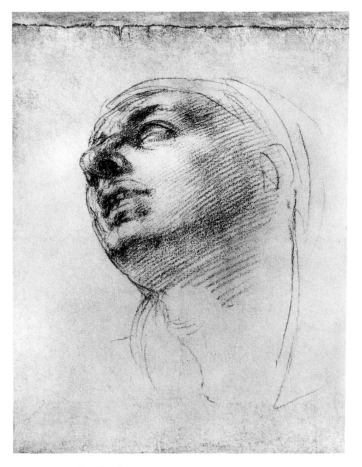

8. Study for THE DONI MADONNA. C. 1503
Drawing, red chalk, 7⅞ × 6¾"
Casa Buonarroti, Florence

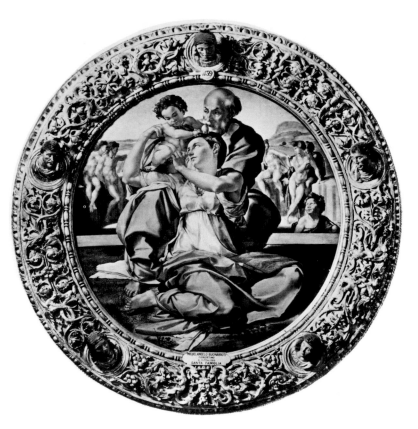

9. THE DONI MADONNA (in original frame)
Probably 1503. Tempera on panel,
diameter 47¼". *Uffizi, Florence*

from a better source, nor could the fundamentals of drawing and the inescapable principles of Renaissance perspective. In many a passage in the Sistine Ceiling one still feels the solidity of Ghirlandaio's form and spatial structure, and even fifty years after his apprenticeship, when occupied with the *Last Judgment*, Michelangelo was still contemptuous of the newfangled methods of painting in oil, preferring the ancient Tuscan fresco technique. In none of his paintings does he accept the shadows and atmosphere of Leonardo da Vinci, for example, but always insists, where the subject permits, on the clarity and brilliance of Florentine tradition.

Nonetheless the boy must have chafed at the narrow and commercial viewpoint of Ghirlandaio's shop. He served out only one of the three years of his apprenticeship, and in 1489, through the good offices of his friend, the minor painter Francesco Granacci, he entered a new and exciting world, the art school run by Lorenzo the Magnificent—in gardens which have since disappeared

—near the monastery of San Marco. Here for the first time he came in contact with the forces that were to shape his future existence—high politics, philosophy, poetry, and the wonders of classical antiquity. His instruction in sculpture was from a surviving pupil of the great Donatello (fig. 3), Bertoldo di Giovanni, but even more from the works of ancient sculpture that lined the walks and the *loggia* of the Medici Gardens. Most important of all, perhaps, was his emergence from the still medieval shop system of the Florentine craftsmen into a completely new and heady atmosphere of intellectual freedom. For the first time, too, he had the opportunity to live on equal terms with the rich and great, for Lorenzo took him into his own palace in the Via Larga, which was bursting with magnificent works of Renaissance painting and sculpture, and ancient cameos, medals, and coins. And now, like many other art students of the day, he went back to the sources of Renaissance form, light, and space, and drew from the frescoes of Giotto in Santa

13

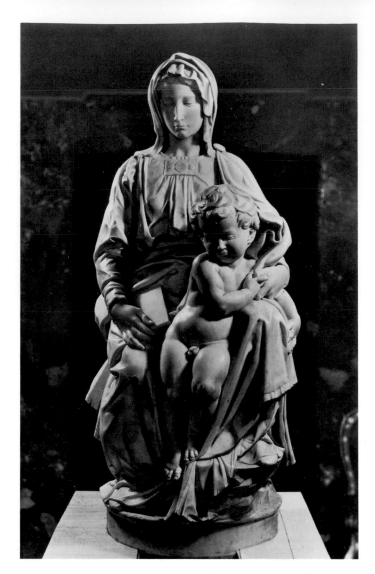

Croce and Masaccio in the Carmine. From this period date Michelangelo's earliest known works, two marble reliefs, the *Madonna of the Stairs* (fig. 1) and the *Battle of Lapiths and Centaurs* (fig. 2). While the first shows his mastery of the delicate marble techniques of the late fifteenth-century sculptors and his absorption in the classical art in the Medici Gardens, the second, deriving from the tradition of Roman battle scenes, gives an astonishing foretaste of his mature ability to unfold passion and tragedy through the interaction of human bodies. The sibyls of the Sistine Ceiling and the nudes of the Last Judgment are already nascent in these reliefs. In fact the *Battle of Lapiths and Centaurs* can fairly be characterized as the most advanced figure composition of its time, in Florence or anywhere else, putting to shame the relatively stiff arrangements of Antonio del Pollaiuolo. It is difficult to imagine any classical work among the statuary fragments, sarcophagi, and such relatively minor objects available to him that this astonishing teen-ager had not

10. MADONNA AND CHILD (BRUGES MADONNA)
c. 1504. Marble, height 50½"
Onze Lieve Vrouwe, Bruges

ABOVE: 11. MADONNA AND CHILD WITH INFANT ST. JOHN
(PITTI MADONNA). c. 1506. Marble,
diameter 33½". *Bargello, Florence*

RIGHT: 12. Jacopo della Quercia: PRUDENCE. 1409–19
Marble. *Fonte Gaia, Palazzo Pubblico, Siena*

already surpassed both in quality and in depth of feeling.

And then at the death of Lorenzo the Magnificent it was all over, and the boy found himself back in the modest house of his father in the stone street following the curves of the old Roman arena, near the church of Santa Croce. If the sources are to be believed, Lorenzo's son and successor, Piero the Unfortunate, although he did

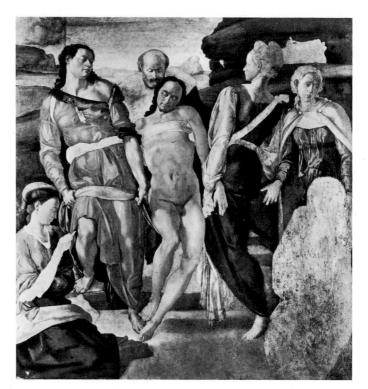

14. Michelangelo and later master:
ENTOMBMENT. Begun c. 1501–3
Oil over tempera on wood,
63 ½ × 59″. *National Gallery, London*

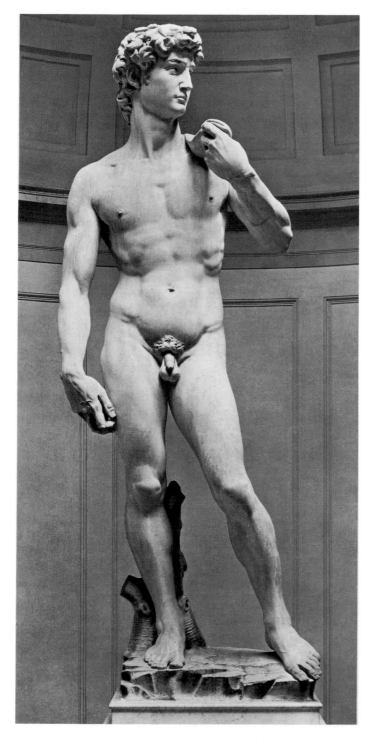

13. DAVID. 1501–4. Marble, height 14′ 3″
Accademia, Florence

call the boy back to the Medici Palace for a few months, had no work for Michelangelo other than a statue in snow. The newly rediscovered wooden *Crucifix* for Santo Spirito and the three statuettes for San Petronio in Bologna show various aspects of Michelangelo's unfolding personality, from an extreme grace and gentleness to an emotional violence prophetic of the grandest aspects of his later sculpture and painting. Particularly important, however, is his own later assertion to his biographer Condivi that he carried on at Santo Spirito anatomical research on corpses furnished him by the Prior. Such study may very well have taken place, but its extent and depth may fairly be questioned, since not a scrap of the resultant drawings has survived, and since also Michelangelo's anatomy in his paintings and sculpture is frequently as imaginative as his memory. There is no evidence to indicate detailed and scientific dissection of the type carried on by Leonardo da Vinci many years later at the Hospital of Santa Maria Nuova. More important, perhaps, was the young man's study of the frescoes by Masaccio in the Brancacci Chapel (fig. 4).

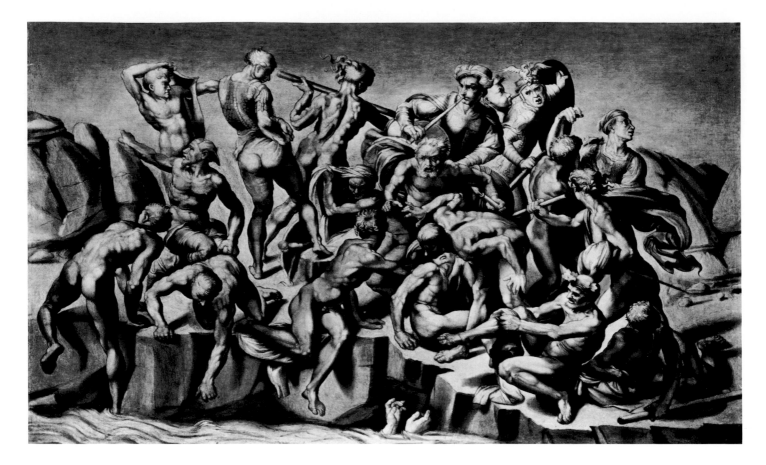

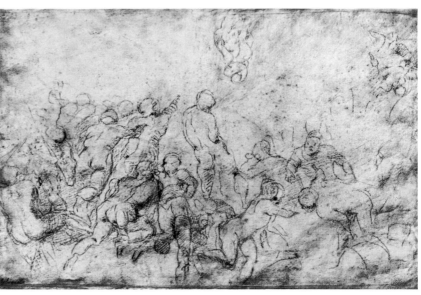

ABOVE: 15. Francesco (or Aristotile) da Sangallo:
Copy of Michelangelo's BATTLE OF CASCINA
Early 16th century. Grisaille
Collection the Earl of Leicester, Holkham Hall
(courtesy the Courtauld Institute of Art, London)

RIGHT: 16. Study for THE BATTLE OF CASCINA. 1504
Drawing, black chalk and silverpoint,
9¼ × 14". *Uffizi, Florence*

The young man's brief visit to Venice in 1494 seems to have had no importance for his art, whose central concern with form remains unaffected by the light and color of Venetian painting. Bolognese painting, of course, could teach nobody very much; but the sculptural reliefs of Jacopo della Quercia on the façade of San Petronio (fig. 5), which Michelangelo must have studied during the winter of 1494–95, must have been a revelation of the expanded powers and dignity of the human body, whether heroically nude or enveloped by surging waves of drapery movement. Jacopo's influence on Michelangelo's style was immediate and profound, playing an important role in the formation of some of the grandest images on the Sistine Ceiling.

Although the Rome of 1496, dominated by the evil genius of the Borgia Pope Alexander VI, can have af-

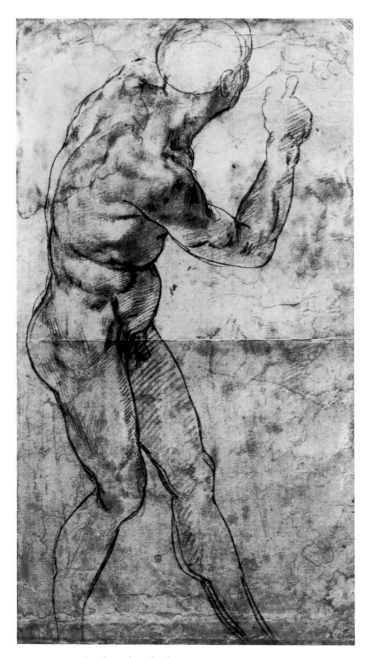

17. Study of nude for THE BATTLE OF CASCINA
1504. Drawing, black chalk,
15⅞ × 10¼". *Teyler Museum, Haarlem*

forded little spiritual inspiration to the twenty-one-year-old artist, it did provide his first contact with the great mass of Roman architecture, sculpture, and painting, whose influence upon his art was incalculable. The rich sensuality of the *Bacchus* (fig. 6), in whose forms Michelangelo explored the chords and cadences of human flesh in a manner unprecedented since ancient times, bears eloquent testimony to the extent to which pagan beauty fascinated the spare, taut young Florentine. But the great *Pietà* of 1498–1500 (fig. 7) is even more important for

18. Apollonius, Son of Nestor:
BELVEDERE TORSO. 150 B.C. Marble, height 62⅝"
Vatican Museum, Rome

Michelangelo's first known pictorial work. Throughout the delicacy and complexity of its fold structure and the extreme refinement of its anatomical drawing moves what can only be described as a conflict between form and line. Forms protrude; lines, even those describing locks of hair, eyebrows, curls of mustache and beard, are actually cut into the surface of the flesh to a perceptible degree. Much later, in his famous letter to Benedetto Varchi in 1549, Michelangelo was to characterize sculpture as the art of "taking away," not that of "putting on," which was similar to painting. In his unfinished statues one can see this process of taking away, or carving, very clearly. Either the surfaces are complete save for the final polishing or they are concealed by the rough masses of the blocked-in marble. There is no intermediate stage, as in the usual unfinished work of a sculptor, all surfaces brought to about the same condition all over at the same moment. One can watch Michelangelo relentlessly driving the profiles around the hidden form, freeing it from the marble by means of a continuous and living silhouette which corresponds to the sculptor's vision of the

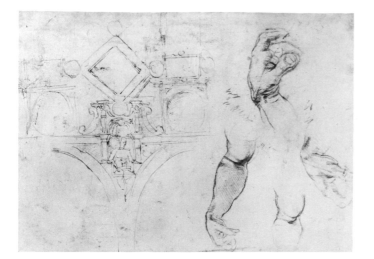

19. Sketch for the SISTINE CEILING:
Studies of Hands and Arms. c. 1508. Drawing, ink and
black chalk, 10⅞ × 15½". *British Museum, London*

form inside the block as he moves around it. No wonder
that the lines should then be so sharp that they cut into
the very flesh of the complete and polished figures.

20. MICHELANGELO PAINTING THE SISTINE CEILING
c. 1510. Ink drawing, portion of
ms. sheet containing sonnet (see page 7)
Archivio Buonarroti, Florence

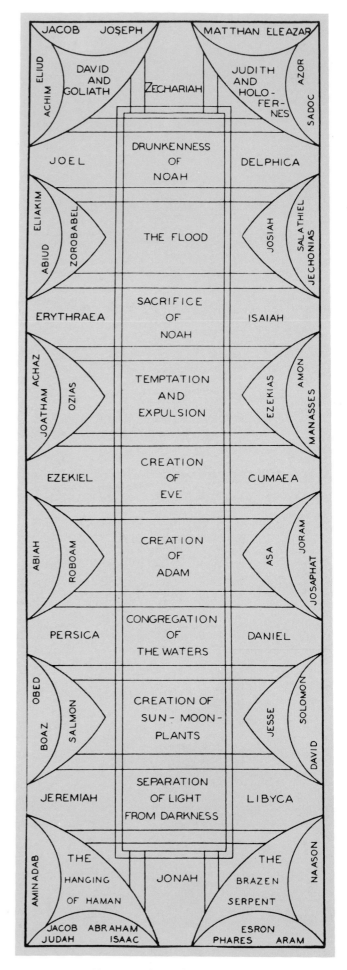

21. Sistine Ceiling, diagram of subjects

In the light of Michelangelo's own declaration that "sculpture is the lantern of painting," it is scarcely surprising to find his pictorial work proceeding on this very principle, with a startling effect of three-dimensionality resulting from the merciless pursuit of the contours; yet at first it is extremely uncertain and disunited simply because no allover system of illumination had been devised to tie the acid silhouettes to the separately polished surfaces. The *Doni Madonna* (pages 49, 51; figs. 8, 9) is probably the first work done by Michelangelo after his return from Rome to Florence in the spring of 1501.

Here, at the Santissima Annunziata, he could see the new cartoon for the *Madonna and St. Anne* exhibited publicly by Leonardo da Vinci, which must have been a marvelous display of exactly the opposite qualities—an unprecedented atmospheric and formal unity, judging by the finished painting in which every form is organically united with every other, and the whole is suffused by a soft glow of light dissolved in moisture-laden air. The harsh brilliance of color and biting intensity of form in the dense and crowded *Doni Madonna* seems a kind of protest against the perfect harmonies of the older artist. Both

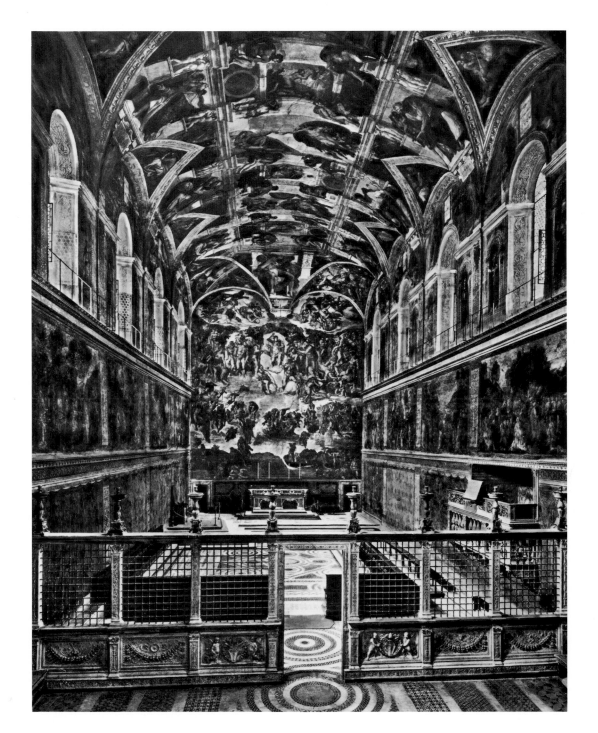

22. Sistine Chapel,
View of Interior
toward the west
Vatican, Rome

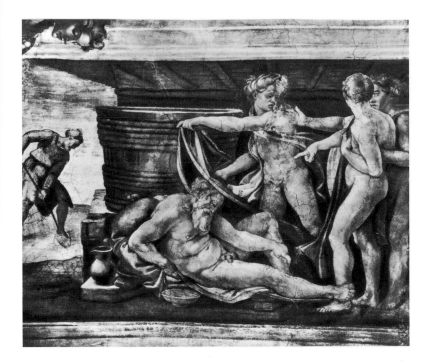

23. THE DRUNKENNESS OF NOAH. 1509. Fresco
Sistine Ceiling, Vatican, Rome

early sixteenth-century Florence was due as much to historical as to artistic reasons. It is not hard to understand how supporters of the newly re-established Republic should desire the protection of the Blessed Virgin, her divine Son, and St. John the Baptist, patron saint of Florence, on their land which was threatened by enemies from every side. Michelangelo's almost overly elaborate painting seems to belong at the head of the procession of *Madonnas* that came from his studio during these years in Florence, and to be closely related to the *Bruges Madonna* (fig. 10). It is hard to conceive of his doing anything of this sort after the dramatic intensity of the unfinished Taddei *tondo*, the majesty of the Pitti *tondo* (fig. 11), or above all, after the immense catharsis of the colossal *David* (fig. 13) and the *Battle of Cascina* (figs. 15–17). Probably during the same months he laid out the never-to-be-finished *Entombment* (fig. 14) and painted the central Christ and Joseph and perhaps the landscape, so close in every detail of treatment to the *Doni Madonna*.

After the heroic scale of the *David*, Michelangelo's first adventure in gigantism, nothing was quite the same again. Perhaps after such altitudes it was well-nigh impossible either for artist or patron to descend to the realities of daily existence. In any case, shortly after the *David* was triumphantly set in its position in front of the Palazzo

paintings were enormously influential among contemporary artists in Florence, and continued to be emulated for at least a decade. Quite possibly the extreme popularity of the subject of the Holy Family in an open landscape in

24. THE DELUGE. 1509. Fresco. *Sistine Ceiling, Vatican, Rome*

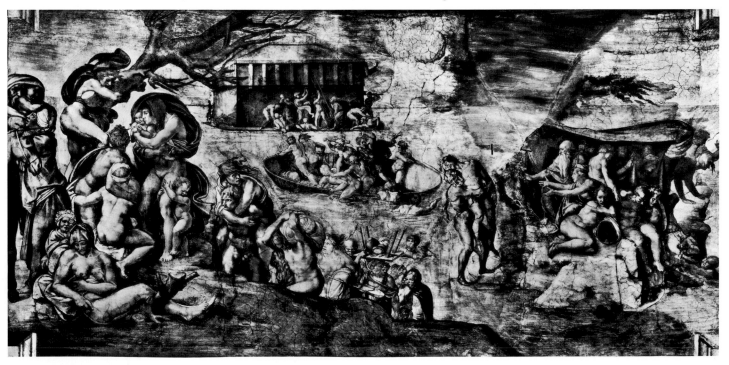

Vecchio, in 1504, to serve as a symbol of the young Republic, the sculptor received his first commission for a colossal work of painting, a fresco of the *Battle of Cascina* (figs. 15–17) for the great council chamber newly constructed by Giuliano da Sangallo as an addition to the Palazzo Vecchio, the ancient home of the government of Florence. There is no evidence that Michelangelo objected or declared that painting was not his profession. In fact he found himself competing again with Leonardo da Vinci who, in the same vast room, was commissioned to paint the *Battle of Anghiari*. The moment chosen by Michelangelo for his subject may seem trivial—the Florentine soldiers, cooling off in the Arno, are called out by

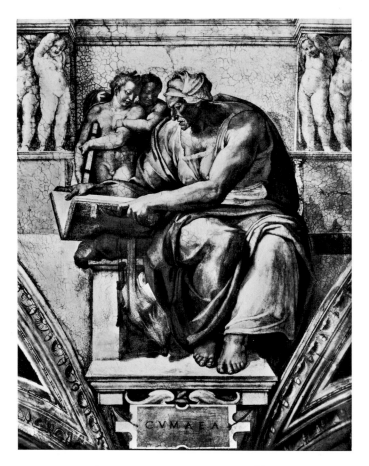

26. THE CUMAEAN SIBYL. 1510. Fresco
Sistine Ceiling, Vatican, Rome

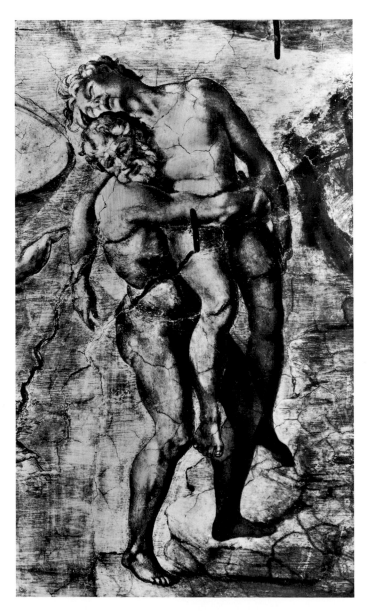

25. THE DELUGE (detail). *Sistine Ceiling, Vatican, Rome*

a sudden alarm and caught in the act of struggling into their clothes and their armor. Yet, like its predecessor, the *Battle of Lapiths and Centaurs* (fig. 2), and like the *Last Judgment* he was later to paint, the *Battle of Cascina* gave him the opportunity of projecting on a plane of intense physical action the emotional stresses of his early existence, as well as of demonstrating his unchallenged mastery of the nude human body. Doubtless, also, he had in mind the recently completed frescoes of the *Last Judgment* by Luca Signorelli in the Cathedral at Orvieto—several incidents from which are organized on somewhat the same principle of a palaestra of active nudes—and the much earlier engraving of the *Battle of the Ten Nudes* by Antonio del Pollaiuolo. Working in secret in the Hospital of Sant'Onofrio, he produced a composition on several levels, a marvelous web of interlocking figures, turning, twisting, crouching, climbing, tugging boots over wet legs, blowing trumpets, reaching to help comrades. According to Vasari some were drawn with crosshatching, some with shading and lighted with white: "Thus seeing such divine figures some said that they had never seen such things

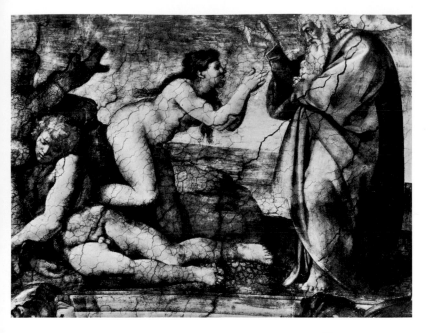

27. THE CREATION OF EVE. 1510–11. Fresco
Sistine Ceiling, Vatican, Rome

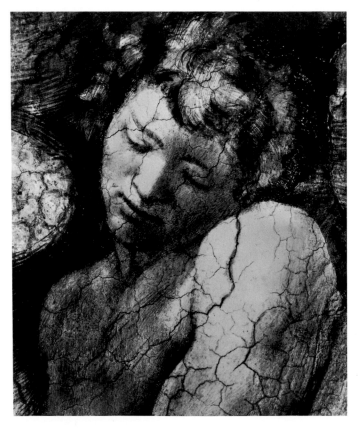

28. THE CREATION OF EVE (detail, head of Adam)
Sistine Ceiling, Vatican, Rome

by his hand or any other, so that to such divinity of art no other mind could ever attain.''

Although Michelangelo probably commenced the ac-

tual painting of the great fresco after his return to Florence from Bologna in 1506, neither the unfinished painting nor a scrap of the cartoon remains. The latter, during its brief existence, became something of an art school in its own right, and was widely imitated by Florentine masters of the High Renaissance and the Mannerist period as an example of how nude figures in action ought to be drawn. The best evidence we have for the original appearance of the cartoon is a series of magnificent drawings by Michelangelo himself, especially a large and turbulent composition sketch in the Uffizi (whose authenticity has been doubted by some scholars, but recently revindicated). It shows an early stage of the evolution of the design in the artist's mind (fig. 16); a copy, probably by Aristotile da Sangallo (fig. 15), probably does not show the entire cartoon. It must have been an awesome thing, bursting not only with a new vision of the splendor of the human body but with a new conception of the excitement of human destiny. Clearly Pope Julius II knew exactly what he was doing when he asked this sculptor to paint the ceiling of his chapel.

It was inevitable, from then on, that an artist so superbly endowed would be called onto the wider stage on which the triumphs and the tragedies of Renaissance history were being enacted. Even a quarter century later, after the Sack of Rome, when the shades of the prison house were closing around Italian independence, he was still not allowed to be a private person. He had caught the attention of the warrior Pope, who wanted Michelangelo to build and carve for him a tomb of unexampled grandeur, formal richness, and dramatic intensity. Again, we have nothing but verbal accounts and some drawings (and a few pieces of marble decoration) with which to reconstruct the three-story mausoleum, with its probably sixteen bound captives and its eight victories, Moses and St. Paul, the Active Life and the Contemplative Life, and at the summit, the bier of the great Pope himself, upheld by grieving Earth and rejoicing Heaven. The commission was suddenly interrupted by the Pope in 1506, after Michelangelo with immense labor and many disasters had brought the marble blocks from Carrara to his studio in the Piazza San Pietro.

Although the circumstances were narrated several times by Michelangelo himself, with always richer and more picturesque detail, it is still not clear why the work was stopped. Presumably the funds had to be diverted to the

rebuilding of St. Peter's, a present necessity considering the state in which the central church of Christendom had been left by the fifteenth-century popes, with the old choir torn down and the new one partly completed but already out of date. In any case the magnificent dream, destined to become a nightmare to Michelangelo for forty years (fig. 40), was still the first instance in which he combined figures and architecture, and was therefore the germ of his major pictorial work, the Sistine Ceiling. Element after element, designed for the 1505 version of the Tomb, came to fruition on the Ceiling, and the Ceiling in turn was to act as a crucible for new sculptural ideas to be utilized in later versions of the Tomb. Shortly after Michelangelo's return to Rome from Carrara, incidentally, the famous Hellenistic sculptural group of *Laocoön*

and His Two Sons was discovered in Rome, and this and the great Belvedere *Torso* (fig. 18) served him as inexhaustible witnesses to the force and tragic intensity of the human body as conceived by antiquity.

After Michelangelo's outraged return to Florence, where apparently he commenced painting the *Battle of Cascina* from the huge cartoon, Julius II began to dream of having him paint the Sistine Ceiling. Instead, the now victorious Pope summoned the sculptor northward to reconquered Bologna to spend eighteen months modeling and casting in bronze a colossal papal portrait statue. The finished work enjoyed an existence of little more than three years before it fell victim to the warfare that was disrupting Italy; it had so short a life, in fact, that no reliable evidence for its appearance has come down to

29. THE CREATION OF SUN, MOON, AND PLANTS. 1511. Fresco. *Sistine Ceiling, Vatican, Rome*

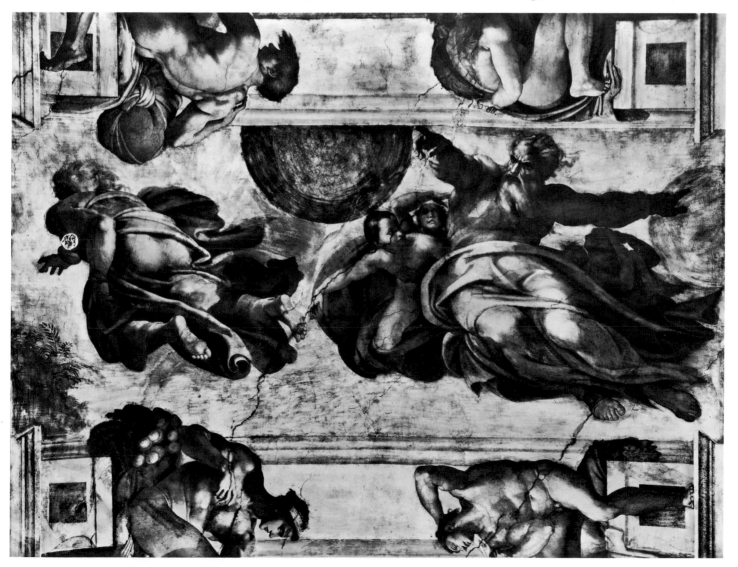

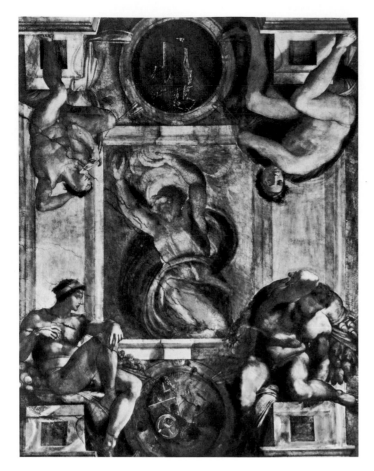

30. THE SEPARATION OF LIGHT FROM DARKNESS
1511. Fresco
Sistine Ceiling, Vatican, Rome

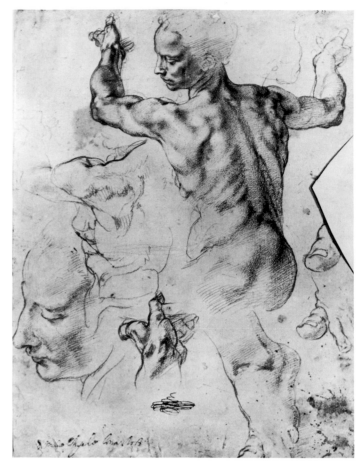

31. Study for THE LIBYAN SIBYL. 1510–11
Drawing, red chalk, 11⅜ × 8½"
The Metropolitan Museum of Art, New York

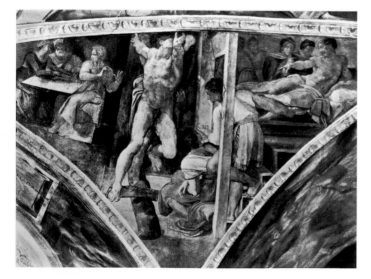

32. STORY OF ESTHER, MORDECAI, AHASUERUS, AND HAMAN
1511. Fresco. *Spandrel, Sistine Ceiling, Vatican, Rome*

us. The artist was hardly back in Florence again in the spring of 1508 when Julius called him to Rome; the dream of painting the Sistine Ceiling had become a definite commission.

The Sistine Chapel, built by Sixtus IV, uncle and predecessor twice removed of Julius II and his protector during his early days as a cardinal in Rome, was intended chiefly for the most sacred deliberations of the College of Cardinals and for the private religious functions of the papal court. Its walls, purposely left uninterrupted by detail, had been decorated in the early 1480s by the principal Florentine and Central Italian painters of the later fifteenth century, not only such universally famous masters as Botticelli, Ghirlandaio, Perugino, Pinturicchio, and Signorelli, but also by the not excessively gifted Cosimo Rosselli, his young and better-known pupil Piero di Cosimo, and the fascinating minor master Bartolommeo della Gatta in his capacity as assistant to Signorelli. The flattened vault, however, was merely painted blue and dotted with gold stars. Here, according to Michelangelo's own later account, the Pope wanted him to paint twelve Apostles, one in each of the spandrels between the twelve arches that upheld the vault. The central part of the ceiling was to have been filled by "ornaments ac-

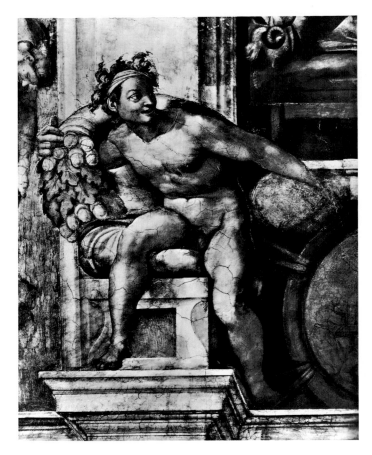

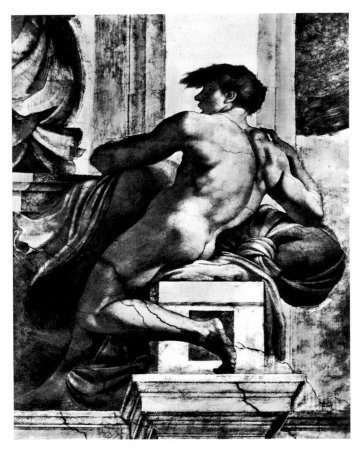

33. NUDE YOUTH AT LEFT ABOVE ISAIAH. 1509–10
Fresco. *Sistine Ceiling, Vatican, Rome*

34. NUDE YOUTH AT RIGHT ABOVE THE PERSIAN SIBYL
1511. Fresco. *Sistine Ceiling, Vatican, Rome*

cording to custom.'' His drawings show the articulation of this first plan (fig. 19).

The enthroned Apostles facing each other across the vault were to have been united by an elaborate network of ornamental motives and geometrical fields, probably based on the designs of ancient Roman ceilings, against which the figures could hardly have asserted themselves. In fact they would have been scaled to harmonize nicely with the figures in the scenes on the side walls and the Popes flanking the windows. Since the left wall had been frescoed with the life of Moses as Lawgiver and Precursor of Christ, the right wall with the life of Christ, and the window level with the Popes, the projected Apostles would have remedied the only major omission in a cycle dealing with ecclesiastical authority.

But then Michelangelo objected; it would be ''a poor thing.'' ''Why?'' asked the Pope. ''Because they [the Apostles] were poor too,'' said Michelangelo. And then, still according to his own version of the story (written fifteen years later when the executors of the Pope's will

were threatening him with a lawsuit for the nondelivery of the Tomb), the fiery old Pontiff told him he could paint anything he liked. Here credulity is somewhat strained. There is no reason to doubt that the expansion of the original program was due to Michelangelo's dissatisfaction. But from the beginnings of Christianity to a period long after the Renaissance the subjects of major Christian artistic projects had invariably been supplied by theologians. The circumstances surrounding Michelangelo's relation to his powerful patron, and the crucial position of the Chapel itself at the nerve center of Western Christendom at the moment of a great ecumenical council hardly suggest that a layman, who in all probability could not read Latin, would have been entrusted with a theological program as complex as the one unfolded in the final version of the Sistine Ceiling. Yet the aura of romantic independence with which Michelangelo has been enveloped since the nineteenth century, contrary to the documents and sources describing his life in the most voluminous detail, has been so strong that it is still difficult

25

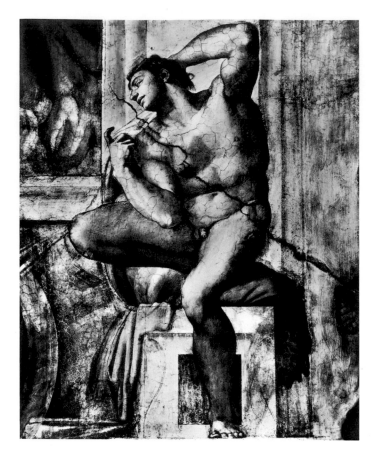

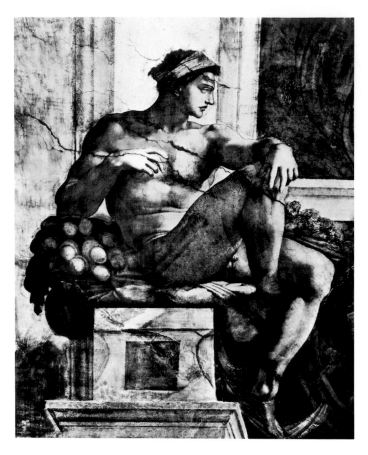

ABOVE: 35. NUDE YOUTH AT RIGHT ABOVE THE LIBYAN SIBYL
1511. Fresco. *Sistine Ceiling, Vatican, Rome*

ABOVE, RIGHT: 36. NUDE YOUTH AT LEFT ABOVE JEREMIAH
1511. Fresco. *Sistine Ceiling, Vatican, Rome*

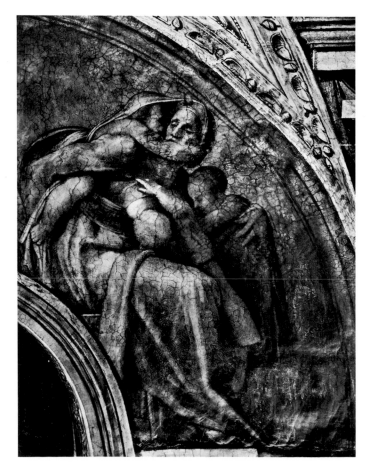

37. JORAM. Fresco. *Lunette,
Sistine Ceiling, Vatican, Rome*

for the public or even for scholars to accept the probability that he did not invent the theological program of the Ceiling.

This is strange, in a way, because our enjoyment of the Gothic cathedrals is only increased by the realization that theologians, architects, sculptors, and stained-glass painters collaborated in building these vast images of salvation. And certainly no one blames G. F. Handel, for example, for not having hunted down all the scriptural passages combined to make the libretto of the *Messiah*. The important question is not the artist's *knowledge* of theological texts and traditions, hardly relevant to his life problem of being a good artist, but his *understanding* of the spiritual and human content of these texts, the artistic possibilities they afford, and his passionate self-identification with their message. The end result of this kind of collaboration between knowledge and creativity

can be a work of such beauty that creativity is revealed as the deeper knowledge. The theological expert is forgotten in the dazzling light of the artist's imagination.

In all probability Michelangelo had his expert, and both were fired by the vision of the mighty pontiff who had committed the papacy itself to a life-and-death struggle for the preservation of Italian liberty, under a charge he seems to have felt came directly from on high. In one of his sonnets Michelangelo called himself "the rays of the Pope's sun." The most likely candidate for the position of Michelangelo's theological adviser in working out the expanded program of the Sistine Ceiling is Marco Vigerio. Like Julius II, Vigerio was a Franciscan and was born in the same Ligurian city of Savona. He was on the first list of cardinals elevated by the new Pope in 1505 and, as one of his closest counselors, was entrusted in 1503 with the defense of the Castel Sant'Angelo, key to the fortifications of the Vatican. The *Christian Decachord* by Cardinal Vigerio, published in 1507, the year before the commission of the Sistine Ceiling, and dedicated to Ju-

lius II, contains many indications that Vigerio was called to advise Michelangelo in the preparation of the subjects for the second program, which was infinitely more ambitious than the first (page 55; figs. 21, 22).

Now the twelve Apostles in the spandrels gave way to an alternation of prophets from the Old Testament and sibyls from classical antiquity, seated in gigantic thrones, so arranged that the prophets alternate with sibyls around the Ceiling, and prophets face sibyls across the Ceiling, with the exception of the key positions at either end of the Chapel, in each of which a prophet is enthroned. The thrones themselves, mere square niches with massive cornices upheld by pairs of *putti* painted to simulate marble sculpture, are a part of the whole vast architecture of the Ceiling, because their verticals are prolonged into ten bands that reach across the Ceiling to merge with the thrones on the opposite side. At the left and right above each throne, save those at the two ends of the Ceiling, sit twenty nude youths holding bands of cloth which pass through slits in the rims of ten medal-

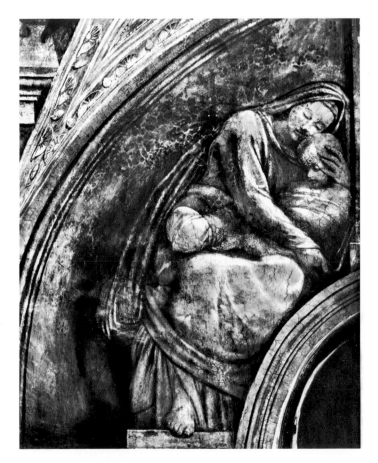

38. RUTH AND OBED. Fresco. *Lunette,*
Sistine Ceiling, Vatican, Rome

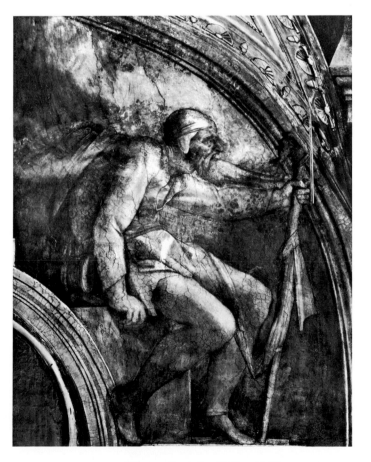

39. BOAZ. Fresco. *Lunette, Sistine Ceiling,*
Vatican, Rome

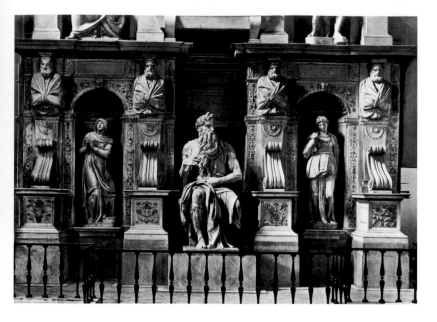

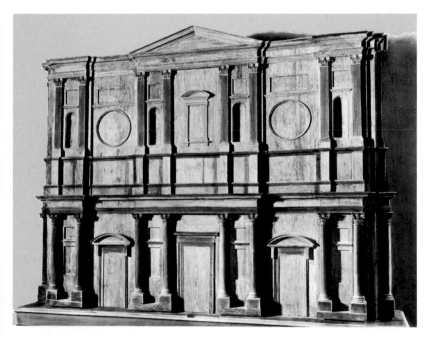

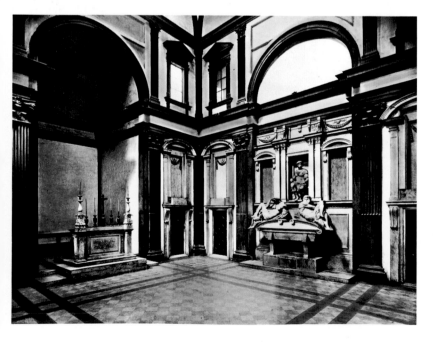

40. TOMB OF JULIUS II (MOSES, 1513–16)
1505–42. *San Pietro in Vincoli, Rome*

41. MODEL FOR FACADE OF SAN LORENZO. C. 1517
Wood. *Casa Buonarroti, Florence*

42. Medici Chapel, View of Interior
including Tomb of Giuliano de'Medici
1520–34. *San Lorenzo, Florence*

lions painted to resemble bronze, and placed above the heads of the ten prophets and sibyls who are seated along the sides of the Ceiling.

The spaces between the ten bands, which resemble the transverse ribs of a medieval barrel vault, are filled by nine scenes from Genesis. The five scenes placed between a prophet on one side of the Ceiling and a sibyl on the other are shortened by the bronze medallions. The other four scenes, between windows, are twice as long. Continuous cornices above the thrones form a frame around the entire central area of the Ceiling. At the corners of this frame, and above the vaulting compartments that surmount the side windows, the cornice seems to be supported by the horns of twelve rams' skulls whose chins are poised upon the stucco bands that separate the ceiling from the vault compartments over the windows and from the spandrels at the four corners of the Chapel. The twenty-four triangular spaces left between the vaulting compartments, the cornice, and the thrones, are filled by bronze-colored nudes, only faintly visible from the floor. The footstool of each of the ten thrones is wedged between the frames of the vaulting compartments, on which its corners seem to rest aided by tiny square supports. In the small space remaining below each of the lateral footstools stands a flesh-colored *putto* with a yoke over his back. From the upward-curving horns of these yokes, cords pass through holes at either end of plaques bearing the names of the prophets and sibyls, sometimes further balanced by the hands of the *putti* themselves. As if this whole fantastic system of figures, enclosures, scenes, and supports were not already complex enough, the four corner spandrels embrace four more scenes from the Old Testament; the eight vaulting compartments and the (formerly) sixteen lunettes above the windows contain figures representing the forty generations of the ancestry of Christ. (Two of these lunettes were later destroyed by

Michelangelo himself to make way for the *Last Judgment* that fills the entire end wall.)

There is, moreover, an elaborate system of interlocking illusions. The prophets, sibyls, nudes, and *putti* below the thrones are painted in naturalistic colors as if actually present, and the nudes and their accessories are frequently permitted to overlap the scenes. The bands simulate marble architecture; the caryatid *putti* flanking the thrones simulate marble sculpture; the medallions and the nudes between the thrones simulate sculpture in bronze. The scenes themselves, however, are clearly paintings without spatial relation to the surrounding figures. Further, the whole colossal structure can never be seen from a single valid viewpoint. For example, one must stand at the entrance to the Chapel in order to look upward and see the scenes right side up, but then one will be reading them backward in time, from the *Drunkenness of Noah* (fig. 23) to the *Separation of Light from Darkness* (fig. 30), and only one of the prophets and sibyls, Jonah, will be upright; Zechariah will be upside down and all the others on their sides. The Ceiling is therefore composed of four converging and conflicting directions of vision, characteristic enough for an artist whose existence was founded on paradox. Finally, although at thirty-six key points (the twenty-four supports for the thrones and the twelve rams' skulls) the Ceiling is tangent to the actual architecture of the Chapel, it is not derived from it in any way, but seems wholly autonomous. And why should it not? No matter how many elements of outer reality a vision may contain, in the last analysis it is incommensurate with the material world.

The message conveyed by this stupendous array of figures, scenes, and shapes may seem defeating at first sight (figs. 21, 22). True, in a chapel lined on one side with representations of the world under the Law, on the other under Grace, the ceiling would logically be devoted to the world before the Law. But then, it is always easy to find logic in theological arrangements—after the fact. The twelve Apostles would also have been an appropriate choice. The difficulty comes with the prophets and sibyls, if they are connected—as they often seem to be—with the central scenes that unite them across the Chapel. How can they be *prophesying* the events of Genesis, which had long since taken place? The answer lies in a basic principle of Christian theology arising in the Gospels themselves, that every event in the New Testament

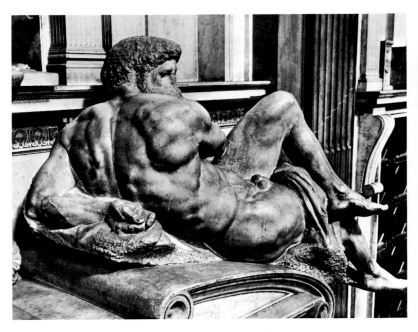

43. GIORNO, from TOMB OF GIULIANO DE'MEDICI
1526–34. Marble, length 6′ 8¾″
Medici Chapel, San Lorenzo, Florence

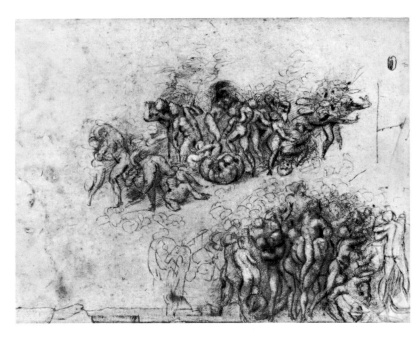

44. THE BRAZEN SERPENT. C. 1520–30. Drawing
(possibly for the Medici Chapel),
red chalk, 9⅝ × 13¼″
Ashmolean Museum, Oxford

is *prophesied* by many in the Old, and to that end the Church Fathers, the medieval scholastic theologians, and the Renaissance preachers devoted a surprising proportion of their thought.

In each of the nine Old Testament scenes on the Sistine

Ceiling some aspect of the coming of Christ is foretold, and in many cases an exact relation can be traced between the prophetic content of the scene and the flanking or adjacent prophets and sibyls. The very first scene, for example, is the *Drunkenness of Noah* (fig. 23). Strange as it may seem to present-day Christians, throughout the Middle Ages and the Renaissance this incident was held to foreshadow the Passion of Christ. For Noah planted the vine and drank of its fruit, and Christ said "I am the vine," and is daily revealed in the wine of the Eucharist. Drunkenness is a kind of death, and Christ died on the Cross. Noah was naked and reviled by his sons, even as Christ was stripped on the Cross and reviled by mankind, His children. Cardinal Vigerio was deeply moved by this simile, to which he devotes an acutely personal passage in his *Christian Decachord*, comparing, incidentally, Ham deriding his father with the naked impenitent thief to the left of Christ. Vigerio then offers himself naked with

Christ on the Cross, and covers up Christ's nakedness as did Shem and Japheth that of their father. I know of no other way to account for the otherwise very puzzling nakedness of Noah's sons in Michelangelo's fresco. The first of the prophets is *Zechariah* (page 57), whose cry, "They shall look upon me whom they have pierced," was held by Franciscan theologians to foretell, like the Drunkenness of Noah, the Passion of Christ. Below Noah's right side is placed a cup of wine, an apparent allusion to the blood almost invariably shown flowing from the right side of the Crucified. *Joel* (page 63) is appropriately enthroned to the left of the *Drunkenness of Noah*, for he had said, "Awake, ye drunkards and weep; and howl all ye drinkers of wine."

The prophetic relationship between the enthroned prophets and sibyls and their flanking scenes clarifies the representations of the ancestors of Christ below. What the prophets and sibyls foresee in the nine stories from

45. LEDA. Sixteenth-century copy after Michelangelo's original, painted 1530. Cartoon. *Royal Academy, London*

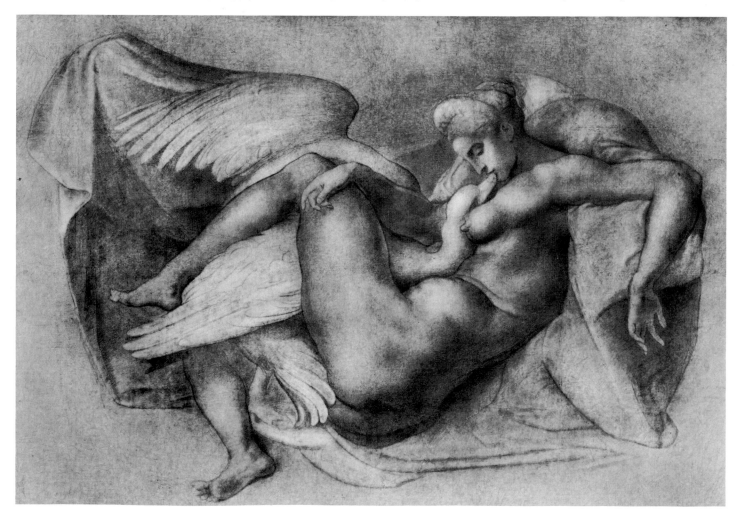

Genesis, the ancestors carry in their own bodies through forty generations (page 107; figs. 37–39). Furthermore the ancestors, whose significance in terms of the Latin translation of their Hebrew names was drawn from a text by the ninth-century theologian Hrabanus Maurus, in almost all instances dovetail exactly into the interpretations of the scenes in the Ceiling above.

Another level of symbolism is provided by the omnipresent oak leaves and acorns, symbols of the Rovere (oak tree) family from which came both Sixtus IV, founder of the Chapel, and his nephew Julius II. Below the wall frescoes, simulated damasks lining both sides of the Chapel are composed completely of oak foliage. All the bands separating the spandrels and vault compartments from the rest of the Ceiling are painted with alternating acorns and shells imitating modeled stucco frames. (The shell, in Christian art, is generally the symbol of eternal life.) The nude youths for the most part uphold heavy garlands of oak leaves and acorns (figs. 33, 36).

The marble barrier which, in the sixteenth century, stood at the center of the Chapel but has since been moved nearer the entrance, is decorated with the Rovere arms—an oak tree. These arms still survive on a gilded stucco shield below the throne of *Zechariah* (page 57), and another was removed from below *Jonah* (page 101) to make way for the *Last Judgment*. The doctrine of the Tree of Life, the Tree of the Cross, is an important Franciscan teaching exploited by St. Bonaventure, whom Julius had Raphael represent alongside his beloved uncle, Sixtus IV, in the fresco of the *Disputa*, at the very moment when Michelangelo was painting the Sistine Ceiling. The oak tree occurs in many other works of art done for the Rovere family and is identified either with the mystical Tree of Life or with its prototypes in the Old Testament, such as the Ark or the Burning Bush; in fact the Burning Bush (*roveto ardente*) is represented in Botticelli's fresco right over the throne destined for Sixtus IV of the Rovere family and occupied by Julius II. Such punning was extremely common in the Renaissance (see commentary on the *Doni Madonna*, page 48).

What six of the seven prophets represented on the Ceiling have in common is their concern with the vision of the Tree of Life, the mystic Branch, the shoot from Jesse's rod, the Messiah. Even Jonah, whose gourd vine in the Vulgate is an ivy plant, ancient symbol of victory, is connected with this poetic identification by giving his ivy

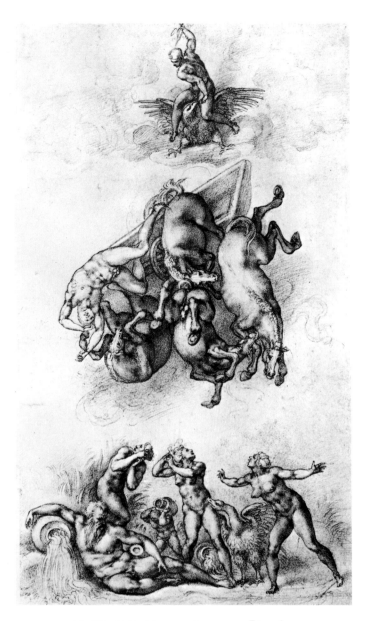

46. THE FALL OF PHAETON. 1533. Drawing,
black chalk, 16½ × 9¼"
Royal Library, Windsor Castle
(by gracious permission of Her Majesty the Queen)

plant the appearance of oak leaves and acorns to suggest the Rovere tree on the shield once directly below him. Tradition connected the sibyls also with the Tree of Life, whose authenticity was widely believed in during the later Middle Ages and Renaissance. Six of the nine scenes from Genesis display prominently trees or wood, and two others are invaded conspicuously by masses of Rovere leaves and acorns from the neighboring nudes. Now the fruit of the Tree of Life is Christ, preserved in the eucharistic sacrifice. It is a curious coincidence that before his elevation to the papacy, Julius II was bishop of Ostia

47. RESURRECTION. 1532–33. Drawing,
black chalk, 12½ × 11⅛"
British Museum, London

water that gushed from the wound in the side of Christ as He slept the sleep of death upon the Cross. Cardinal Vigerio may well have familiarized Michelangelo with this doctrine, for he says in the *Decachord*, "From the side of the first Adam, Eve was formed. And from the side of the Messiah the King, when he was exalted upon the Cross, your daughters, all the churches of the believing peoples Then shall they spring forth when through the streams of water and blood from the side which the soldier opened with his lance the redemption of the human race shall be shown to be completed." A truncated tree, already a kind of Cross, rises above Adam in Michelangelo's fresco.

Now the *Creation of Eve* (figs. 27, 28) was painted directly above the barrier which, in the Renaissance, separated the section of the Chapel reserved for the Pope and the cardinals from that to which ordinary persons might penetrate, and it was flanked by paintings of *Ezekiel*, who saw the mystery of the sanctuary, and *Cumaea*, sibyl of the Roman mysteries (see pages 81, 79; fig. 26). Over the first part of the Chapel outside the barrier are painted the *Drunkenness of Noah* (fig. 23), the *Deluge* (page 69; figs. 24, 25), and the *Sacrifice of Noah* (see page 73), and the *Fall of Man* (page 77), all represented as disasters. God appears in none of these. They deal in succession with Earth, Water, Fire, and Air. Above the barrier, in the *Creation of Eve*, God appears for the first time, standing on earth, His mantle wrapped around Him and His eyes either averted or actually closed. Once past the barrier, the whole world changes. In the *Creation of Adam*, the *Congregation of the Waters*, the *Creation of Sun, Moon, and Plants*, and the *Separation of Light from Darkness* (pages 83–87, 93; figs. 29, 30), we have exactly the same succession of the four elements, Earth, Water, Fire, and Air, but now the Lord is in every scene, flying through the heavens, His mantle open, His gaze intense, leading mankind to salvation through the eucharistic sacrifice.

The last scene, the first in time, brings the *Separation of Light from Darkness* (fig. 30) directly over the altar on which Mass was celebrated, and now even the point of view changes. For the only time in the entire Ceiling one of the scenes is presented as if viewed from below. With His arms raised like the priest at the Consecration of the Host, the Lord shows His plan for human salvation as pre-existent from the beginning of time. This vision of the archetypal message of Catholic Christianity is illumi-

("host"), and, as Pope, the consecrated host preceded him wherever he went. The fruit of his tree, the acorn, alternates with the shell, symbol of eternal life. The rams' skulls, classic symbols of sacrifice—as indeed are garlands —complete the visual symbolism, made specifically Christian by the bands upheld by the nude youths which so strikingly resemble not only the swaddling clothes in which the Christ Child was wrapped but the grave wrappings of the dead Christ in Michelangelo's own unfinished early *Entombment* (fig. 14).

Upon contemplation of the whole structure of the Ceiling, a still further layer of symbolism appears, which clarifies the other two. The central scene, the *Creation of Eve* (fig. 27), symbolizes in a great number of medieval and Renaissance works of art the Creation of the Church. For as Eve was born from the side of the sleeping Adam, so was the Church, in its principal sacraments of Baptism and the Holy Eucharist, born from the blood and

nated in Vigerio's *Decachord* by a mighty dialogue across the centuries between Moses and St. John, the authors of the first and last books of the Old and New Testament respectively, Alpha and Omega of the Scriptures:

Moses: In the beginning God created the heavens and the earth.

John: In the beginning was the Word.

Moses: The earth was without form and void.

John: The Word was with God and the Word was God.

Moses: Darkness was on the face of the abyss.

John: In him was life, and the life was the light of men, and the light shineth in darkness.

Moses: The spirit of God floated over the waters.

John: And the Word was made flesh.

In the words of the last gospel, repeated after every Mass, Moses on the left wall is united with Christ on the right, through the Christian revelation of the meaning of Moses' words. The message of the entire pictorial cycle of the Chapel, ceiling and walls, culminates as it should in the sacrifice of the Eucharist, fruit of the Tree of Life.

The spandrels enrich this message. The victory of Judith over Holofernes (page 61) foretold the triumph of Mary over Satan, as the victory of David over Goliath announced the triumph of Christ over sin (page 59). Moses lifting up the Brazen Serpent in the Wilderness meant the lifting up of Christ upon the Cross (page 103). Haman, strangely enough, is executed not on the textual gallows he prepared for Mordecai, but rather on a rude cross (fig. 32), which interpretation comes fom a medieval source identifying Mordecai with Christ and Haman with sin and quoting St. Paul's statement that Christ had crucified sin upon His cross.

We have no way of knowing how readily Michelangelo accepted this amazing structure of interlocking allusions, but he certainly provided it with an appropriate visual equivalent in the intricate design relationships of the Ceiling. Moreover, he was able to find in each of the scenes and each of the figures a content so deep and a formal grandeur so compelling that it is generally difficult to think of these subjects in any other way. Inspired by the message, and starting with his new vision of human beauty, Michelangelo rose to heights from which he alone, among all Renaissance artists, saw the Creator face to face.

He set to work at once, starting to produce the two or three hundred preliminary drawings that had to be made before the great cartoons could be started. Most of the drawings and all the cartoons have perished, but a number of splendid studies remain to show the labor that must have gone into every detail of the work (fig. 31). The cartoons were laid up against the surface of the coat of plaster applied freshly day by day, and the outlines traced through with a stylus whose marks can be clearly seen in many portions of the work. Michelangelo designed a new kind of scaffolding which could bring him up to the proper level, without support either from the ceiling or the walls. By January, 1509, he was already painting and already in difficulties. Apparently he did not know enough about the proper composition of the fine plaster, because the *Deluge* molded and had to be scraped off and redone. His work continued parallel with the most dramatic events in the action-charged pontificate of Julius II. When he ran out of money, which happened repeatedly, he had to go up to Bologna and beg from the

48. Study for THE LAST JUDGMENT. 1534
Drawing, black chalk, 16¼ × 11¾"
Casa Buonarroti, Florence

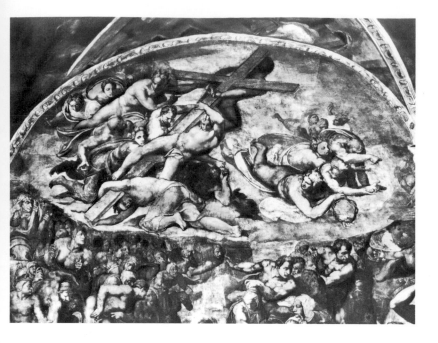

LEFT: 49. THE LAST JUDGMENT (detail, Angels Carrying the Cross and Crown of Thorns) *Sistine Chapel, Vatican, Rome*

BELOW LEFT: 50. THE LAST JUDGMENT (detail, head of Angel Carrying the Cross) *Sistine Chapel, Vatican, Rome*

Whatever the source of his inspiration, Michelangelo became more deeply involved as the work proceeded. The first section of the Ceiling to be undertaken, populated by relatively small-scale, neatly drawn figures, comprising the Noah scenes, the first two spandrels, the first two vaulting compartments, and the first five prophets and sibyls (pages 57–75; figs. 23–25), is relatively timid in handling, and at times Michelangelo's bitter self-criticism appears almost justified—it is, in a sense, dead painting, because he had not yet made it his profession. The grandeur of the ideas and the heroic postures of the figures seem, in the first portion of the Ceiling, to be held in check by the very precision of the sculptor's linear drawing. Nonetheless, even in this first section appears a rapid growth in Michelangelo's ideas and the breadth of his technique. *The Delphic Sibyl* (pages 65, 67), *Isaiah* (page 71), *Zechariah* (page 57), and *The Erythraean Sibyl* (page 75), for example, contrast strikingly in monumentality as well as in pictorial beauty with the Noah scenes and with the hesitant execution of *Joel* (page 63). The pairs of nudes, moreover, now contrast in pose and mood rather than mirroring each other exactly like those over *Joel*, which must have been executed from the same cartoon but in reverse, as is so common in the later fifteenth century.

The second section of the Ceiling, comprising the *Fall of Man*, the *Creation of Eve, The Cumaean Sibyl, Ezekiel* (pages 77, 79, 81; figs. 26–28), and two more vaulting compartments, was painted between September, 1509, and September, 1510. The first change in conception and technique is abundantly visible within the first section of the Ceiling, almost certainly executed while the same scaffolding was still in place. Thus the generally accepted idea that Michelangelo changed his style because in September, 1509, he had his first chance to see how the work looked from the floor, is not very convincing. At any rate the second section, which must have been painted from a new scaffolding, carries out consistently, even

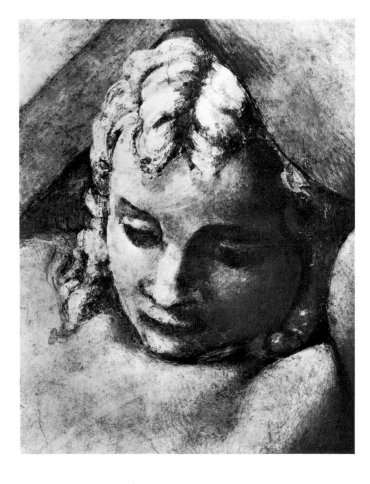

Pope, who was in the midst of the most crucial phase of his war against the French. Quite possibly the artist was moved by the spectacle of the old man's heroism, as well as by his magnificent vision of a new Italy under papal leadership.

expands, the newly discovered breadth of style. It is magnificent throughout, and the prophets, sibyls, nudes, and scenes are harmoniously scaled and interrelated, without any of the jumps or discrepancies sometimes disturbing in the earlier work.

The unexampled sublimity of the final section of the Ceiling proper was apparently matched by its speed of execution. Although the preparatory drawings and cartoons were probably done earlier, the four glorious Creation scenes and the last five prophets and sibyls, four vault compartments, and two spandrels (pages 83–103; figs. 29, 30, 34–36) must have been painted in approximately one hundred working days, between Michelangelo's return to Rome in early January, 1511, and the dedicatory Mass celebrated on the eve of the Feast of the Assumption of the Virgin by Julius II himself. In this third section, again doubtless painted from still another scaffolding, the figures move with greater freedom and constantly expand in scale. In the scenes they swell beyond the limits of their frames and free themselves from their strict adherence to the foreground plane. The prophets and sibyls suddenly grow in stature by almost one third. The little pedestals below their thrones, which move slightly down or up as one looks from one of these figures to the next in the first two sections of the Ceiling, are suddenly lowered between the enframing arches, so that pedestals and name plaques shrink. The expanded figures not only utilize but overflow the newly gained space, protruding so far at times as to cover almost entirely the flanking plinths which uphold the caryatid *putti*. These little creatures are also swept by the general excitement, and instead of merely posturing they wrestle or make love or both, with the wildest abandon. And the linear tightness of the first section has now vanished entirely. Michelangelo has learned to paint freely, with broad motions of the brush, and to make his sculptural masses stand out through movement of color and through light and shade far more than he could have done by the sharp black lines and limited modeling that prevail in the earliest work on the Ceiling. His "*pittura morta*" has come gloriously alive. The newly gained pictorial knowledge is reflected even in his sculptural work, for the *Moses* (fig. 40) is handled with a breadth and freedom completely absent from Michelangelo's earlier sculpture. Throughout the Ceiling, however, the inevitable breaks in the plaster, which correspond to the limits of a day's

BELOW: 51. THE LAST JUDGMENT (detail, Angels Carrying the Column, Ladder, and Sponge) *Sistine Chapel, Vatican, Rome*

BOTTOM: 52. THE LAST JUDGMENT (detail, Angel Carrying the Column) *Sistine Chapel, Vatican, Rome*

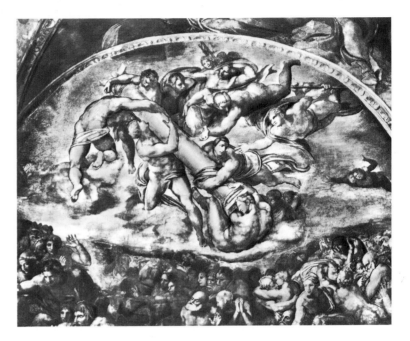

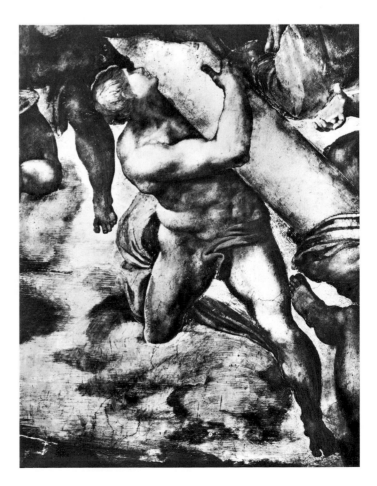

35

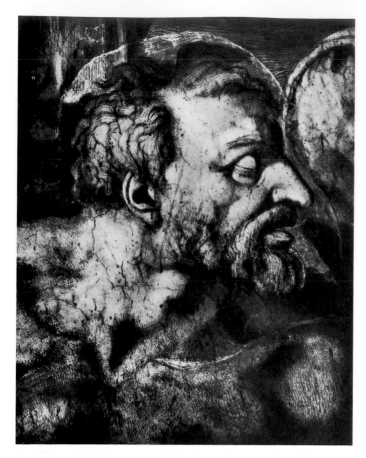

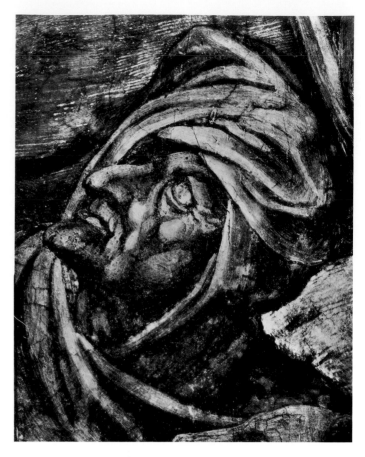

53. THE LAST JUDGMENT (detail, head of
St. John the Baptist)
Sistine Chapel, Vatican, Rome

54. THE LAST JUDGMENT
(detail, head of Aged Woman)
Sistine Chapel, Vatican, Rome

work, usually follow the contour of a figure exactly, so that each figure is actually treated as a solid object, cut out with a knife.

The sixteen lunettes, containing figures that represent together with the vaulting compartments the forty generations of the ancestry of Christ, were surely painted from an entirely different kind of scaffolding, since they are on vertical surfaces of wall, enabling the artist to abandon the cramped position from which he had been forced to paint so much of the vault surface, with the physical side-effects about which he is so eloquent in the grim sonnet quoted at the beginning of this book (page 7). This scaffolding could even have been very simple, just large enough for one lunette, so that it could be moved to a new one cheaply and easily every few weeks as the work progressed. The lunettes (page 107; figs. 37–39) show a surprising change in feeling and in style, sharply detached from the heroic excitement of the vault itself. The figures are frequently very realistic, even to the point of caricature, in their representation of the humble circumstances of daily existence. They remind one of Daumier rather than of classical antiquity, and their mood is frequently one of depression and gloom. The artist's conception seems even to have changed since the painting of those of the ancestors who appear in the vaulting compartments done by necessity from the same scaffolding as the rest of the vault. He must have designed the cartoons for the lunettes while Julius was in Rome, desperately ill. A revolt was brewing among the Roman nobles and it looked as if everything Julius had fought for was about to fall apart. As late as April 11 of the following year, when a number of the lunettes must have been completed, came the catastrophic rout of the papal forces at Ravenna, the first great slaughter of modern history. Not until June 27 did the Pope's strategy suddenly succeed, and the French were driven out of Italy. Before the Lateran Council Julius declared that "God has left us nothing more to ask from Him; we have only to pour forth our gratitude for the splendor of our triumph." That triumph, alas, Michelangelo was destined never to be able to celebrate. He finished the sad lunettes, the Sistine Chapel was reopened to the public on Halloween of 1512, and on February 21 of the following year the old warrior, with whom Michelangelo had fought so bitterly and

36

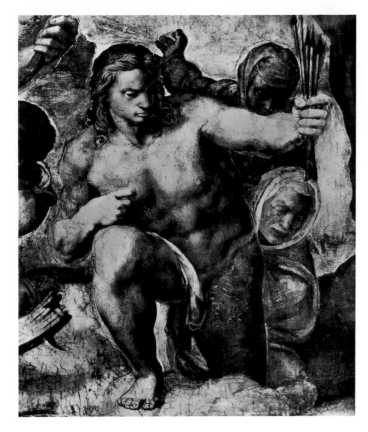

55. THE LAST JUDGMENT
(detail, St. Sebastian)
Sistine Chapel, Vatican, Rome

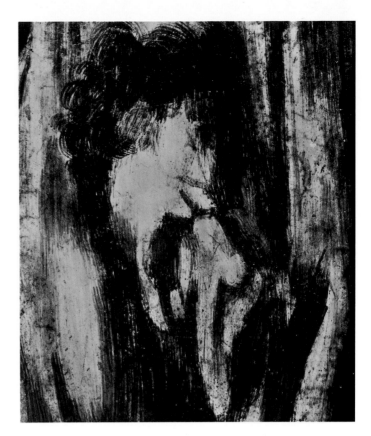

56. THE LAST JUDGMENT (detail, Self-Portrait of
Michelangelo in the Skin Held by St. Bartholomew)
Sistine Chapel, Vatican, Rome

whom he probably at once feared and loved, was dead. The Sistine Ceiling, the greatest work of High Renaissance painting, Michelangelo's most important achievement in an art alien to his genius, is a more appropriate monument to Julius II than the truncated and inhibited structure in San Pietro in Vincoli.

The pontificate of the easygoing, pleasure-loving Pope Leo X, with whom Michelangelo had sat at Lorenzo's table when they were both adolescents, was for the great artist a period of almost unmitigated disaster. "Michelangelo is frightening *(terribile)*," the Medici Pope is reported to have said to the Venetian painter Sebastiano del Piombo, "one can't deal with him." The artist later caricatured Leo's cousin and successor Clement VII unmercifully in a sonnet portraying "the greatest medic of our ills" laughing so that his nose split his glasses, and referring contemptuously to Cardinal Ippolito de'Medici as the "minor medic" among all the "others who deny Christ." In considerable isolation Michelangelo worked away on sculpture for the Tomb of Julius II, but on no more works of painting. Then followed three years consumed in the appalling fiasco of the façade of San Lorenzo

(fig. 41), which wasted the energy of the greatest artist of his time quarrying marble for a project eventually abandoned.

For twenty-four years, in fact, from the completion of the Sistine Ceiling in 1512 to the commencement of actual work on the *Last Judgment* in 1536, we have no work of painting from Michelangelo's hand. But this does not mean that he had deserted his adopted art. There is considerable evidence to suggest that paintings were intended to fill the three lunettes of the tomb chapel for the Medici family (fig. 42), whose architecture he was commissioned to construct and embellish with sculpture in 1519, and which occupied him, with interruptions precipitated by political events (at one point even endangering the artist's life), until he left Florence forever in 1534. A drawing showing in two incidents a scene from the Old Testament already depicted in one of the spandrels of the Sistine Ceiling (page 103)—the attack of the fiery serpents against the Israelites in the wilderness and the healing of the venomous bites by the Brazen Serpent lifted up by Moses (fig. 44)—has been suggested as the subject of two of these lunettes, over the tombs of the

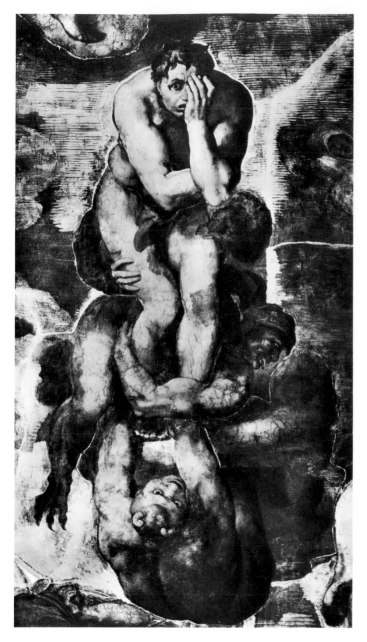

57. THE LAST JUDGMENT
(detail, Soul Carried Down to Hell)
Sistine Chapel, Vatican, Rome

deadly venom . . . they begin with the tongue to spread the poison of serpents."

And Michelangelo did paint during this period one of his most famous works, the panel picture of *Leda and the Swan*, intended for Duke Alfonso d'Este and now lost, like most of his works that had the bad fortune to emigrate to France. Although never begun, others were planned, including a *Noli Me Tangere*, and still others were entertained as ideas. Moreover, Michelangelo kept providing drawings used by his Venetian follower Sebastiano del Piombo in his Roman paintings, so that at least the great artist's pictorial influence continued, if not his pictorial production. The *Leda* must have been a wonderful thing. A number of copies of the painting and of the

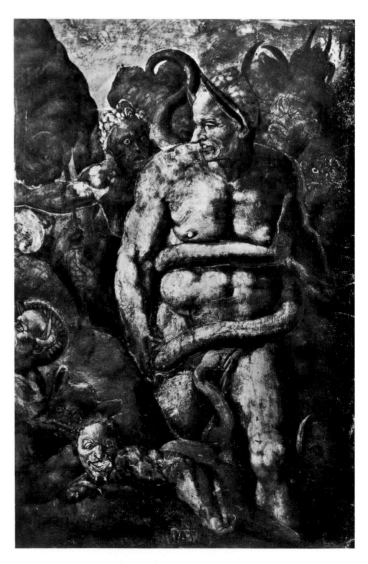

58. THE LAST JUDGMENT
(detail, Minos, King of Hell)
Sistine Chapel, Vatican, Rome

two Dukes, which would have been completed by a *Resurrection* in the central lunette over the Medici Madonna. "Even as Moses lifted up the Brazen Serpent in the wilderness, so shall the Son of Man be lifted up." The Resurrection was a subject of special and personal importance to Leo X, who was crowned on Easter Sunday, 1513, and whose Bull against Martin Luther, launched on June 15, 1520, shortly after the commission of the Medici Chapel, was entitled *Exurge Domine* (Rise up, O Lord), and condemned "lying teachers, introducing sects of perdition . . . whose tongue is fire, restless evil, full of

cartoon (fig. 45), also lost, survive to show all the principal elements. The artist adapted the pose of his own *Notte*, on which he was working for the Medici Chapel, letting the left arm hang freely while the right wrist crossed over the bent left knee. In the *Notte* an owl crouched below this bent left leg; Michelangelo simply put Jupiter's swan in the same general location, but let the left wing escape to beat freely in the air while the shoulder of the right wing presses against the underside of the bent leg. As the swan's great neck writhes against Leda's body and bosom, so that his beak may kiss her apparently sleeping lips, his tail caresses her buttocks in much the same way that the wing of Goliath's helmet caresses the leg of Donatello's bronze *David*. This strikingly lascivious painting seems to have set the fashion for the private erotic imagery which, in the curious ambivalence of the mid-sixteenth century, accompanied the most unbridled public demonstrations of piety.

The drawings made by Michelangelo to celebrate his passionate attachment to the young Roman nobleman, Tommaso Cavalieri, are so ambitious and so finished as almost to become paintings in their own right. Perhaps the grandest of these are the three drawings illustrating the *Fall of Phaeton*. The sheet in the Royal Library at Windsor Castle (fig. 46) is probably the final version, but all three have long been considered closely related to the ideas that reached monumental embodiment in the *Last Judgment*. The impetuosity of the youth who drove the sun-chariot of his father, Apollo, too close to the heavens and then to the earth is compared allegorically to the overweening love of Michelangelo for one so far above him. Zeus wielding his thunderbolt is later translated into the damning Christ; Phaeton hurtling toward his doom, into the souls sinking into Hell; and the divisions into superimposed registers united by a vertical movement, into the vast structure of Michelangelo's vision of eternity. The carefully polished drawing also contains a number of reminiscences of earlier works. Phaeton himself, a spiritual self-portrait of the tormented artist, not only in his relation to Cavalieri but also to his father (who had just died), is drawn from one of the nudes of the Sistine Ceiling, seated directly above Libyca, a figure whose pose is partly related to one of the sons of Laocoön. Strikingly enough this is the only one of the nudes who dares look directly into the face of God (figs. 35, 46), and in the Phaeton drawing Michelangelo has

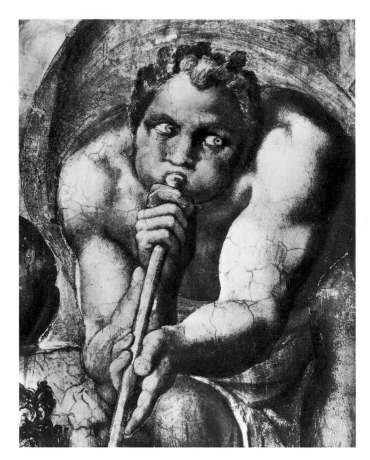

59. THE LAST JUDGMENT
(detail, head of Angel Blowing the Last Trumpet)
Sistine Chapel, Vatican, Rome

turned him upside down for his blasphemy. Two of Phaeton's sisters echo the Eve of the *Fall of Man* (page 77), and the reclining deity of the River Po is closely related to the river gods sketched out but never completed for the Medici Chapel.

At first Clement VII intended for Michelangelo to paint the *Resurrection* on the altar wall of the Sistine Chapel, to replace the fresco of the *Assumption of the Virgin* by Perugino, which must have seemed dreadfully old-fashioned in 1534; the scaffolding was actually erected. We cannot, of course, prove which of the many *Resurrection* drawings done by Michelangelo about this time was intended for this never-executed fresco, or in fact whether he ever got as far as making any designs for it. But there are a number of likely possibilities, among them a glorious drawing in the British Museum (fig. 47) which shows a completely nude Christ floating effortlessly from the open tomb. The lid of the sarcophagus, a guard still resting upon it, has been removed to the ground by the gentle power of the Resurrection; other guards fall back in

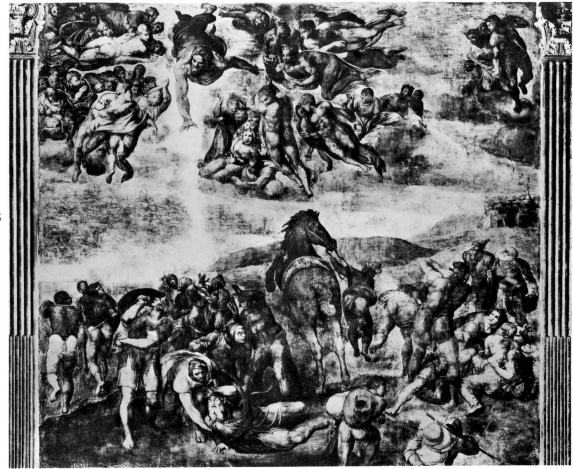

60. THE CONVERSION
OF SAINT PAUL. 1542–45
Fresco, 20′4″ × 22′
Pauline Chapel,
Vatican, Rome

awe or flee in terror. Modeled with the utmost delicacy of surface and flexibility of volume, the figure is silhouetted against His streaming shroud like the Creator against His heavenmantle in the Sistine Chapel. Over His crossed hands the Risen Christ looks heavenward, as if toward the *Separation of Light from Darkness* (fig. 30). The least one can say about this drawing is that it is closely related to the Sistine Ceiling and thoroughly worthy of being painted in so exalted a position. Considering the depth of Michelangelo's passion for Tommaso Cavalieri, of whom he painted a now-vanished portrait, and the strong connection of this attachment with his lifelong belief in the revelation of divinity through the beauty of the mortal veil, it is not impossible that this sublime drawing reflects also something of what Varchi described as Cavalieri's "incomparable beauty." Given the habitual Christian mystical identification of the believer with Christ, there would have seemed to Michelangelo nothing improper in placing an image of the Risen Christ, with such a component, above the altar on which His body rose every day in the sacrifice of the Mass, or below

the Jonah, prophet of the Resurrection, whose face is turned upward to the beginning of all things in the mind of God.

Nonetheless, in the dark and impoverished Rome of the 1530s, the subject finally chosen as appropriate for the end wall of the Sistine Chapel was not the Risen Christ but Christ the Judge. Images of justice and of punishment on a grand scale had appeared in many portions of Italy. The penitential component of the Counter Reformation made the selection of the *Last Judgment* for the end wall of the papal chapel almost inevitable under Paul III. Certainly the idea captured the imagination of the great artist, who devoted a wonderful series of studies to the cyclonic composition with its torrents of figures (Frontispiece; fig. 48). Possibly he had slight compunction in tearing down two more frescoes by Perugino, the *Nativity of Christ* and the *Finding of Moses*, and may have sacrificed quite cheerfully the end windows and their flanking figures of Popes. But it is difficult to imagine his feelings on ordering the destruction of his own lunettes over the windows, representing Abraham, Isaac,

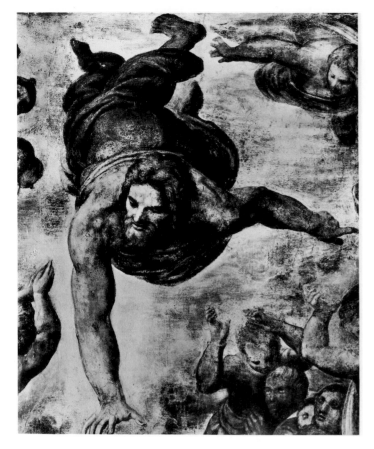

61. THE CONVERSION OF SAINT PAUL
(detail, Christ)
Pauline Chapel, Vatican, Rome

Jacob and Judah, Phares, Esron and Aram, not only great works in themselves but the very start of the series of the Ancestors of Christ. In his construction of the new fresco composition he did at least retain the autonomy of the two lunettes (figs. 49, 51) separated from the rest of the wall by the edges of the floating clouds in which they are enveloped. He also preserved the axes of the spandrels above, in the diagonal placing of the Cross and column carried by the angels at the left and the right, in the wall below the cross of Haman (fig. 32) and the columnar staff of Moses around which the Brazen Serpent is wrapped (page 103). It is not generally recognized that he even kept something of the meaning of the destroyed lunettes, for Isaac carrying the wood for his own sacrifice foretold the Cross, and the staff in the hand of the vanished Aram is related to the column carried by the angels.

For the rest of the gigantic fresco, Michelangelo dissolved the end wall of the Chapel as if it had fallen away in an earthquake. Instead of the solid hierarchical structures of medieval Last Judgments (generally inside the entrance wall), in which all figures but the damned are customarily dressed according to their social position, and Christ, the Virgin, and the Apostles are suitably enthroned in Heaven, Michelangelo has represented a unified scene without any break, without thrones, without insignia of rank, generally even without clothes. In a vast space stretching from just above the altar and the doors at either side up to the clouds of the lunettes, in a huge circular motion which has been compared to a kind of Wheel of Fortune, figures rise from their graves, gather around the central Christ, sink downward toward Hell.

What has given the fresco its special character is certainly the vision of the Second Coming in Matthew 24:30–31: "And then shall appear the sign of the Son of man in heaven: and then shall all the tribes of the earth mourn, and they shall see the Son of man coming in the clouds of heaven with power and great glory. And he shall send his angels with a great sound of a trumpet, and they shall gather together his elect from the four winds, from one end of heaven to the other." Even from the earliest drawings for the *Last Judgment*, therefore, Michelangelo saw a vast gathering of figures approaching the Son of man from all directions in heaven (fig. 48). At the start he may even have intended to include a representation of the Fall of the Rebel Angels, visible at the lower right of the Casa Buonarroti drawing. The airy background of the fresco, of course, should not be construed as infinity; the notion of infinite space had occurred to nobody in the 1530s. It is simply the fulfillment of the text from Matthew 24:35, "Heaven and earth shall pass away." In fact only enough of the earth is shown to contain graves from which the dead can rise. The nudity of most of the figures, so shocking to the prudery of the Counter Reformation which required that little pieces of drapery be supplied to conceal offending portions, is perfectly in harmony with Michelangelo's lifelong concern with the human being in his most elemental aspect. It is also justified by a passage in one of the artist's last poetical fragments,

> *My dear Lord, thou alone dost clothe and strip,*
> *and with thy blood purge and heal the souls*
> *from the infinite human sins.*

Thus not only the dead rising from their graves but all the elect in Heaven are shown naked before the purging Christ, above the altar on which His blood is daily shed.

As the damned descend to their inevitable fate, a few have the temerity to struggle against the angels who drive them from heaven; some rage, but most resign themselves to the overpowering force of divine will. Here and there Michelangelo has singled out an individual for special emphasis. One tragic young man, clearly the source for Rodin's *Thinker*, is dragged downward by exultant demons (fig. 57). Although their hands and even their beaks clutch at him, he seems not to notice. He covers one eye with his left hand; the other stares blankly outward.

As a child the artist must have contemplated again and again the torments of the damned shown in such elaborate detail in the vast *Inferno* painted by Nardo di Cione in the Strozzi Chapel in Michelangelo's own parish church of Santa Croce. Again and again he had read Dante's account, which Nardo illustrated. Surely on his trips to Venice he had passed through Padua and seen Giotto's *Last Judgment*. It is surprising how little effect these universally known works of literature and art had upon him. His interests move in a realm far beyond that of physical torment, indeed physical experience of any sort. The hell within is far more terrible to him. In 1525 he wrote,

> *I live for sin, dying to myself I live;*
> *it is no longer my life, but that of sin:*
> *my good by heaven, my evil by myself was given me,*
> *by my free will, of which I am deprived.*

And in 1532, in a fierce cry for help to the Cross and Him Who hangs thereon,

> *O flesh, O blood, O wood, O extreme pain,*
> *only by you is justified my sin*
> *in which I was born, and also was my father.*
> *Thou only art good; may Thy supreme pity*
> *succor me from my iniquitous state,*
> *so close to death and yet so far from God.*

The eye stares; the mind contemplates the final evil, eternal alienation from the divine presence.

After the long lapse since the monumental paintings of the Sistine Ceiling, a very strong change, as was natural, has come over Michelangelo's style. The figures are much broader and fuller, the proportions heavier, the heads smaller. They have less in common with even the latest phase of the work on the Ceiling proper, as represented by the *Brazen Serpent* (page 103), than they do with the overwhelming power of the *Giorno* from the Medici Chapel (fig. 43). Preponderantly male, they are, of course, a complete fulfillment of the great dream of conflicting masculine figures, which had reappeared again and again in Michelangelo's art since the days of the *Battle of Lapiths and Centaurs* (fig. 2). In the organization of the enormous scene the artist has adopted an arbitrary scale involving striking increases in size as the figures ascend, too sudden and too great to be accounted for by the mere counteracting of perspective diminution. Although the ideal of physical freedom and flexibility has changed between the perfect nudes of the Ceiling (page 105; figs. 33–36) and these strange, massive beings (figs. 52, 55, 57), they are painted with passionate directness as well as with a great sense of plastic volume, and the fresco abounds not only in appropriately horror-stricken heads (figs. 53, 54) but in faces of the most brilliant and arresting beauty. Among them all, empty before the presence of the almighty Judge Himself, the skin in the hand of the flayed St. Bartholomew holds an anguished self-portrait of Michelangelo (fig. 56), revealing even more vividly than do his letters and poems the intensity of his inner tragedy.

Still hounded by the heirs of Julius II on account of the unfinished Tomb, the sixty-seven-year-old artist took up his brushes once again in 1542 and climbed still another scaffold to paint the two principal frescoes in the chapel newly constructed by Pope Paul III off the Sala Regia in the Vatican, just outside the principal entrance to the Sistine Chapel. "I cannot deny anything to Pope Paul," he wrote; "I will paint discontentedly and I will make discontented things." Interrupted by illness and by other commissions, he worked spasmodically on the two frescoes, representing the *Conversion of St. Paul* and the *Crucifixion of St. Peter*. The Pauline Chapel, as it has been named, was not complete until the spring of 1550, several months after the old Pope's death.

Perhaps because so few visitors have ever seen the frescoes in the Pauline Chapel (pages 125, 127; figs. 60–64), compared to the thousands that jam the Sistine daily, these great works are not as well known as they should be. Yet in spite of passages now in poor condition, the Pauline paintings are among Michelangelo's most moving works. True, a kind of rigidity has set in, disturbing after the freedom of the Sistine Ceiling or even the *Last Judgment*, but the artist's powers of expression and drawing have in no way diminished, and conversely the move-

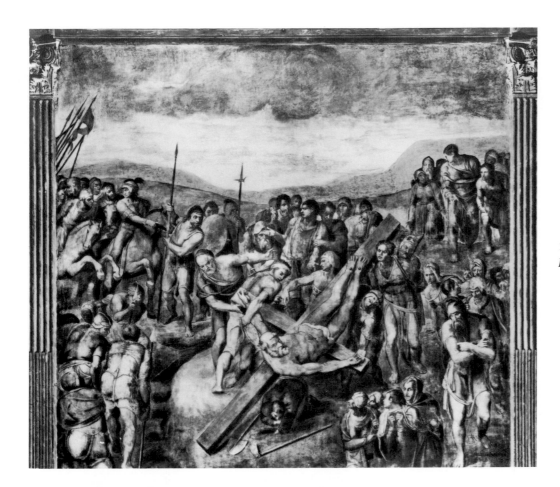

62. THE CRUCIFIXION
OF SAINT PETER
1545–50. Fresco, 20′ 4″ × 22′
Pauline Chapel, Vatican, Rome

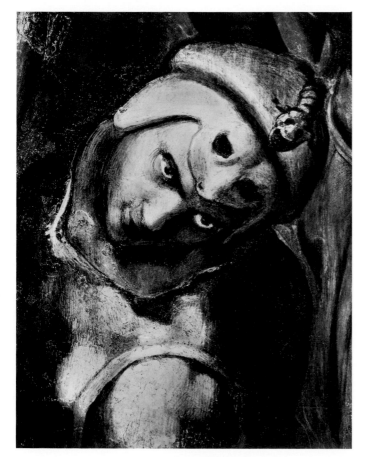

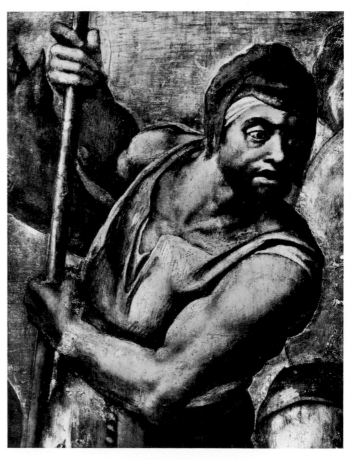

63. THE CRUCIFIXION OF SAINT PETER
(detail, head of Soldier)
Pauline Chapel, Vatican, Rome

64. THE CRUCIFIXION OF SAINT PETER
(detail, Soldier)
Pauline Chapel, Vatican, Rome

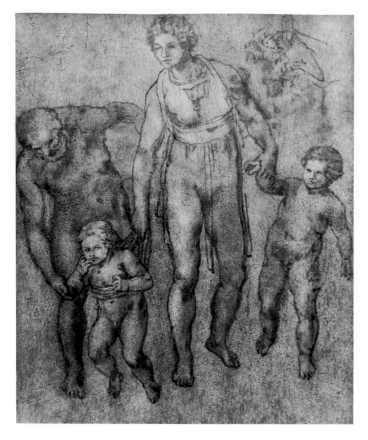

65. HOLY FAMILY WITH ST. JOHN THE BAPTIST
Underpainting in brown on green-toned panel
by Michelangelo, slightly retouched. 26 × 21⅛″
Ashmolean Museum, Oxford

ment of color shows a freedom and release completely unexpected, in view of the meticulous delicacy of the tones on the Sistine Ceiling or the largely monochromatic quality of the *Last Judgment*.

Against barren landscapes whose buttes and ridges still recall the desolation of the mountains of Caprese where Michelangelo was born, the terrible events are staged with cataclysmic violence. The fierce Saul, struck down by a ray from the heavenly apparition, falls from his horse on the road to Damascus whither he was bound for further persecutions of the Christians (page 125). The vision here is fully corporeal. A sharply foreshortened Christ, without any of the expected luminary display (fig. 61), appears in the sky among five angelic platoons whose figures, reminiscent of many in the *Last Judgment*, seem to have been formed into blocks, their curves flattened into planes. As Christ moves downward and

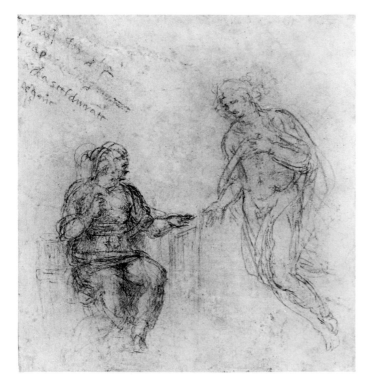

66. ANNUNCIATION. c. 1555. Drawing,
black chalk, 8½ × 7⅞″
Ashmolean Museum, Oxford

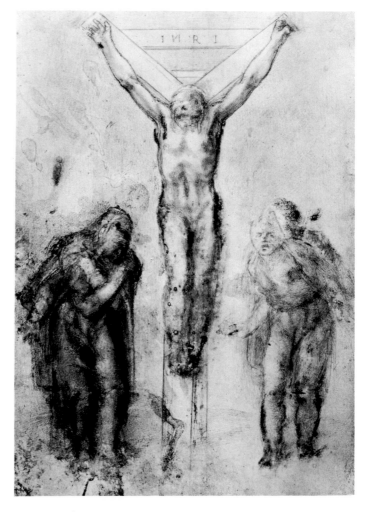

67. CRUCIFIXION WITH VIRGIN AND ST. JOHN
c. 1555. Drawing, black and white chalks,
16⅜ × 11¼″. *British Museum, London*

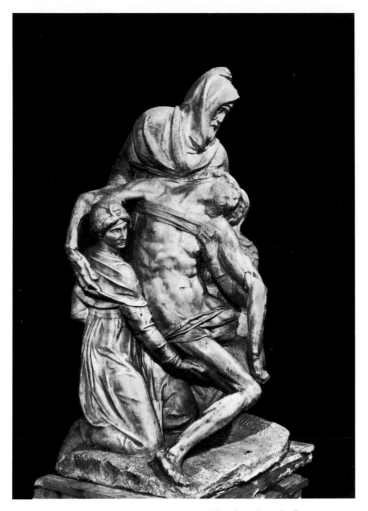

68. PIETÀ. 1547–55. Marble, height 7' 8"
Cathedral, Florence

69. PIETÀ (detail, Self–Portrait of Michelangelo
as Nicodemus). *Cathedral, Florence*

outward, the equally foreshortened horse leaps upward and inward, splitting Saul's attendants also into blocks of figures. In the foreground the blinded Saul, shortly to become the Apostle Paul—one of Michelangelo's most beautiful figures—falls forward as if struck by some power emanating from the floating Christ.

The *Crucifixion of St. Peter* (fig. 62) becomes a kind of hollow square tilted up with the rising movement of the landscape, and traversed by the powerful diagonal of St. Peter's cross. Yet for all the massiveness of both frescoes, they seem strangely weightless, floating, phantasmal. In spite of the emphasis on block shapes, the foreground figures now seem to stand on the ground, now to rise from nowhere, cut off at the waist or the knee by the frames. Renaissance perspective, always uninteresting for an artist so much more responsive to things that can be felt than to optical effects, is abandoned completely and, with an archaistic disregard of real space, what is behind

is, instead, represented above. And the distances, with their surging horizons and threatening clouds, make ready at any moment to engulf the tragic figures. The strange composition, with its ranks of figures seeming to float upward, generally facing the observer, culminates in an awestruck group silhouetted against the distant promontories. They look down, they look at each other, with the same expressions of trance-like wonder, and these are shared even by the soldiers and executioners, who are performing what appears to be more like a mystic rite than an actual execution or a martyrdom.

For the first time there appears in this fresco the strange figure-type which runs throughout so many of the inventions of the artist during the last years of his life (fig. 65). Male and female are made to resemble each other so closely that in the case of certain drawings scholars have experienced difficulty in deciding which is which. Men and women have the same thick waists and broad, slop-

70. RONDANINI PIETÀ. 1555–64. Marble,
height 63⅜". *Castello Sforzesco, Milan*

visual reality faded during the final nineteen years left to him, his architectural forms became always grander and more richly articulated. It was as if the sense of mass which, in his earlier art, had arisen from the human figure, had now outgrown it and could function on its own in the noble buildings he imagined, sometimes literally in his dreams, for a power-haunted Florence and a new and grander Rome. The human being, Michelangelo, was left in spiritual isolation to contemplate his return to the divine source from which he had come.

Lacerated by one personal bereavement after another, yet still comforted by the divine and human love for which his entire life had been an unending search, Michelangelo becomes strangely gentle in his last years. Instead of berating his nephew Lionardo for his visits and scorning his gifts, he thanks the young man, and even desires his presence. In the last letters death is always near. But the artist no longer dreams of the mighty Creator nor even so much of the awesome Judge; rather the self-immolating Victim, the merciful Redeemer. In the late poems and the visionary drawings of the crucified Christ (fig. 67) Michelangelo pursues

> *That Love divine*
> *which opened to embrace us*
> *His arms upon the Cross.*

In the late Annunciation drawings (fig. 66) he sees the miracle of the Incarnation take place in his own heart, with a soft radiance that dissolves all solid forms. In the Florence *Pietà* intended for his own tomb (figs. 68, 69) he folds the head of the sacrificed Saviour lovingly into his bosom. In the Rondanini *Pietà* (fig. 70) the sculptor —now but a few days away from death—seeks the indwelling spirit through successive ghostly stages of shattered marble; under his shaking hands earthly images and earthly substance melt away; Christ and the Virgin fuse in a common spirituality which now claims him, and his own identity merges with theirs. In the peace that descends over his last days it is clear that his battles were at an end. Yet to succeeding generations, each confronted by old yet ever new enemies in the insoluble dilemma of our dark mortality, he left a deathless example of how the earthly war should be conducted.

ing shoulders, the same flat noses and heavy cheekbones, the same central fold of drapery falling between heavy thighs revealed by clinging clothes. The women's breasts have been flattened until they now protrude little more than male pectoral muscles.

Now aged seventy-five, threatened by ill-health and failing eyesight, he was not able to carry out any more pictorial commissions. Oddly enough, as his control of the immediate circumstances of practical existence and

COLORPLATES

THE DONI MADONNA

Probably painted 1503

Tempera on wood panel; vertical diameter 35 ½", horizontal diameter 31 ½"

Uffizi, Florence

During the fifteenth century, circular Madonnas, Holy Families, and scenes from the infancy of Christ (*tondi*, from the word for "round") were very popular in Florence (fig 9). The circular form, unsuitable for altarpieces, was often associated with marriage in Renaissance art, but the composition of the *Doni Madonna* is indebted to Leonardo's lost cartoon for the *Madonna and St. Anne*, which Michelangelo must have seen in 1501, when he had returned to Florence from Rome and was at work on the *David*. Michelangelo's painting was done for the prosperous weaver Agnolo Doni. The appearance of Doni and his wife, Maddalena Strozzi, of the famous banking family, is well known from Raphael's portraits painted four or five years later. The *Madonna* was painted to celebrate Doni's wedding, probably in 1503. According to Vasari, Doni was at first unwilling to pay the promised seventy ducats for the painting, but eventually the artist extracted from him double the contract price.

The difficult meaning of the picture has provoked some farfetched explanations. While the *Doni Madonna* may perpetually defy exact interpretation, certain elements are clear. Mary and Joseph appear to be presenting or giving the Child. The secret prayer for the Octave of Epiphany, which appears as early as the Roman Missal of 1474, exhorts the Lord to look down in mercy on the gifts of His Church, by which we offer "that which is signified, immolated, and received by these gifts, Jesus Christ"; *doni* is the Italian for "gifts." The curious dry font or tank on whose edge the nude youths sit or lean is a half moon, the symbol in the Strozzi arms, which appear in the original frame of the painting. The Epistle for the Fifth Sunday after Epiphany, also in the 1474 Missal and in medieval sources, and significantly enough in the modern Mass of the Holy Family, is drawn from Colossians 3:12–17, and in the preceding chapter St. Paul characterizes the new moon as "a shadow of things to come, but the body is of Christ." The Epistle deals with Baptism as a death to the old life and a resurrection in Christ, and the infant Baptist appears in the font. (The first four sons of Angelo and Maddalena Doni, all of whom died shortly after birth, were named Giovanni Battista.) We are adjured to strip ourselves of "the old man with his deeds" and put on the new, and the Epistle lists two groups of five vices to be renounced. There are five nude youths (and five medallions in the original frame). Five virtues are to be put on instead, and the youths have partly or entirely removed their colored garments, and are stretching out white cloths. We are asked to forgive one another "if any have a complaint against another," and the two youths at the left turn toward those at the right, as if to dissuade them from their quarrel.

Some symbols here are traditional. A conspicuous flower rising before the stone enclosing the dry font recalls Isaiah's prophecy of the Virgin Birth, "for he shall grow up before him as a tender plant, and as a root out of a dry ground." The bay of water in the background recalls Mary's title as "Port of Our Salvation." But the position of the Virgin, seated lower than her husband, in spite of Mary's exalted rank as Queen of Heaven, comes again from Colossians (3:18), "Wives be subject to your husbands," and the total configuration comes from the Epistle for the Sunday in the Octave of the Epiphany, repeated as Communion today in the Mass of the Holy Family (Luke 2:51), "Jesus descended with them . . . and was subject to them."

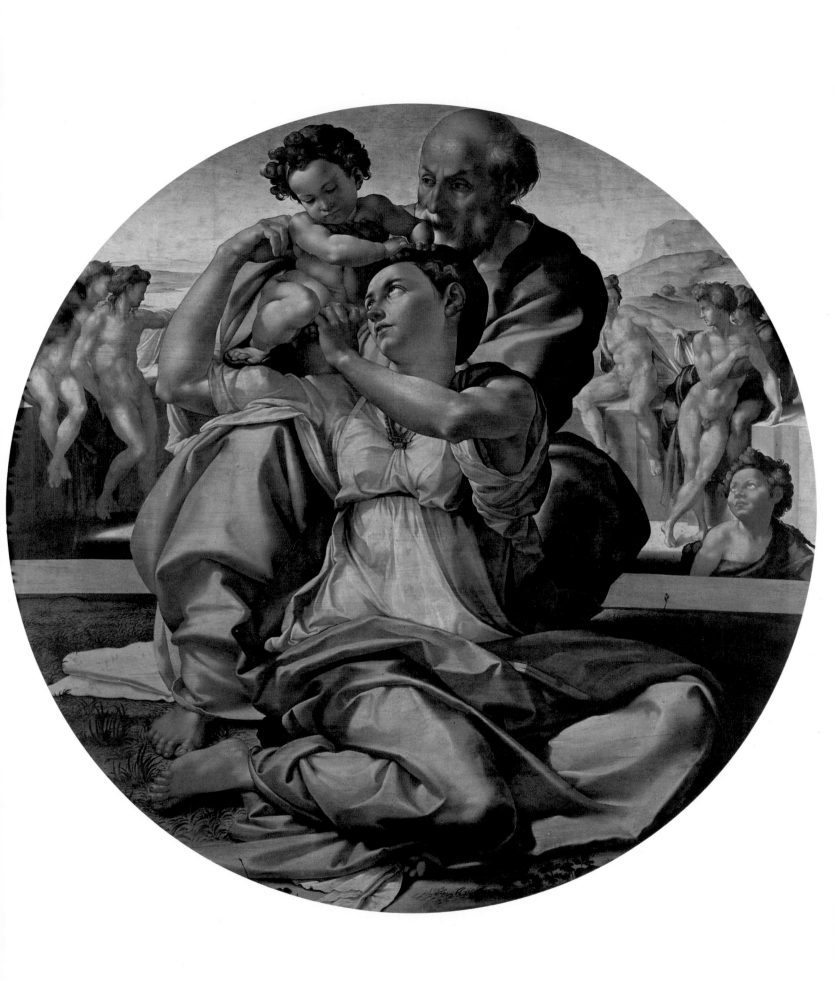

THE DONI MADONNA (detail)

Probably painted 1503
Uffizi, Florence

The tightly wound knot of arms, legs, and heads in which the painting culminates is defined with disturbing precision by polished surfaces and sharp, black contour lines, at war with each other as are line and substance in the sculpture of Michelangelo's early maturity, projecting forms of a startling brilliance and clarity. Yet so uneven is the emphasis that at times the exact position in space of certain planes is not easy to determine.

The Madonna herself, the ancestress of Eve in the *Fall of Man* (page 77), was certainly done from a male model. In the magnificent structure of her left arm and its exquisite surface polish, as smooth as the artist's beloved marble, full of the most delicate interplay of planes, contours, and reflected lights, Michelangelo pushes his love for sculptural form almost beyond the possibilities of painting. He will repeat this arm, more broadly treated, in the Delphic Sibyl (page 65). A powerful drawing for the Virgin's head (fig. 8), possibly used again years later in reverse for the head of *Jonah* (page 101), shows the artist's fascination with the problem of foreshortening. In the actual painting, the turn of the eyeball within the lids and the exact structure of these and of the surrounding muscles are defined with a cold and medical accuracy. One is reminded of the almost untranslatable lines in which Michelangelo, discussing the eyelids, says,

> The eye, which is beneath, turns about with ease,
> uncovers a small part of a large ball,
> which less uplifts its clear gaze
> and less rises and descends when it is covered . . .

The same obsessive precision which carves out of the panel the muscular arm of the Virgin pervades the soft, rich drawing of the Child's chubby yet powerful body and His smooth cheeks and forehead, full of the most delicate nuances of tone and line. We are constantly reminded of the somewhat earlier *Bruges Madonna* (fig. 10), almost as if the artist had it in front of him while he was painting. The magnificent display of corkscrew curls bursting from the Child's head reappears in several of the nudes of the Sistine Ceiling. The strange pose of the Christ Child, treading the Virgin's arm between His foot and the knee of St. Joseph, may refer to the famous prophecy of the Virgin Birth and of the Passion from Lamentations, "The Lord hath trodden the virgin, the daughter of Judah, as in a winepress."

In all probability the picture was intended to celebrate the virtues of Christian marriage in terms associated with Angelo and Maddalena themselves, and to place their conjugal life under the protection of the Holy Family, although we should not exclude the possibility that the death of their first child is somehow alluded to. In this case the date of the painting may be later.

In spite of the great beauties contained in the *Doni Madonna*, its somewhat strained composition and metallic color (the orange tone of Joseph's mantle clashes with Mary's rose tunic) have curtailed its popularity. Nonetheless the highly compressed grouping has a power that is increased by the sharp and brilliant modeling of the sometimes angular, sometimes curving folds of the drapery masses, and is stabilized by the horizontal line. Unequal in its plastic emphasis, the painting was nonetheless an astonishing achievement; many of its ideas came to more complete fruition in later paintings by Michelangelo (see especially pages 65 and 105). Throughout the sixteenth century in Florence, it was almost impossible for anyone to paint a Holy Family without remembering in some way Michelangelo's grand and bitter masterpiece.

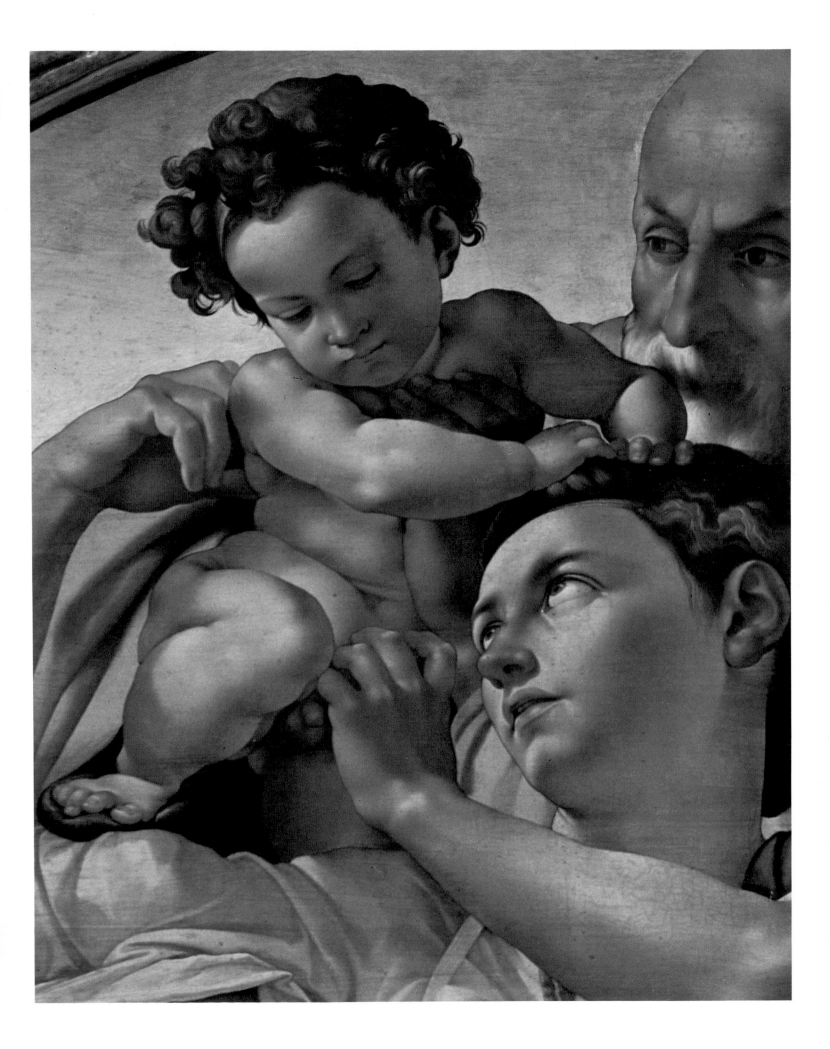

THE DONI MADONNA (detail)

Probably painted 1503

Uffizi, Florence

The nude youths seated or leaning on the edge of the mysterious basin behind the Holy Family (see also page 49) give us a premonition of the role to be played by youthful masculine beauty in the Sistine Ceiling and the Tomb of Julius II. The long cloth they are engaged in unfolding prefigures also the bands that their descendants on the Sistine Ceiling (page 105; figs. 33–36) use to uphold the bronze-colored medallions and which, in the two Louvre *Slaves* for the Tomb, bind the nude figures to the marble blocks from which they try to escape. The youths here may suggest Baptism. They move around the edges of a dry tank or font (whose crescent shape is again associated with the Strozzi arms), in which St. John the Baptist stands looking up at Christ, Whose side pierced upon the Cross was to be the source of the principal sacraments, Eucharist and Baptism. The youths in the background spread in the sunshine bands of cloth which might be the swaddling clothes of the Child; but these were mystically identified with the bands that wrapped the dead body of Christ, and Michelangelo has made them resemble the bands in the *Entombment* (fig. 14). Also in representations of the Baptism of Christ, His clothes were held by angels.

Considering the intense anatomical interests of Leonardo da Vinci at this period, and the account that Michelangelo himself did some dissection at the Hospital of Santo Spirito in 1492–94, the construction of these figures is remarkably arbitrary, abounding in violations of strict anatomical accuracy. Whatever their actual state—and certain portions are clearly unfinished—these nudes, direct ancestors of the celebrated nudes of the Sistine Ceiling, show an attitude toward pulsating human flesh as a continuous substance very different from the perfectly articulated and smoothly functioning human machines designed by his older rival Leonardo. Time and again we find difficulty in establishing the position of crucial bones and joints under this generalized fleshy substance. Yet its beauty can scarcely be denied; it arises from a soft yet controlled swell and fall of light and dark planes and pulsating contours, whose gentle, muted rhythm creates a welcome transition between the brilliantly lighted, harshly plastic forms of the foreground and the broad shapes of the hills and flat surface of the distant bay.

In the modeling of these nude youths is visible none of the smoothness of the foreground figures, and none of their sharpness of line. Planes of light and dark blend very easily and gently, and only here and there does the artist emphasize strongly the independent body contour so characteristic of him. Nevertheless these "melodious contours," as they have been aptly described, function throughout the figures, their ebb and flow integrated in the most beautiful manner with the polyphonic structure of the entire background. It could very well be that the foreground figures were at first painted in this comparatively flexible manner as a kind of underpaint, and then modeled up with the amazing degree of surface polish—in imitation of marble—that the artist was never to attempt in any of his later paintings.

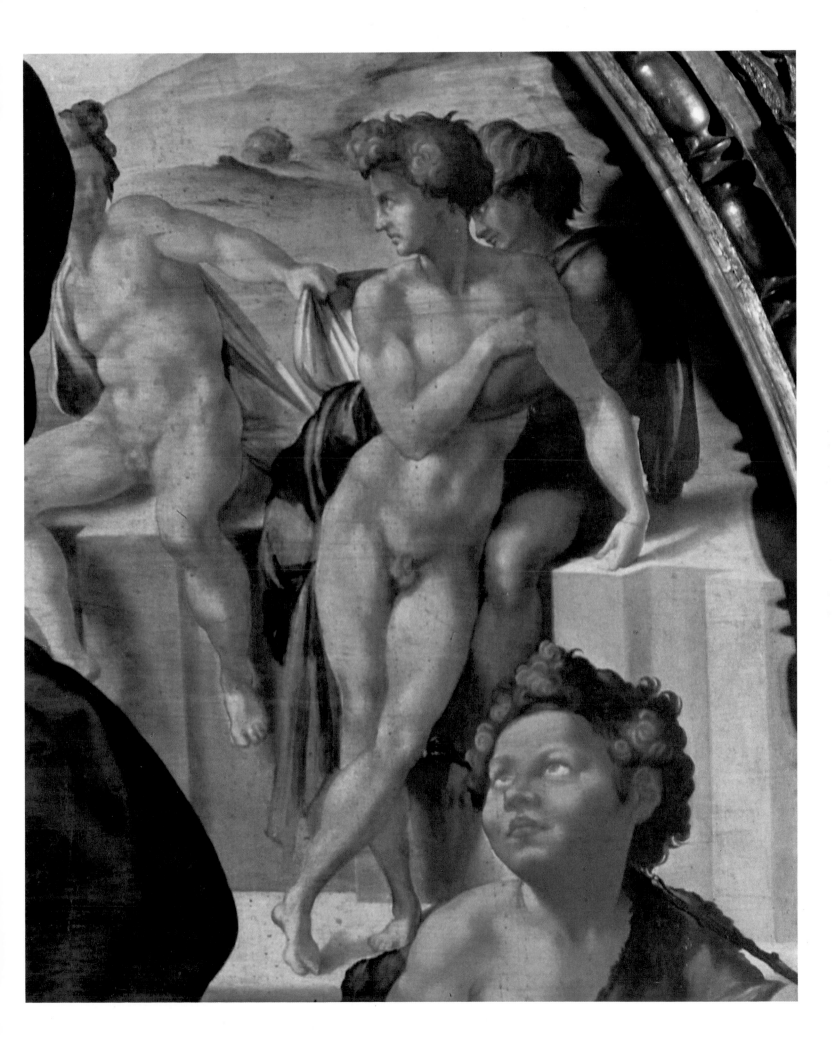

THE SISTINE CEILING (western section)

Fresco, 1511; entire ceiling 130' 6"× 43' 5"; highest point above floor, 59'

Sistine Chapel, Vatican, Rome

When Michelangelo actually started painting the Ceiling at the east end, probably in the early months of 1509, the implications of the structure had not been entirely established in his mind. The first section still contains sharp discrepancies in scale between the large figures outside the central scenes and the smaller figures that crowd within them. Furthermore, there is at the start little sense of unity of design among the various components of the entire structure. As he proceeded, however, he was able to integrate the elements so closely, and move the observer's eye from one to the other so logically, that in the west end, above the altar, one scarcely notices that he retained several incompatible scales—one for the prophets and sibyls, another for the seated nudes, a third for the bronze-colored nudes, and a fourth for the scenes in the central rectangles and the corner spandrels.

Unity is accomplished partly by increasing the scale from the seated nudes to the figures in the scenes, rather than diminishing it as in the first portion of the Ceiling, where the central scenes, especially, look a little weak from the floor. Even more important, however, Michelangelo was extremely careful to continue diagonal motions from one scene to the next or from the scenes to the nudes, across all intervening barriers. The diagonal movement of the wall separating the two central incidents in the *Haman* scene, for example, is continued in the bend of the legs of the Creator in the *Separation of Light from Darkness* (fig. 30) and the position of His head in the *Creation of Sun, Moon, and Plants* (page 95; fig. 29). Similarly the diagonal of Moses' rod in the *Brazen Serpent* (page 103) is prolonged in the back of the nude left above Libyca and the raised right leg of the diagonally opposite nude, left above Jeremiah (fig. 36). In fact, these diagonal movements are still reflected in the legs and backs of all four nudes in the next bay. Each group of four nudes, moreover, surrounds one of the smaller scenes so that some of its forms converge on the scene in the shape of a huge "X," while others move about it diagonally, giving the square group the suggestion of an octagonal frame of living limbs (fig. 30). All of the last five prophets and sibyls are so richly integrated with their surrounding elements in this manner that it is artificial to detach them, as one must for the purposes of a book, and see them separately. Michelangelo intended all the forces to work together, like those in the flying buttresses, transverse, diagonal, and wall ribs that support the vault of a Gothic cathedral. Figures, scenes, architecture, and decoration have become an indissoluble unity.

Color throughout is calculated to enhance the total sense of structure. While the Ceiling is dominated by the soft gray and whitish tones of the simulated marble and the gray-blue of the sky, it is punctuated by sharper accents of sometimes extremely vivid color, chiefly the bright garments of the prophets and sibyls and the figures in the corner spandrels, but also the warm flesh colors of the nudes, sometimes pale, sometimes deeply tanned, the brownish bronze of the medallions, the gold-bronze of the nudes between the thrones, and the soft lilac of their background, echoed in the lilac and gray-violet tones in the Lord's mantle.

Throughout the entire Ceiling, among all the figures which are imagined to exist in the actual space of the room outside the frames—the seated nudes, the prophets and sibyls, and their attendant figures—the lighting is unified. It comes not from the windows of the Chapel, as would have been customary in the illusionistic wall paintings of the fifteenth century, but from the direction of the altar, toward which, in the vast, celestial world of the Ceiling, all forms and forces, symbols and events, are directed.

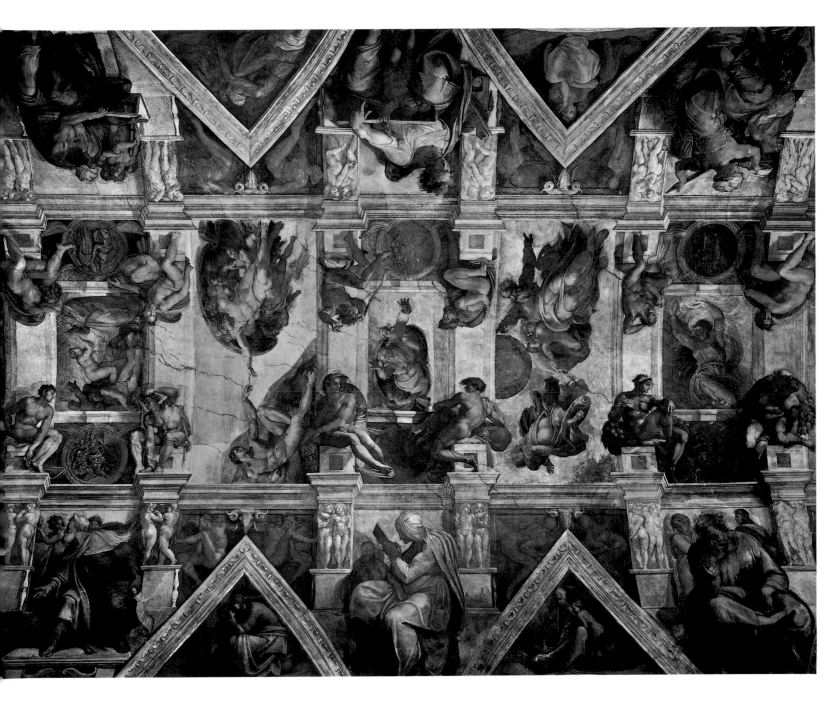

ZECHARIAH

Fresco, 1509

Sistine Ceiling, Vatican, Rome

The first of Michelangelo's prophets is scarcely the best known to modern readers of the Scriptures; in both Catholic and Protestant Bibles he is placed next to the last. Yet to the Middle Ages and the Renaissance, Zechariah was a prophet of vast importance: this is reflected in the little book by Filippo Barbieri dedicated to Sixtus IV who built the Sistine Chapel, and in the *Christian Decachord* by Cardinal Vigerio, Michelangelo's probable theological adviser. Zechariah foretold the Entry into Jerusalem ("Rejoice greatly, O daughter of Zion; shout, O daughter of Jerusalem: behold, thy King cometh unto thee: . . . lowly, and riding upon an ass . . ."). Doubtless for this reason he presides over the *entrance* into the Chapel. In the lunette below him the King Himself can be dimly seen—the little Christ Child, the last in the generations of the ancestry of Christ.

Zechariah is the prophet of the mighty "BRANCH . . . he shall sit and rule upon his throne," traditionally interpreted as Christ, and, in the Sistine Ceiling, Zechariah is enthroned above the tree of the Rovere arms, whose poetic and prophetic amplification as the Tree of Life and the Tree of Jesse runs throughout the symbolism of the Sistine Chapel, both walls and ceiling. As its branches move from side to side across the Chapel, the genealogical tree of the ancestry of Christ in the vault compartments and the lunettes culminates below Zechariah. The Hebrew word for "branch" is "*tsemach,*" translated as "*Oriens*" in the Vulgate and as "Orient" in the Douay Bible, since Christ is the sun which rises in the east. Again, it can scarcely be by accident that Zechariah appears at the east end of the Chapel.

As Vigerio pointed out, Zechariah foretold the thirty pieces of silver for which Judas betrayed Christ, and the potter's field in which He was buried. This prophet of the Passion also spoke of the pierced Son and the planting of the vine, and directly above his head appears the *Drunkenness of Noah* (fig. 23), which prefigures the death of Christ upon the Cross, and the planting of Noah's vine which foreshadows the Eucharist. In his mysterious parable of the two staves that were cut down to feed the flock of slaughter, Zechariah also foretold the coming of the Shepherd. He is placed spectacularly between the cutting down of two enemies of the Chosen People, Goliath and Holofernes.

Zechariah introduced his prophecy of the Branch thus: "Now Joshua [Jesus, in Catholic Bibles] was clothed with filthy garments, and stood before the angel. . . . And unto him he said, Behold, I have caused thine iniquity to pass from thee, and I will clothe thee with change of raiment." Again, it seems scarcely an accident that this prophecy of the robing of Christ at the Passion should be uttered by the prophet seated below the *Drunkenness of Noah,* in which Noah, as a type of Christ, is reverently clothed by his son.

Old and bearded, Michelangelo's Zechariah holds his book high, as if suggesting the flying volume of his vision, and myopically searches the pages for their inner meaning. The cover is lilac, always connected in the Sistine Ceiling with the heaven-mantle of the Lord. Zechariah's mantle is a splendid, deep green, lined with red, and the rich yellow of his tunic is trimmed with a clear blue. He sits with one foot on the footstool concealed under his cloak, and the other set down to prop his body. The huge masses of the mantle envelop him; light bathes the back of his head and the edges of his beard, but the quiet face is deep in shadow.

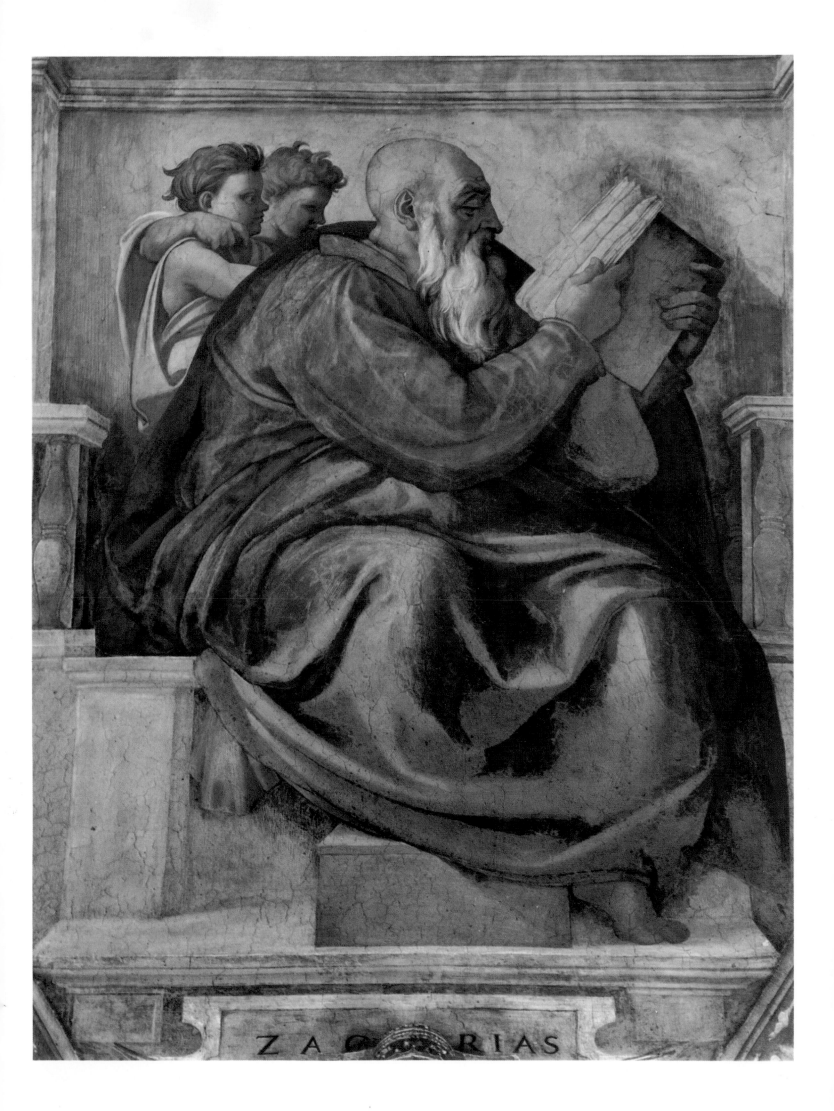

DAVID AND GOLIATH

Fresco, 1509

Sistine Ceiling, Vatican, Rome

David fills the role of Zechariah's shepherd, and is, indeed, the ancestor of the Good Shepherd. Vigerio celebrates the great victory of the shepherd boy in the *Christian Decachord;* his beheading of Goliath had from the days of St. Augustine signified Christ's triumph over Satan. In the corner spandrel Michelangelo allows us to look into the camp of the Philistines, symbolized by a single tent partially seen, and two dim heads at either corner. The terrified giant awaiting decapitation and the heroic youth crowd into the foreground in a composition whose curves echo and support the curves of the frame in a towering mass of figures reminiscent of the arrangement of the *Doni Madonna* (page 49). David strides over the prone and helpless Goliath, his huge raised sword reminiscent of the memorable *Judith* by Donatello, which stood in the courtyard of the Medici Palace when the boy Michelangelo lived there and which, after the expulsion of the Medici in 1494, had been placed in front of the Palazzo Vecchio in Florence, where indeed it still stands. The straddling position of victor over vanquished was to be repeated in the colossal sculpture of *Victory* intended for the Tomb of Julius II, now by a curious coincidence also in the Palazzo Vecchio, as well as in a number of drawings dating from Michelangelo's last years.

The shapes are so powerful, and command the entire space with such authority, as to suggest that Michelangelo painted them after the somewhat more tentative *Deluge* (page 69; figs. 24, 25). The color is kept fairly subdued compared with that of the prophets and sibyls against their pale gray marble thrones, but it still contains great brilliance in the costumes. David is clad in sky blue with softer blue lights, and an unexpected olive cloak floats from his shoulders, while Goliath appears in a brighter green doublet, now heavily oxidized, and gray-blue hose. His parti-colored sleeves are especially brilliant—white on the outside with gold stripes and orange underneath. These bright tones are softened by the rich play of siena, ocher, and terra verde in the earth, with dark gray shadows, and by the pale and darker grays of the tent.

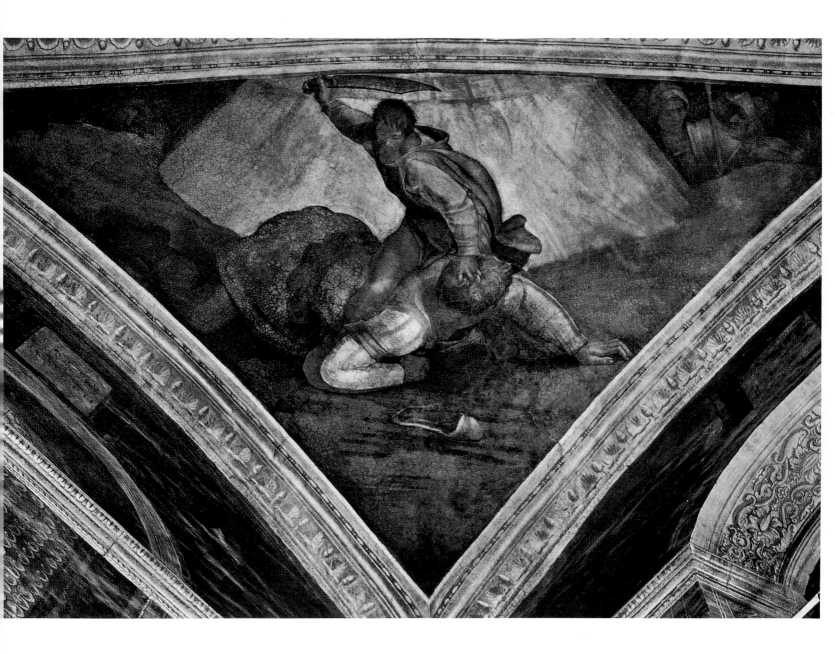

JUDITH AND HOLOFERNES

Fresco, 1509

Sistine Ceiling, Vatican, Rome

The slaying of the general of the Assyrians, Holofernes, by the beautiful and chaste Judith, heroic leader of her people, and ancestress of Christ, who was faithful to the memory of her dead husband Manasses, foretells the victory of Mary over sin. The association of Judith and Mary, going at least as far back as St. Jerome, was made particularly vivid in the Renaissance by St. Antonine, predecessor of Savonarola at San Marco and later archbishop of Florence, in the chapter of his *Summa* which provides the program for Donatello's *Judith*.

Several liberties have been taken with the biblical text. Judith has not removed the canopy from the bed or rolled away the body, and instead of putting the head into her "wallet," the servant carries it in a basin, which the victorious widow is about to cover with a fringed towel. Both towel and basin are symbols of Mary's purity, here especially significant because, as St. Antonine underlines almost needlessly, Judith's victory was a triumph of purity over lust. Michelangelo has concentrated attention upon the terrible burden, but it is improbable that the wrinkled features of the toothless head, whose lower jaw nearly meets its nose, are those of the thirty-three-year-old artist, as has been suggested.

The retention of the naked body of Holofernes sprawling on the still-canopied bed—in violation of the text—is not without meaning. The hanging arm recalls that of the dead Christ in the *Pietà* in St. Peter's, and is repeated almost exactly in the arm of Erythraea (page 75). The pose of the legs reappears in the nude seated left above Jeremiah (fig. 36), the youth who gazes with such calm beauty directly into the void in which the Lord separates the light from the darkness. But this is the self-same pose as the legs of Noah (fig. 23), asleep like Holofernes through excess of wine, only seen from the other side, to be repeated in the legs of Adam in the *Creation of Man* (page 83) and other figures typifying Christ Whose sacrifice is perpetuated in the wine of the Eucharist. In the mysterious system of opposites which runs throughout the Sistine Ceiling, even Holofernes, representing Pride and Lust, the leaders of all vices, can appear as a dark antitype of the great precursors of Christ: Adam, Noah, and John the Baptist.

As in the David spandrel (page 59), Michelangelo has erected a towering pyramid of figures to unite all three sides of the awkward triangular field. The brilliantly lit women in the center, with their sharp, almost cubist masses, are set off against the softer illumination of the curving, sensuous body on one side and the bloated sentinel on the other.

The generally soft, rich coloring of the fresco comes to an astonishing climax in the clothing of the servant. Her bright red outer garment, suggesting freshly shed blood, turns outward to show a gray-violet lining (close to the cloak of the Lord in the Creation scenes) and a brilliant gold tunic whose shadows change from gray to green. Against the shadowed corners the gorgeous figure produces an effect of brassy clangor. Her face, reddened either by effort or by the reflection of her outer garment, contrasts with the gray mask of the decapitated head she carries. Judith is exquisitely arrayed, with gray-blue sleeves, gold epaulets and armhole and neckline borders, and a lilac diagonal shoulder strap. Her pale gray outer garment has sea green panels gored at the sides and back of the skirt and bodice, and a pale yellow fringe. Most beautiful of all is her gray-blue headdress with a lavender fillet crossing two gold ribs which border a band of colossal pearls. The whitish wall reflects much yellow, and the earth harmonizes with that in the David spandrel. The guard's sleeves suggest Goliath's costume. Holofernes' body moves against delicate rose-gray curtains with deeper rose shadows.

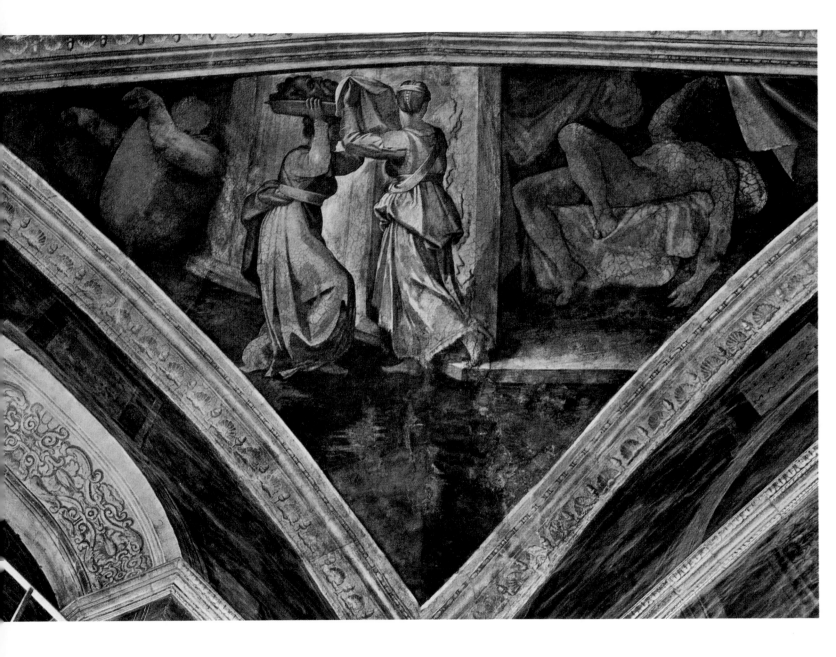

JOEL

Fresco, 1509

Sistine Ceiling, Vatican, Rome

This vigorous, balding prophet in late middle age peruses an open scroll as he sits on the other side of the drunken Noah stretched out upon the floor (fig. 23), and directly below Noah's gigantic wine vat. Joel prophesied, "The floors shall be full of wheat, and the vats overflow with wine and oil." As he reads, he turns his head in the direction of the *Deluge* (page 69; figs. 24, 25). Chiefly, Joel is a prophet of disaster, of terrible events on the land, and of the sun and moon darkened in the heavens. Barbieri's little book quoted his words of destruction, and yet of hope: "And it shall come to pass that whosoever shall call on the name of the Lord shall be delivered: for in mount Zion and in Jerusalem shall be deliverance, as the Lord hath said, and in the remnant whom the Lord shall call." This very remnant is saved in the Ark.

"Gird yourselves and lament, ye priests; howl ye ministers of the altar . . . for the meat offering and the drink offering is withholden from the house of your God. Sanctify a feast, call a solemn assembly, gather the elders and all the inhabitants of the land into the house of the Lord your God." Joel's denunciation must have seemed to Pope Julius II and his court especially appropriate in the days of his interdict against Venice and his fulminations against the schismatic Council of Pisa, summoned by the French to dethrone him. Joel had also prophesied that the vine would be dried up, the fig tree would languish, and that the meat offering and drink offering would be cut off from the house of the Lord. Christ Himself, standing outside the Temple, compared the Deluge to His second coming: "For as in the days before the Flood they were eating and drinking, marrying and giving in marriage, until the days that Noah entered into the ark; . . . so shall the coming of the Son of Man be." Joel's prophecy is specifically fulfilled in Michelangelo's *Deluge*, with its dried-up vine and ravaged fig tree, as Christ's analogy is carried out in the helpless mortals who can no longer eat or drink, marry or give in marriage.

Joel is dressed in a soft lavender-gray tunic, like the cloak of the Lord in the Creation scenes, with softer lavender lights and deeper lavender shadows, contrasting with the exquisite blue of the band over his shoulder. The pale yellow of the reading desk is related to the yellow hair of the *putto* at the right. Joel's hair is a very cool gray, quite different from the warm gray of *Isaiah* (page 71). The delicate, cool, polished skin of the *putto* at the right is typical of the rather tight figure drawing prevalent throughout the first section of the Ceiling. He carries a green book, while the boy on the left holds a book whose sharp cinnamon color, like that of Zechariah's cloak, will be repeated frequently throughout the *Deluge*.

Very possibly Joel was the first of the prophets and sibyls to be completed. Here and there, he still shows some of the curious spatial and formal discrepancies of the *Doni Madonna* (page 49). Like the head of Joseph in that early painting, his head is unsuccessfully projected in space. Despite the occasional faults of execution, there is an earnestness about the conception of this prophet that echoes St. Peter's quotation of his prophecies after the Pentecost: "Your sons and daughters shall prophesy, and your young men shall see visions, and your old men shall dream dreams."

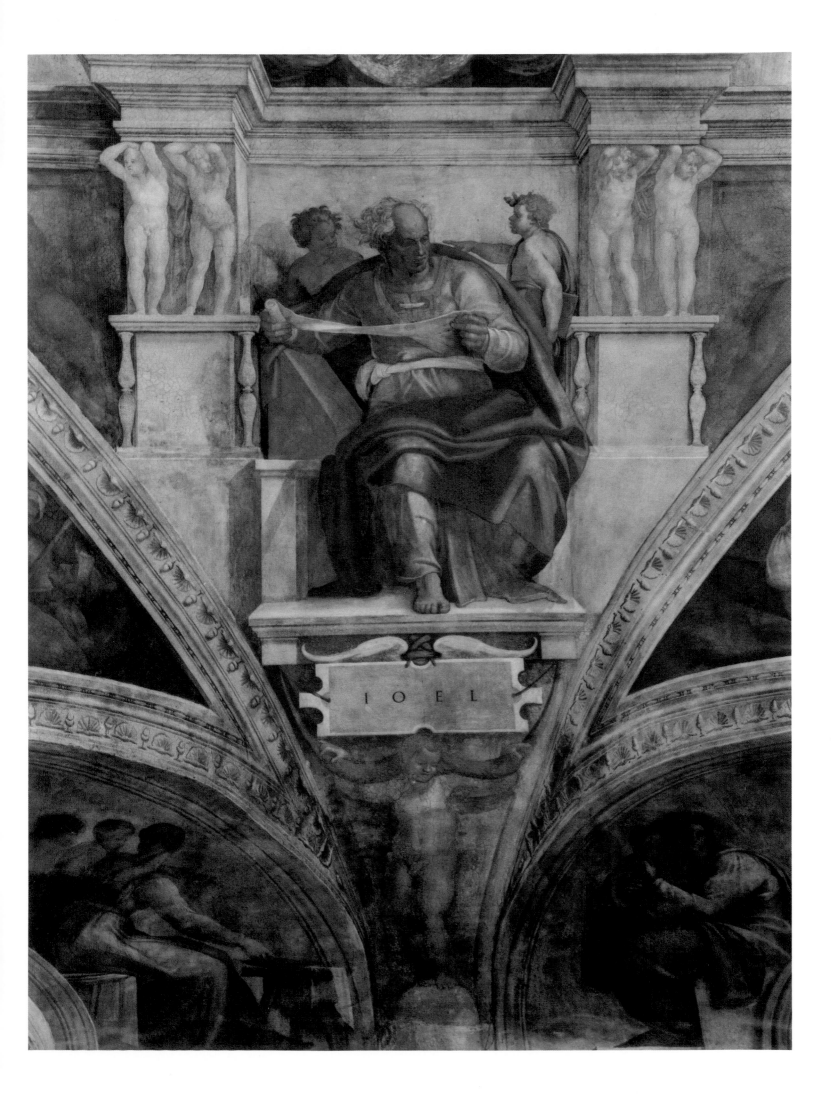

THE DELPHIC SIBYL

Fresco, 1509

Sistine Ceiling, Vatican, Rome

Youngest and loveliest of the five sibyls, Delphica sits in a pose suggested by Jacopo della Quercia's *Prudence* (fig. 12) which then still stood alongside the central basin of the Fonte Gaia in the principal square of Siena. She adjoins the Judith spandrel, the symbol of Mary's triumph, and not unnaturally is developed from Michelangelo's early Madonnas, especially the *Pitti Madonna* (fig. 11); her arm comes directly from that of the *Doni Madonna* (page 49). She shares with Greek tradition only her Apollonian beauty. In reality the meaning of the image is based, as in the other sibyls, on the little book by Filippo Barbieri dedicated to Sixtus IV, builder of the Sistine Chapel, that was surely available to Cardinal Vigerio and to Michelangelo. Barbieri tells us that Delphica, guided by the Holy Spirit, wrote many poems about the Incarnation, the Virgin Birth, the Passion, the Crucifixion, and the Resurrection. Not by accident, therefore, she is not only Madonna-like but placed directly below the *Drunkenness of Noah* (fig. 23) which foreshadows the death of Christ as the planting of the vine does His daily resurrection in the Eucharist.

In one glorious motion Delphica turns toward us, her eyes looking in the direction of the Judith scene, her mouth open in a cry of wonder, her hair and cloak blown by what has been described as the wind of the Spirit. As she listens to the words read into her ear by one beautiful attendant *putto* from a book upheld by the other, she rolls up almost unconsciously the scroll of her prophecies as if it were no longer of any meaning. In a series of magnificent curves, now to left, now to right, the masses of her body, drapery, and the attendant figures well upward and outward. Splendid as the nearby painting of the *Deluge* is in detail, Michelangelo has reached in *The Delphic Sibyl* a higher stage of formal control and rhythmic breadth. Her grand left arm and the richly muscled back of her attendant rank among the most beautiful passages of figure drawing in the entire Ceiling.

The excitement of the form is immeasurably increased by the high key of the color, set first of all by the splendid orange of the sibyl's cloak, varied by golden-yellow lights and deep, red-orange shadows. The soft blue lining has contrived to get itself so twisted that the orange side runs behind Delphica's back and over her knees, while a sky-blue stretch goes over her shoulders. Her sea-green tunic is lighted with pale yellow, and in the scarf over her head delicate variants of silver shimmer through lavender-gray middle tones, white lights, and greenish-gray shadows. Her hair is a soft, brownish blonde; her flesh shows a wholly new understanding of the use of color. Terra verde shadows become rosy in the lights; elbows, wrists, and hands are quite pink.

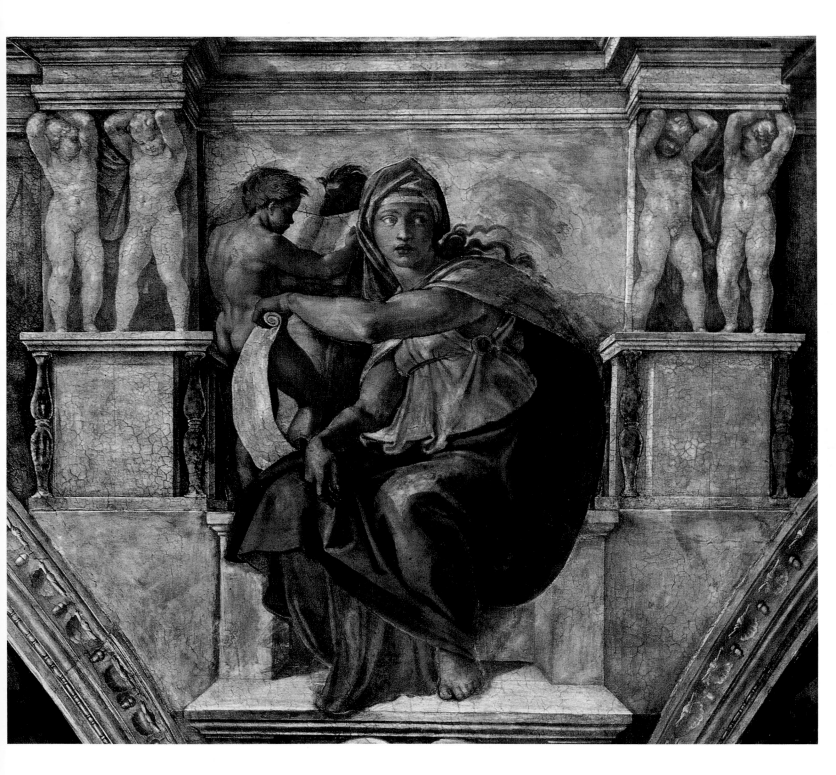

THE DELPHIC SIBYL (detail)

Fresco, 1509

Sistine Ceiling, Vatican, Rome

Compared with any of Michelangelo's earlier heads, that of *The Delphic Sibyl* is a miracle of simplification. Not only do the noble features seem decades removed from the exquisite delicacy of the *Bruges Madonna* of about 1504 (fig. 10) or the obsessive precision of the *Doni Madonna* of 1503 (page 49), but their cubic breadth makes even the *Pitti Madonna*, done about 1506 (fig. 11), look a bit tentative. The sculptor who lamented that painting was not his profession can now paint with sovereign authority, fusing the principles of painting and sculpture.

The head is, first of all, constructed. Despite the fact that it must have been worked out in advance in a cartoon, Michelangelo still used a right angle and a straight-edge to rule the cross he incised in the surface of the *intonaco*. One line bisects the face along the ridge of the nose from veil to shoulder, the other goes through the corners of the eyes from temple to temple. The veil is then so drawn as to break just outside the points of the cross, creating a kind of lozenge or diamond shape. Yet within this lozenge, the cubic mass of the face operates independently. The cheeks, the chin, the nose, the eyebrows, and eyelids are all squared off. Where the cube collides with the lozenge, corners are rounded so as to produce a kind of harmony out of conflict, summed up in the great clockwise twist of the veil behind the head against the counter-clockwise twist of the neck. The general effect of square within lozenge, block within diamond, reminds us not only of the struggle of Michelangelo's sculptural figures within their marble blocks but of the fused lozenge and square outline of his plan for St. Peter's.

His brush moves with breadth, ease, and speed, defining shapes with powerful strokes, building up a definite *impasto* in the nose, the upper lip, and the chin. The pearly play of hues in the head kerchief is enchanting, and so is the warm, slightly grayed golden-brown of the eyes—the exact tint of the eyebrows and hair.

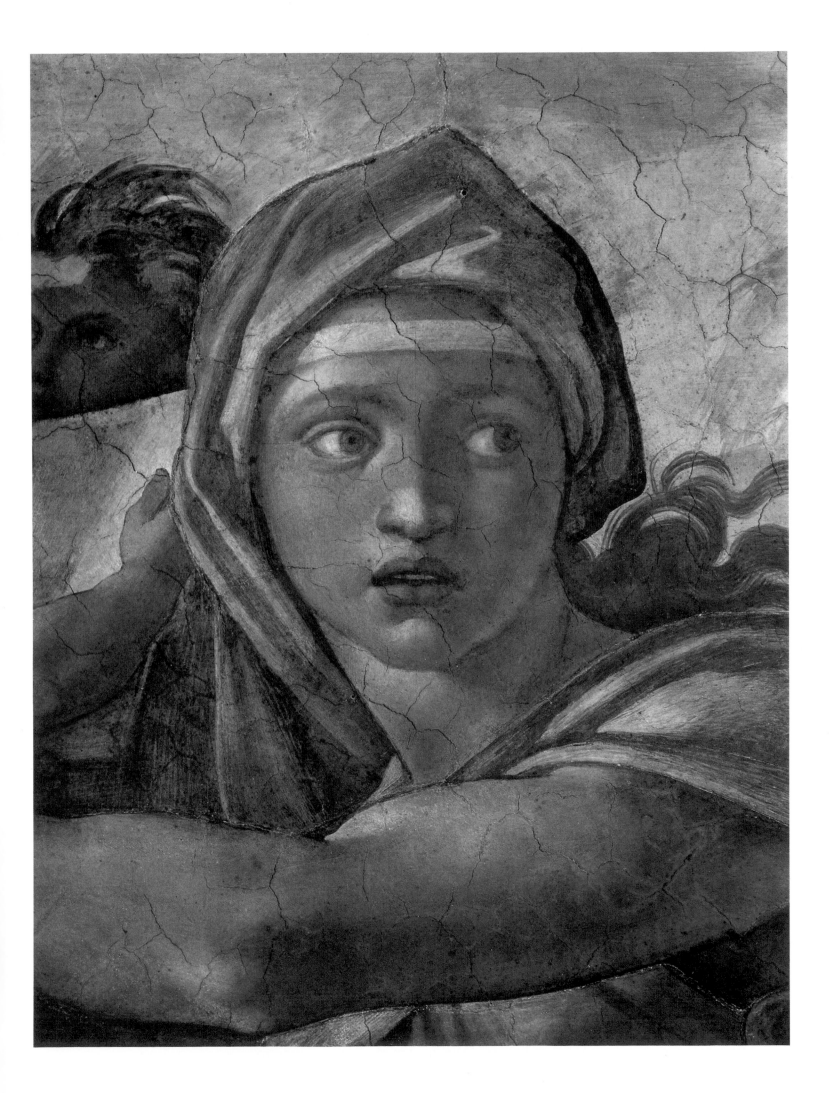

THE DELUGE (detail)

Fresco, 1509

Sistine Ceiling, Vatican, Rome

The five smaller scenes in the Ceiling are flanked by prophets or sibyls, but the four large scenes stretch from cornice to cornice. In the first of these is represented the *Deluge*, a scene of cosmic desolation and terror, haunted by the words of Joel and the dread analogy of Christ Himself, speaking of His second coming (page 62; fig. 24).

Michelangelo has depicted the Flood at a moment when only two rocks remain above the rising waters. On one stands a withered tree, on the other a green tree (largely destroyed in an explosion in 1797), which recall not only Joel's prophecy but Christ's words when led to Calvary: "If they do this in the green tree, what will they do in the dry?" This was interpreted by theologians as signifying the Tree of Life and the Tree of Knowledge of Good and Evil, and explaining the frequent appearance of green and withered trees flanking the Sepulcher of Christ in Renaissance Entombments. On these two rocks helpless men, women, and children try desperately to save themselves. In the foreground those who had been eating and drinking, marrying and giving in marriage, carry their tables, utensils, bread, and wine from their interrupted meal, and even carry each other as they struggle upward from the destroying tide toward the barren tree. In the right half, others have saved their wine keg and spread a huge cloth over their languishing tree to keep dry. Between the two trees the Ark (according to St. Augustine and later theologians, including Savonarola, not only the symbol of the Cross but of the mystical Body of Christ, the Eucharist) contrasts with the impious bread and wine of those who had not called upon the name of the Lord. As Joel had said, the remnant of humanity, the family of Noah, is saved on the Ark, while others strive horribly to reach it in a round and whirling boat, or climb aboard only to be cut down and beaten off. On April 27, 1509, probably in the very days during which Michelangelo was painting the *Deluge*, Julius II imposed the dread interdict on Venice. Conspicuous among the unfortunates in the foreground (fig. 24) are the lovers who cannot now be married, the reclining woman who has given birth and cannot be churched, the children who cannot be baptized or confirmed, the dead who cannot receive the last rites or Christian burial; no one here can confess or receive absolution, and all, as Joel prophesied, are cut off from the Eucharist.

In its panoramic view, filled with tightly drawn figures resembling sculptural groups, the *Deluge* suggests what must have been the original appearance of the now-lost *Battle of Cascina* (see page 20; figs. 15, 16). Despite the beauty of the individual figures and the terrifying grandeur of the conception, the composition is not so closely unified as the other large scenes.

The pale bluish gray of sea and sky and the variegated green, yellow, and gray of the earth form a soft foil for the warm flesh tones and the frequently repeated touches of red-brown and orange, yellow, clear green, and powder blue with plum-colored shadows. The cinnamon tones for the cloak of the last man up the hill and the flying cloak of the man in the boat are particularly striking. The warm and rosy flesh of the father contrasts with the gray of the dead son he carries. This tragic group (fig. 25), one of Michelangelo's most deeply moving ideas, remained in his mind to be used in various forms for images of the *Pietà* in his last years.

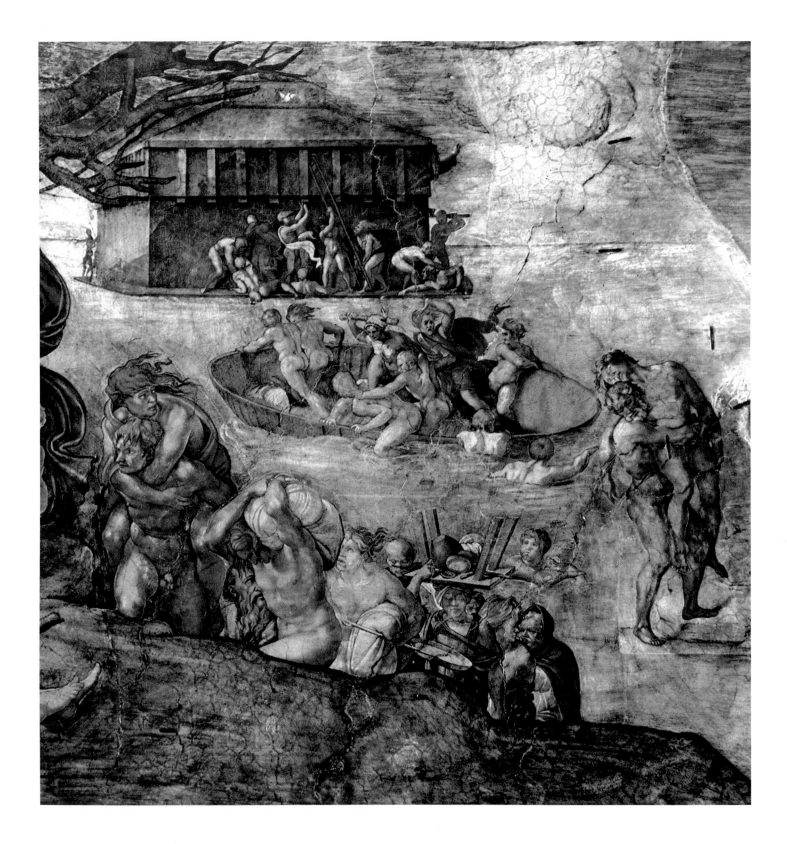

ISAIAH

Fresco, 1509–10

Sistine Ceiling, Vatican, Rome

Seen by Michelangelo as relatively youthful, with a poet's face ravaged by profound thought, Isaiah is the greatest prophet at once of the Virgin Birth and of the Passion, and in terms which recall frequently the doctrine of the Tree of Life. "Behold, a virgin shall conceive and bear a son, and shall call his name Immanuel," the Lord said to Isaiah; he prophesied, "And there shall come forth a rod out of the stem of Jesse, and a branch shall grow out of his roots: And the spirit of the Lord shall rest upon him," and also "For he shall grow up before him as a tender plant, and as a root out of a dry ground . . . he is despised and rejected of men, a man of sorrows and acquainted with grief . . . Surely he hath borne our griefs and carried our sorrows . . . But he was wounded for our transgressions, he was bruised for our iniquities" Michelangelo's Isaiah turns his face from the *Deluge;* the Lord said to him, "For as I have sworn that the waters of Noah should no more go over the earth; so have I sworn that I would not be wroth with thee."

Wrapped in bitter meditation, Isaiah closes his book and turns in a majestic movement, about to drop his left hand on which his head had apparently been propped, as he listens to his attendant *putto,* who points toward the *Fall of Man* (**page 77**), and the locks of his prematurely gray hair rise on his head. The great blue cloak billowing from his shoulders recalls that of Delphica (**page 65**) but shows a brighter green lining, turned out over the left arm and shoulder. Behind the prophet's right shoulder the cloak is blown against the *putto* so as to reveal the shape of his leg through the cloth. The sleeve colors are particularly hard to account for in naturalistic terms. The right sleeve seems yellow, but is actually made up of changing tones of white, yellow, and gray, while the left is a pale lavender with some yellow and some lavender lights. A marvelous play of yellow and lavender tones shimmers through the tunic below the cloak, with shadows of deep gray. These colors harmonize richly with the tanned face, hands, and feet. Like Delphica's, Isaiah's heavy-lidded eyes and high eyebrows are a soft brown, but his open, splendidly carved lips are rosy, suggesting the rosy flesh of the *putti.* The hair is a beautiful, very luminous gray, with a definite lavender component. The concentration of golden yellow on the right arm, together with the intense light on the powerfully sculptured profile, establishes a continuous arc crossing the body from the forehead to the lightly held book. At once taut and rich in shapes, brilliant and sweet in color, old and young in appearance, the figure exerts an effect as disturbing and as full of contrasts as the haunted expression of the incredible face, or as the alternate hope and tragedy suffusing the grand verses of the prophet himself, on which Michelangelo must have brooded with deep personal understanding.

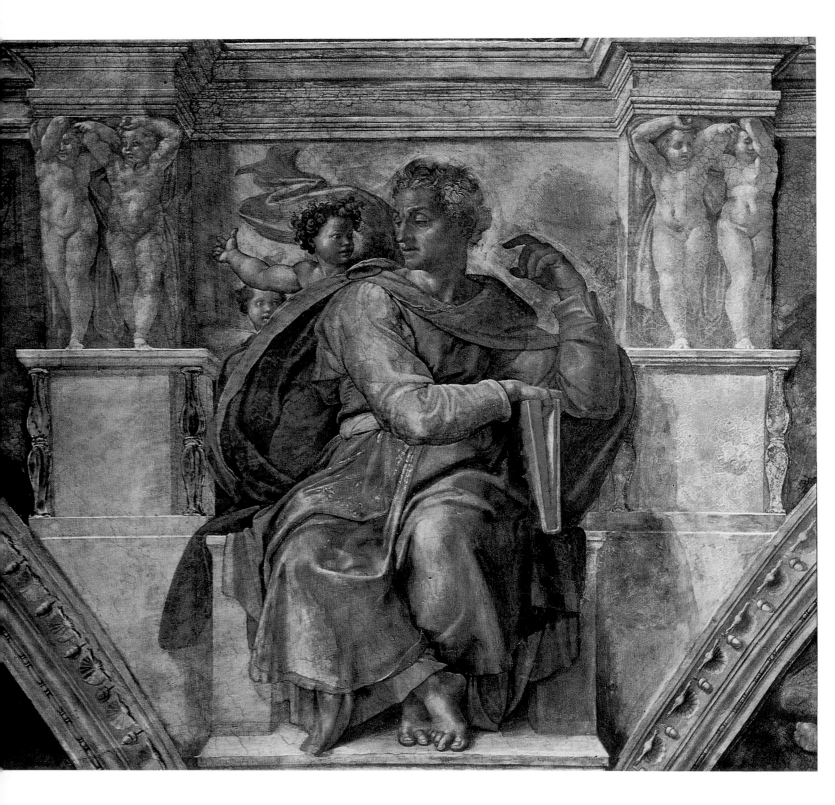

THE SACRIFICE OF NOAH

Fresco, 1509

Sistine Ceiling, Vatican, Rome

Oddly enough, Condivi, Michelangelo's friend and biographer, in 1553 called this scene the sacrifice of Cain and Abel, which it cannot possibly represent. The *Sacrifice of Noah*, of course, appears out of chronological order, but it does follow the succession of earth, water, fire, and air in each of the two groups of four scenes on either side of the barrier (page 32; fig. 22).

One of Noah's daughters-in-law hides her face from the heat of the flames as she places a brand in the flames rising from the hole in the center of the altar. Michelangelo derived this pose line for line from a well-known Roman sarcophagus representing Althea, who, angered by the love of her son Meleager for the huntress Atalanta, replaced in the fire the brand she had plucked from it when, at Meleager's birth, she had been told her child's life would last only as long as this wood remained unburnt. Zechariah (page 57), first of the prophets on the Ceiling, had spoken of a brand plucked from the fire; St. Jerome saw in this passage the Burning Bush, as a type of the Virgin Birth. *The Erythraean Sibyl* (page 75), to the left of the *Sacrifice of Noah*, was identified as one of Noah's daughters-in-law. Among the numerous prophecies attributed to this very important lady, Barbieri singled out for special attention that of the Virgin Birth.

Isaiah (page 71), on the right side of the *Sacrifice of Noah*, once had his lips purified by an angel with a coal from the fire and foretold, in the same chapter with his reference to the waters of Noah, a "smith who bloweth the coals in the fire . . . a waster to destroy." St. Jerome saw in Isaiah's fireblower a type of the devil; and Michelangelo's crouching youth blows the fire under the brand of life. Isaiah condemned the sacrifice of animals; the true sacrifice was a humble and a contrite heart. Another of Noah's daughters-in-law carries wood for the fire in exactly the same pose that Michelangelo, in his destroyed lunette, gave to Isaac carrying the wood for his fire—a famous type of Christ carrying the Cross on which He was sacrificed that was placed at the head of the Chapel, next to the shield bearing the representation of the Rovere tree. In the same chapter in which he foretold the Messiah rising as a tender plant, a root out of the dry ground, Isaiah compared the Man of Sorrows to the sheep led to slaughter, "who openeth not his mouth." In his prophecy of the Virgin Birth he said, "The ox knoweth his master, and the ass his master's crib, but Israel doth not know, my people doth not consider." This passage, responsible for the appearance of the traditional ox and ass in countless representations of the Nativity, was quoted in the opening speech at the Lateran Council summoned by Julius II in 1513. Thus, in their very relationship to Noah, Erythraea and Isaiah combine to foretell the Virgin Birth and the Cross in the burning of the brand and the slaughter of the lamb.

The fresco, unfortunately, has suffered severely. The youth at the left (Shem?) was completely restored shortly after Michelangelo's death, except for his left lower leg and foot, along with the laurel-crowned head and the upper arm of his wife. Nonetheless, the close-packed composition, with its curving rhythms alternating with sharp corners, its tragic animals and powerful movements, the red entrails and the incandescent interior of the altar, is fiercely exciting. Both in shape and golden-gray color the swirling locks of the kneeling Japheth's hair are identified with the flames above them. Noah's lilac cloak foreshadows the heavenly mantle of the Lord in the Creation scenes, just as the white head-covering of his wife will be repeated in the veil of Persica (page 89).

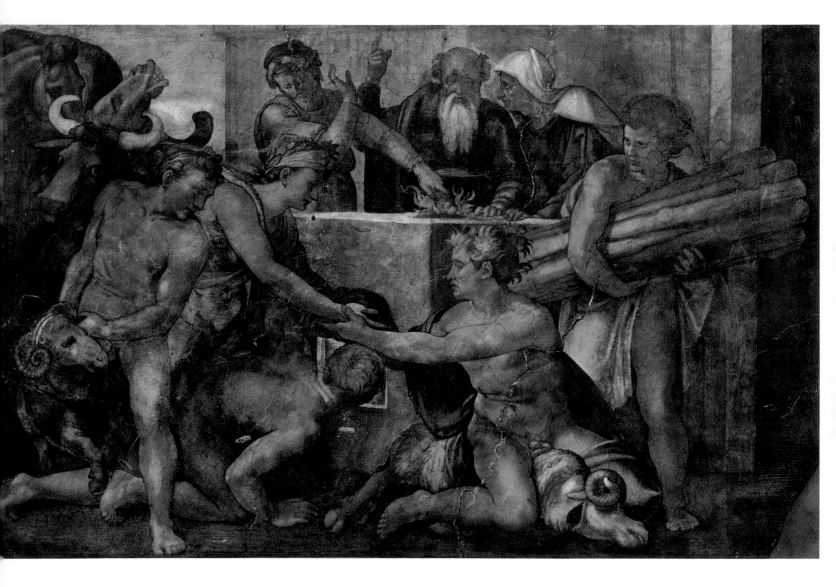

THE ERYTHRAEAN SIBYL

Fresco, 1509

Sistine Ceiling, Vatican, Rome

As relaxed as Delphica is excited, Erythraea sits quietly contemplating a large book, whose pages she holds open with her left hand while her right arm hangs at her side and the fingers of her right hand are lost in the folds of her mantle. One of her attendant *putti* lights a lamp to help illuminate her pages, while the other, in the shadow, sleepily rubs his eyes.

As we have seen (page 72), Erythraea was thought to be a daughter-in-law of Noah, and is thus appropriately represented next the *Sacrifice of Noah*. Possibly she is the very personage represented placing the brand in the burning, that brand now used to light her lamp of prophecy. As has often been noted, her pose repeats almost exactly that of a nude youth in Signorelli's fresco of the *Last Days of Moses* on the wall directly below her. The youth sits enraptured, drinking in the farewell instructions of Moses about to depart for his final view of the Promised Land he was never to reach, his secret death and hidden grave. It is noteworthy that the Lord told Moses to command that the children of Israel bring pure oil for the light, to cause lamps to burn continually, outside the veil of the temple and in the tabernacle of the congregation, and that is just where Erythraea's lamp is placed in the Sistine Chapel.

For the Middle Ages Erythraea was *the* sibyl, whose prophecy of the Last Judgment is preserved to this very day in the Dies Irae of the Requiem. Barbieri's little book, of so much use in formulating the program of the Ceiling, speaks at length about Erythraea's book, which contained a poem of twenty-seven lines about the Last Judgment, whose initial letters in Greek spelled out "Jesus Christ, Son of God, Saviour." In the number twenty-seven, the cube of three, was concealed according to Barbieri, the mystery of the Trinity—three multiplied by itself three times. In her book were also explicitly foretold the details of the Passion of Christ, including the smiting, the boxing on the ears, the spitting, the beating upon the back, the crowning with thorns, the drink of vinegar and gall, the rending of the veil of the temple, the three hours of darkness, the three days' sleep in death, the Resurrection, and the descent into Hell. Some of these prophecies, of course, Erythraea shares with Isaiah, her neighbor across the Chapel. All are doubtless contained in the pages so grandly exposed before us, on which Michelangelo has not permitted us to read a single letter.

The noble figure, closely connected with the forms of the nude youths, and clearly studied from a male model, is shown in absolute facial profile, with her crossed legs parallel to the picture plane in the manner of some of Michelangelo's early Madonnas, but the extension of her left arm twists her torso so as to expose the beautiful anatomical structure implicit under the clothing. The drapery shapes have been simplified to eliminate the merely accidental and to subordinate all to the great, controlling S-curve of the mantle over the right thigh.

In color this is one of the loveliest of the sibyls, with her rose bodice bordered in the same incredibly delicate blue (one of the "beautiful blues" Michelangelo had ordered) used for the belt, the headdress, and the lectern. Against these tones play the clear green of the mantle lighted with golden yellow and its lemon-yellow lining.

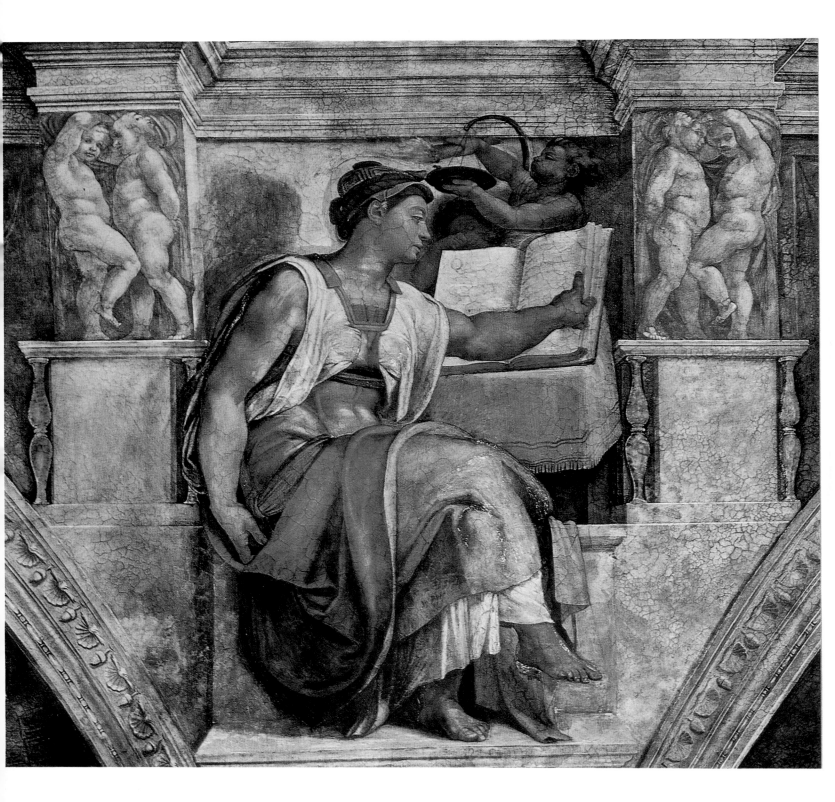

THE FALL OF MAN

Fresco, 1509–10

Sistine Ceiling, Vatican, Rome

The Temptation and Expulsion had always been depicted separately before. Michelangelo has united them with the gigantic tree that almost fills the scene from side to side, and reflects the shape of the Rovere tree in the reliefs adorning the barrier below. In one overarching shape the crime leads to its punishment. The tempting Satan and the avenging angel function as branches. Recalling Joel's prophecy of the destruction of vine and fig tree, the stump of a withered vine is to be seen behind Eve, and the Tree of Knowledge bears fig leaves and figs, both having strong sexual significance. On the right its shape is continued by the angel's arm and sword and by the Rovere leaves and acorns which invade the scene from the cornucopia held by the youth just outside. The tree that challenges heaven is a fig tree when it represents the Tree of Knowledge which brought mankind to destruction, an oak when it symbolizes the Tree of Life and the punishment of the guilty.

The *putto* behind Isaiah (page 71) directs his attention to the *Fall of Man*. Isaiah had sung of the vineyard of the beloved that brought forth only wild grapes; the Lord devastated it and broke down the fence of stones. To St. Jerome the beloved signified Israel, the vineyard Christ. The vineyard was sacrificed, the Old Law destroyed. The stones remain in Michelangelo's background, and the dead branches suggest the Cross, as in the *Creation of Eve* (fig. 27). To reinforce the connection between Eve and the vineyard, Michelangelo has given her the pose of the woman in the *Deluge* (fig. 24) who crouches over the wine keg.

Vigério described the Temptation as an antitype of the Last Supper, and the fruit of the Tree of Knowledge as an opposite to the Eucharist, fruit of the Tree of Life, following St. Paul's characterization of Christ as the second Adam. Vigerio tells how Adam "fell while eating"; how he "turned his eyes from the morning light (which is God), and gave himself over to the fickle and dark desires of the woman, as to the evening twilight." I know of no other explanation for this unprecedented representation of Adam plucking the fruit from the tree, turning his face away from the light, and connected with Eve in so suggestive a manner. This is one of the most striking connections between Michelangelo and Vigerio.

In this scene begins a transformation in Michelangelo's attitude toward form and color. For the first time the figures command the entire foreground space, and are scaled to harmonize with the surrounding nudes; the swelling movement is so ample as to dissolve the surface of Michelangelo's anatomies in a rich play of shapes and tones; foreshortened masses and features appear in a manner that will be exploited in the later scenes. Along with the softer forms and contours of the muscles, the color is richer than before. The delicate flesh tones of Delphica (page 65) and her attendants now suffuse the bodies with a sanguine warmth, particularly gratifying between the strong greens of earth and foliage and the gray-blue of the sky. Especially surprising are the rose-pink of the angel's tunic, the range of iridescence in the green-gold-violet of the coils of the sirenlike serpent, and the change in Adam's hair from blond before the Fall to red-brown afterward.

Michelangelo's expressive depth has also greatly increased. In no earlier works do we find any face approaching in anguished intensity of feeling that of the expelled Adam. His pose, shielding himself from the relentless sword of the angel, is related to that of Orestes pursued by the Fates in a well-known Roman sarcophagus relief. It is also close to that of Noah's wife in the *Sacrifice of Noah* (page 73) as she places the fatal brand in the fire. Eve's clutching hands will reappear in those of a sister of Phaeton (fig. 46). Adam's pose in the Temptation repeats that of the young man in the couple at the left of the *Deluge* (fig. 24), which in turn utilized a pose developed for the *Battle of Cascina* (fig. 15).

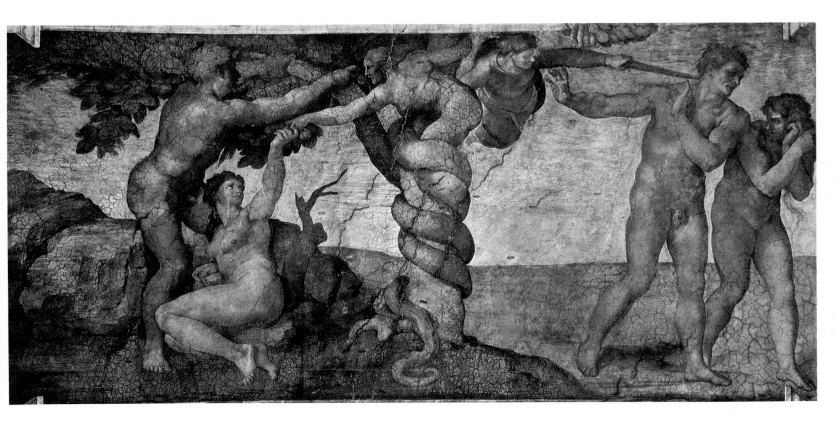

THE CUMAEAN SIBYL (detail)

Fresco, 1510

Sistine Ceiling, Vatican, Rome

Immensely old, incredibly muscular, this mighty woman (fig. 26) is enthroned above the spot where originally stood the barrier that separated the section of the Chapel reserved for the princes of the Church from that to which the laity were admitted. Turning her wrinkled face in the direction of the altar, from which all figures outside the frames are uniformly illuminated throughout the Ceiling, she reads a book while her attendants hold another. In her youth the Cumaean sibyl was loved by Apollo, who granted her as many years of life as the grains of sand she held in her hand, but when she persisted in refusing him, he doomed her to look her age. She offered nine books of prophecies to Tarquin, and when he refused her price, she burned three and offered six at the price of the original nine. When she came back the third time with only three books, still at the original price, Tarquin bought them and they were kept in secret on the Capitol in Rome. Barbieri's little book shows her as prophetess of a virgin queen and a child redeemer, as well as of a new people sent down from heaven to bring about an age of gold. Clearly she is the sibyl of the Roman Church whose strength, age, wisdom, and resistance to false gods she so grandly embodies. Also, she has now only *two* books, suggesting the Old and New Testaments.

Cumaea flanks the *Creation of Eve* (fig. 27) in which God appears for the first time, His mantle closed, standing upon earth. Below Him, in shadow, at the foot of a withered tree, lies Adam deep in sleep. From his side the Lord conjures Eve, who emerges with her hands clasped in prayer. The creation of Eve from Adam's rib is one of the scenes most frequently chosen to foreshadow the Creation of the Church from the blood and water issuing from Christ's side during the Crucifixion. In the *Christian Decachord* Cardinal Vigerio says, "From the side of the first Adam, Eve was formed. And from the side of the Messiah, the King, when he was exalted upon the Cross, your daughters, all the churches of the believing peoples . . . They shall spring forth through the streams of water and blood from the side which the soldier opened with his lance . . ." Even the opposition of the sinful Adam of the *Fall of Man* with the Christ-Adam of this scene is clarified by Vigerio: "The first Adam sinned through disobedience. The second made himself obedient even unto death . . . The first was conquered in the green tree, beautiful with its apple, the second conquered in the withered and bare tree." The completely transformed appearance of Adam (fig. 28), the look of obedience and resignation, and the suggestion of death rather than sleep—almost of a Descent from the Cross—is illuminated by Vigerio's text, and above all the tragic silhouette of the Cross-like withered tree contrasting so strongly with the fierce pride of the green tree in the *Fall of Man* (page 77). As in that scene, the few grand figures fill the field from edge to edge with the simple noble movements of broadly painted masses. His lilac heaven-mantle wrapped about Him, the Lord stands with closed eyes and long, white hair and beard, very different from the stupendous figure who, in succeeding scenes, will unfold all the glories of Creation.

This revelation, presumably, Cumaea reads in her book with awe and terror. Her attendant *putti*, whose arms echo the position of the richly modeled arm of the Christ Child in the *Bruges Madonna* (fig. 10), look down on her gently, almost sympathetically. Her savage features, burnt brown in the sun, carved into buttresses and arches by the terrible chisel of age, are worked into a huge architectural unity with the stony masses of her white, gray-shadowed cap. Her pale-blue tunic with its plum-colored shadows and green and gold band is filled with light. Her cloak is bright and coppery as a new penny. Most wonderful of all is her left arm, modeled in rose, terra verde, ocher, and gray, every facet carved by color changes in a way prophetic of Rubens and Cézanne.

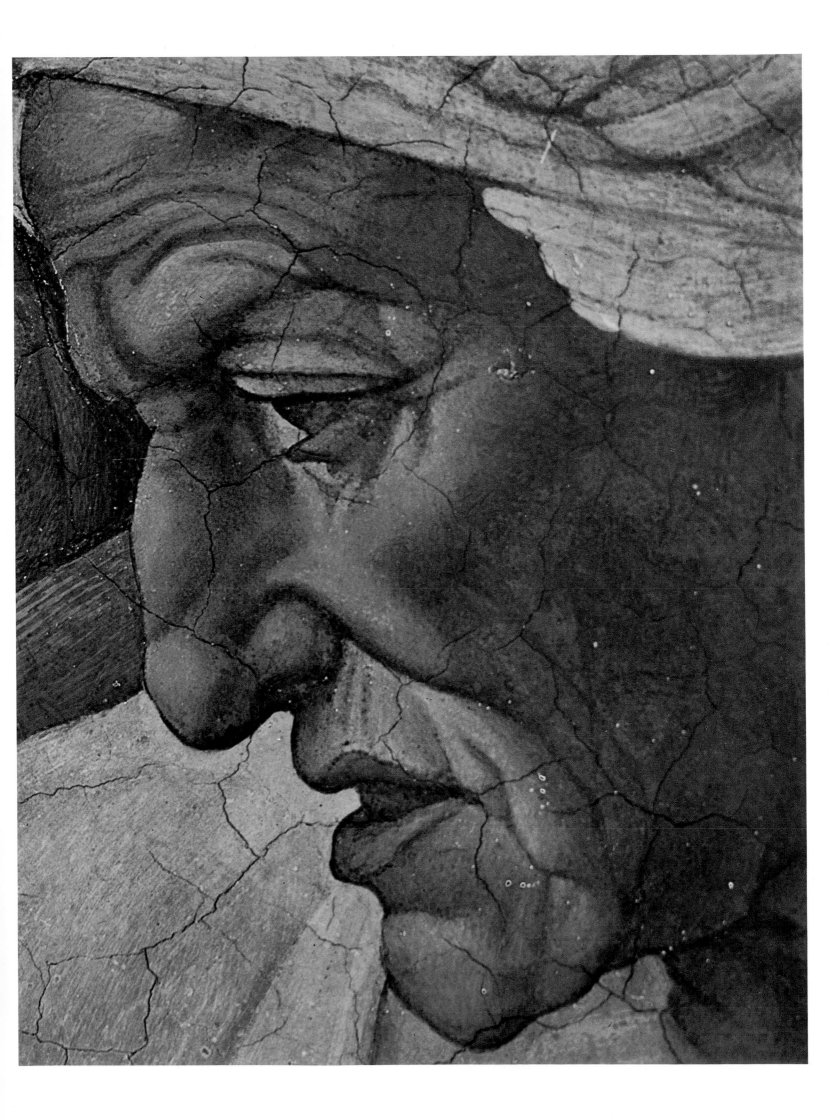

EZEKIEL

Fresco, 1510

Sistine Ceiling, Vatican, Rome

A match for his mighty counterpart, *The Cumaean Sibyl* (page 79), but unlike her, deeply excited, the aged Ezekiel, holding an open scroll of prophecy in his left hand, twists in the direction of the *Fall of Man* (page 77). Like Isaiah, Ezekiel too had a vision not only of the Tree of Life, "whose leaf shall not fade, neither shall the fruit thereof be consumed . . . the fruit thereof shall be for meat and the leaf thereof for medicine," but also of the Tree of Knowledge, that the deep set up on high, and "under his shadow dwelt all great nations." This tree shall be cut down, its boughs broken, the peoples of the earth will leave it, it will be "cast down to hell with them that descend into the pit." Nonetheless the prophet is deflected from his terrible vision of the trees in the *Fall of Man* (page 77) by the earnest words of his attendant *putto*. The child points upward like a youthful St. John the Baptist to the *Creation of Eve* (fig. 27), with its Christ-Adam extended below the dry tree, as if to bear the Lord's message, that He would bring down the high tree and exalt the low, dry up the green tree, and make the dry tree to flourish.

Under his title as the Son of Man, Ezekiel is a type of Christ. He is also one of the principal prophets of the Virgin Birth, by reason of his vision in which an angel brought him before the gate of the sanctuary. "Then said the Lord unto me; this gate shall be shut, it shall not be opened, and no man shall enter in by it; because the Lord, the God of Israel, hath entered in by it . . . It is for the prince, the prince, he shall sit in it to eat bread before the Lord . . ." Throughout Christian thought and art the closed gate of Ezekiel was taken to signify the virginity of Mary, and was identified liturgically with the gate of the sanctuary, over which frequently appeared the Annunciation to the Virgin, the very moment of the entrance of divinity into the sanctuary of Mary's body. It is no accident, therefore, that Ezekiel is placed above the barrier to the sanctuary in the Sistine Chapel, facing the sibyl of the Roman Church and flanking with her the *Creation of Eve*, which symbolizes the creation of the Church. It is hardly a surprise to discover the passage describing Ezekiel's vision of the closed gate below his picture in Barbieri's little book dedicated to Sixtus IV, who built the Chapel and commenced its decoration.

A kind of storm rushes through the figure of Ezekiel, agitating his pale-blue shawl, his rust-brown mantle, and his scroll. His feet are planted so firmly on his pedestal that his right foot seems almost to sink into the marble. His head juts forward to bring the shadowed profile into incisive relief, and his powerfully carved right hand violates the very surface of the vault as it thrusts toward the observer.

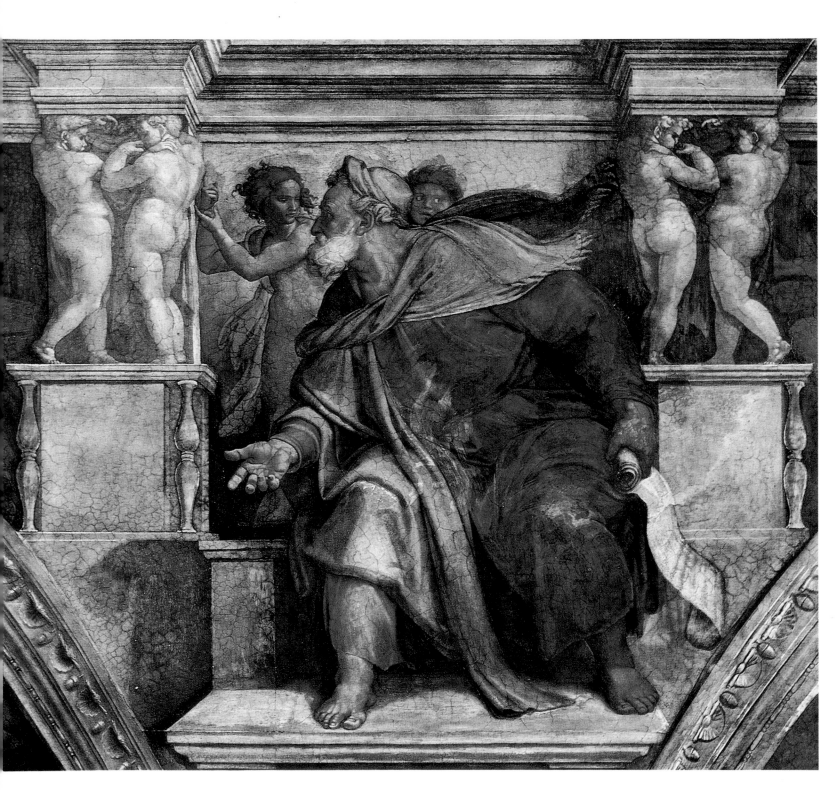

THE CREATION OF ADAM

Fresco, 1511

Sistine Ceiling, Vatican, Rome

Of all the marvelous images that crowd the immense complex of the Sistine Ceiling, the *Creation of Adam* is undoubtedly the one which has most deeply impressed posterity. No wonder, for here we are given a single overwhelming vision of the sublimity of God and the potential nobility of man unprecedented and unrivaled in the entire history of visual art. No longer standing upon earth with closed eyes and mantle, the Lord floats through the heavens, His mantle widespread and bursting with angelic forms, and His calm gaze accompanying and reinforcing the movement of His mighty arm. He extends His forefinger, about to touch that of Adam, who reclines on the barren coast of earth, barely able as yet to lift his hand. The divine form is convex, explosive, paternal; the human concave, receptive, and conspicuously impotent. The incipient, infecundating contact about to take place between the two index fingers has often been described as a spark or a current, a modern electrical metaphor doubtless foreign to the sixteenth century, but natural enough considering the river of life which seems about to flow into the waiting body.

Genesis tells how the Lord created Adam from the dust of the earth and breathed into his nostrils the breath of life. This story is never illustrated literally in Renaissance art. Usually, as in Jacopo della Quercia's beautiful relief on the façade of the church of San Petronio in Bologna (fig. 5), which must have impressed the young Michelangelo deeply, the Creator stands on earth and blesses the already formed body of Adam, read together with the ground, since his name in Hebrew means earth. Michelangelo's completely new image seems to symbolize a still further idea—the instillation of divine power in humanity, which took place at the Incarnation. Given Cardinal Vigerio's reiterated insistence on the doctrine of the two Adams, and the position of the scene immediately after the barrier to the sanctuary, at the spot where the Annunciation customarily appeared, and after Ezekiel with his vision of the Virgin Birth, this would seem natural enough. The scene recalls the famous verses from Isaiah, "Who hath believed our report? and to whom is the arm of the Lord revealed? For he shall grow up before him as a tender plant, and as a root out of a dry ground . . . ," invariably taken by theologians to foretell the Incarnation of Christ, shoot of Jesse's rod. Two striking visual elements make clear that this was one of the passages actually recommended to Michelangelo by his probable adviser, Cardinal Vigerio. First, the mighty right arm of the Lord *is* revealed, naked as in no other of His appearances on the Sistine Ceiling, nor anywhere else, as far as I have been able to determine, in all of Christian art prior to this time. (The left arm is clothed, at least to the elbow, by a white sleeve.) Second, directly under Adam, the arm of the veiled youth to the left above the Persian Sibyl projects into the scene—a matter that involved considerable advance planning—coming as close to touching Adam's thigh as the Creator does his finger. This hand holds a cornucopia bursting with Rovere leaves and acorns, appearing to grow from the dry ground, as full of potency as Adam ("ground") is empty of it. Such an image is characteristic not only of Michelangelo, who insofar as possible preferred to show male figures, including that of Christ, completely naked, but of the Roman High Renaissance and of Julius II himself, whose language as recorded by his astonished contemporaries overflows with boasts of his own physical strength and potency.

Such medieval writers as Hrabanus Maurus, whose *Praises of the Holy Cross* received a splendid printed edition in 1503, the year of the accession of Julius II, found the mystery of Christ's body in the number of letters in Adam's name. In the words of the second Psalm, quoted by St. Paul as signifying the Incarnation: "Thou art my son, this day have I begotten thee."

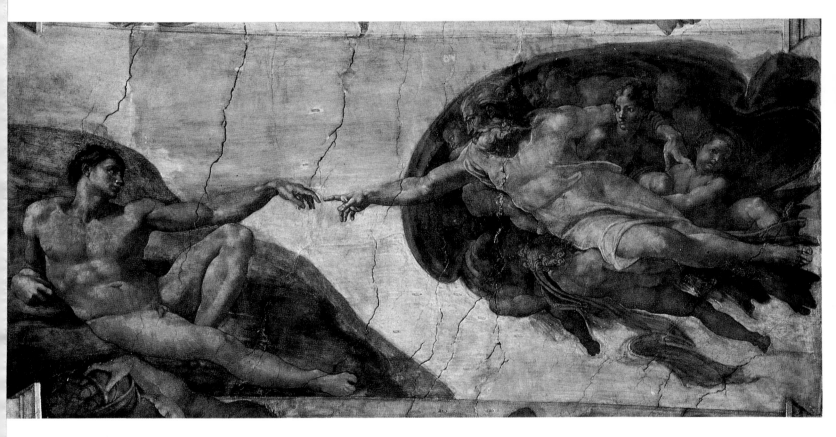

THE CREATION OF ADAM (detail, Adam)

Fresco, 1511

Sistine Ceiling, Vatican, Rome

Love and longing stream from the silent face of Adam toward the Omnipotent Who is about to give him life and strength. In the breadth and nobility of the proportions, in the pulsation of the forms and the flow of their contours, above all in the almost incredible intensity of feeling that moves through every plane, this is one of the most beautiful human figures ever imagined. A century of early Renaissance research into the nature and possibilities of human anatomy seems in retrospect only to lead up to this single, unrecapturable moment, in which all the pride of pagan antiquity in the glory of the physical, tangible body, all the yearning of Christianity for the "substance of things hoped for, the evidence of things unseen," seem at last to have reached a mysterious and perfect harmony.

Adam, before the Fall, was beautiful even as Christ was beautiful because, the theologians said, he was made in God's image. Julius II was a Franciscan, like his uncle and protector Sixtus IV, and like Cardinal Vigerio. The great Franciscan theologian, the Seraphic Doctor St. Bonaventure, speaks of the beauty of Christ in words that can hardly help but recall Michelangelo's glowing vision of the potentiality of all mankind: "Verily the most beautiful flower of the root of Jesse, which flowered at the Incarnation . . . For his body is most glorious, delicate, agile, and immortal, clothed with the glory of such brightness that verily it must be more radiant than the sun, revealing the exemplary beauty of the resurrected bodies of all men."

Strengthless as the muscled body seems, it is also weightless. Not a form is pressed out of shape by contact with the ground, Adam's namesake, out of which he does indeed seem to have grown like a tender plant, fulfilling the latent energies of the earth mass in one full and complete curve, with the inner rhythm of the growth of plants, from the right foot upward through the extended leg and the body to the head, then hesitating and trembling through the muscles of the left arm to the limp and nerveless hand.

Michelangelo's life studies for this and other nude figures on the Sistine Ceiling show that their miraculous beauty was derived from his imagination, not his outer vision. Muscles that in the live model were knotted and awkward become in the finished fresco transfigured by the force that flows through them and by the unearthly inner glow of the flesh tones. What has been so well termed Michelangelo's "melodic contour" never for a moment loses, in its onward rush, the sense of construction, of harmonic interrelationship between its tones, that a good melody must have. And it is related to the masses as a melody is to underlying chords. The eye moving over these shapes is bewildered, astonished, and delighted at the artist's mastery of the most intricate relationships of shape and line, idealizing the anatomical forms of nature by virtue of what seems a higher nature. Never again was he or anyone else to achieve such a figure.

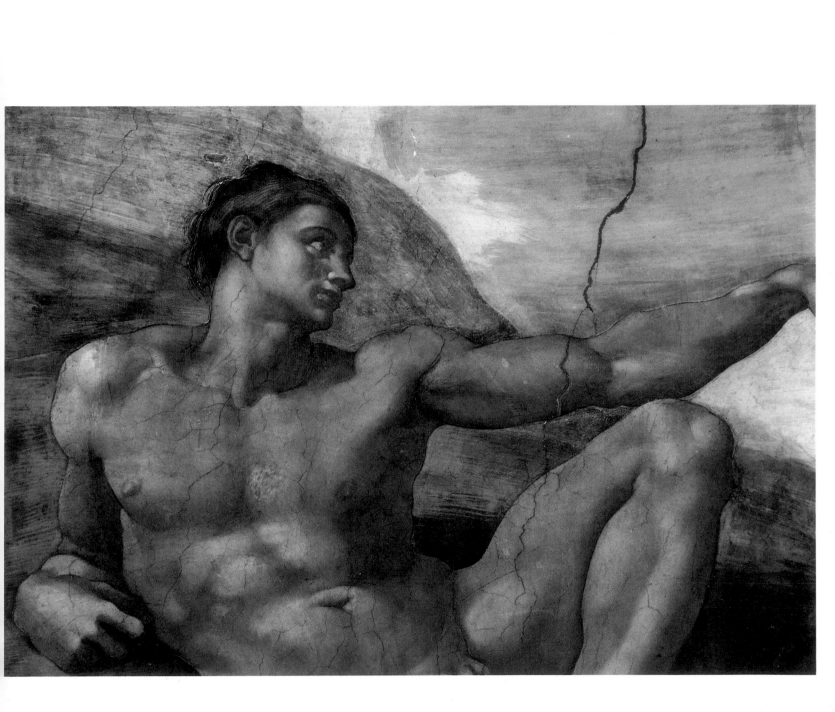

THE CREATION OF ADAM (detail, the Creator)

Fresco, 1511

Sistine Ceiling, Vatican, Rome

All the ritual pomp and material splendor of medieval and early Renaissance depictions of the Almighty, regally enthroned and bedecked, have been swept away as irrelevant to the doctrine of the omnipotent Father to which both Christianity and Judaism are devoted. Garbed only in a short white tunic which reveals the power of His body and limbs, the Lord soars, embracing and lightly supported by His wingless angels under the vast curve of His heavenly mantle. The whole group floats rapidly forward, borne, as in the Psalms, on the wings of the wind. Even Michelangelo's precise depiction of muscles, veins, wrinkles, fingernails, and gray hair does not in any way reduce the universality of this celestial apparition, or impede His irresistible motion. The anthropomorphic concept radiates a power so immense as to seem a fitting embodiment of such modern ideas as that of cosmic energy, no matter how alien to the sixteenth century. To this representation one can really "ascribe, as is most justly due, all might, majesty, dominion, and power."

Confronted with such a miracle, the commentator would be rash indeed to try to account for it in words. But one can at least note some of the devices by which Michelangelo has enhanced the feeling of transcendent power in this mighty vision. For example, the forward surge of curves in the boldly illuminated right leg and torso of the Lord, culminating in the procreative gesture of the extended arm and hand, is reinforced by the movement of repeated curves in the limbs of the angels in His shadow, tentative, spasmodic at first as the eye ascends, then fulfilled in the final tremendous thrust of the whole divine being. Then, by turning the angelic profiles, of varying degrees of dimness and definition, in the same direction as the Creator's head, the quiet power of His glance is built up as if by echoes from behind. Finally, the whole configuration of limbs and bodies and gazes is surrounded by the vast gray-lilac mantle. Combined with the movement of the pale green scarf streaming from the shoulders of the beautifully modeled adolescent angel below the Lord, the whole mass of drapery is constructed once above the group and almost at the right edge of the scene, then twice below, in hook-like folds, from which the parabolic curve of the mantle seems to release the energies of the entire group like an arrow from a taut bow.

Michelangelo has also brought the whole vast configuration, with its broad enclosing movements and smaller, pulsating shapes, to a sharper focus in the sweeps of gray hair and beard, which resemble the swirling water in Leonardo da Vinci's drawings for the end of the world, conceived, significantly enough, several years later. The divine countenance itself is far more sharply defined than any of the other surrounding faces, with their broad, unmodeled, and sometimes uncontoured planes. In this face, and in the limbs of the figures in full or partial shadow, Michelangelo has at last found an accord between the two opposing principles of his earlier pictorial style, the incisive contour and the patchy chiaroscuro. Now they are united, and so convincingly that the beautiful arms and legs and bodies turn in space even when no light touches them at all, yet the line never for a moment loses its delicious pulsation and clear definition of form.

There is something so overwhelming in Michelangelo's conception of God that it seems, mercifully enough, to have occurred to no one to explain it as a "father image." The great artist set forth his vision on the Sistine Ceiling with the force, purity, and conviction of deep religious experience. It is characteristic of Michelangelo that the Creation and the Incarnation should be fused in a supreme act of love, so noble that mankind has never since been able to forget or to escape it. It is just as characteristic of the High Renaissance in Rome that such an idea could take shape at the center of papal power at the very moment when that power seemed to be facing inevitable ruin.

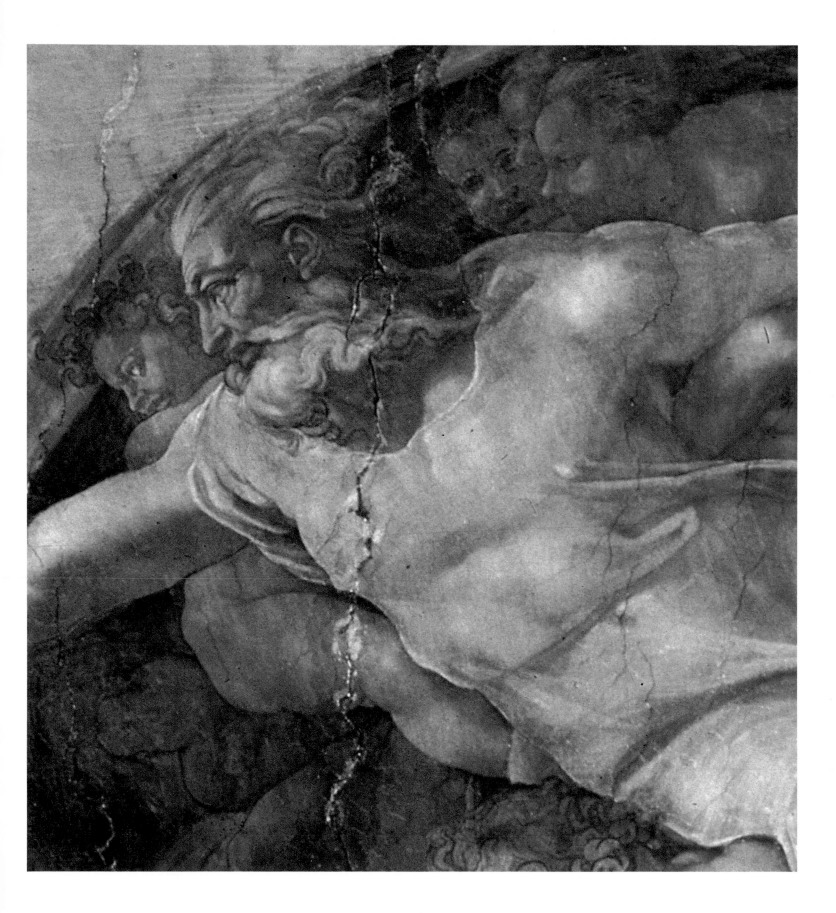

THE PERSIAN SIBYL

Fresco, 1511

Sistine Ceiling, Vatican, Rome

Although *The Persian Sibyl* flanks the *Congregation of the Waters* (page 93), this is apparently not the principal subject of her prophecy. Her head and body are conspicuously turned in the direction of the *Creation of Adam* (pages 83–87), presented by Michelangelo as a fore-shadowing of the Incarnation. Filippo Barbieri's little book dedicated to Sixtus IV, which must have been used by Cardinal Vigerio for the meaning of the prophets and sibyls, quotes Persica thus: "Behold, O beast, thou shalt be trampled; and the Lord shall be brought forth in the orb of the lands, and the womb of a virgin shall be the salvation of the peoples, and her feet the salvation of men." Although no letters can be made out on the summarily indicated page, this is clearly what Persica is reading in the book she holds to her near-sighted eyes, the better to see it by the light coming from the direction of the altar. She even wears on her head the white veil Barbieri has prescribed for her, as her open lips seem to repeat the wonderful words foretelling the Virgin Birth and the coming of the Saviour.

Michelangelo has shown Persica as an aged crone, her head bent forward, her shoulders hunched, her whole being concentrated on the mystery revealed in the small book she holds. Her two attendant *putti*, unlike the others on the Ceiling, are reverently clothed, and present themselves in line like the assistant ministers during the Kyrie, the Gloria, and the Preface to the Sanctus at High Mass. The face of the first *putto* is shielded from the lumi-nous revelation by the shadow of the book, like that of an Apostle protecting his eyes from the great light of Christ in a painting of the Transfiguration. The tiny attendant is wrapped in what suggests the cope which can be worn by one or all of the assistant ministers at a Solemn High Mass. Under the cope he clasps his hands in prayer before the mystery, and looks upward toward the *Congregation of the Waters* (page 93) in which the Creator spreads out His hands like those of the celebrant during the Canon of the Mass. Even in color the moment of the Incarnation is subtly symbolized, for Persica wears a rose-colored cloak, suggesting the hue traditionally accorded to Mary's tunic, but as she reads, it is turned out to show a lavender-gray lining like the cloak of God throughout the Ceiling.

In spite of her age, the Sibyl is shown as immensely strong, her biceps appearing under her sleeve as her arm moves across her body like the Child's arm in the *Bruges Madonna* (fig. 10) In this last portion of the Ceiling, Michelangelo sharply lowered the level of the pedestals, and was perhaps aware of the effect this would have on the prophets and sibyls, who now expand to overflow their thrones. He has emphasized more strongly the relation of their bodies to the simulated vaulting ribs rising around them, and concentrated attention on the support of vast weights by sharp points—in this instance, a single foot.

The movement of color is broader and softer than in the earlier prophets and sibyls, with less emphasis on iridescence. But the chromatic effects are still full of subtleties. The cover of the book reflects the rose of the sibyl's cloak, and the warm white of the sleeves, whose shadows are tinged with ocher and lavender-gray, contrasts delicately with the cool white of the veil and its bluish and at times faintly greenish-gray shadows. The pale, sea-green tunic, lighted with shimmering, almost white passages, is edged by soft yellow-gold in the belt (suggesting the Virgin's golden girdle) and with warm red-gold in the shoes, repeating the color of the attendant's cope. Even the drapery masses move more softly than in any of the earlier figures on the Ceiling, only hinting, in their great breadth and fullness, at the existence of such little snags as the level of the marble seat, or the leg under which some of the folds are tucked.

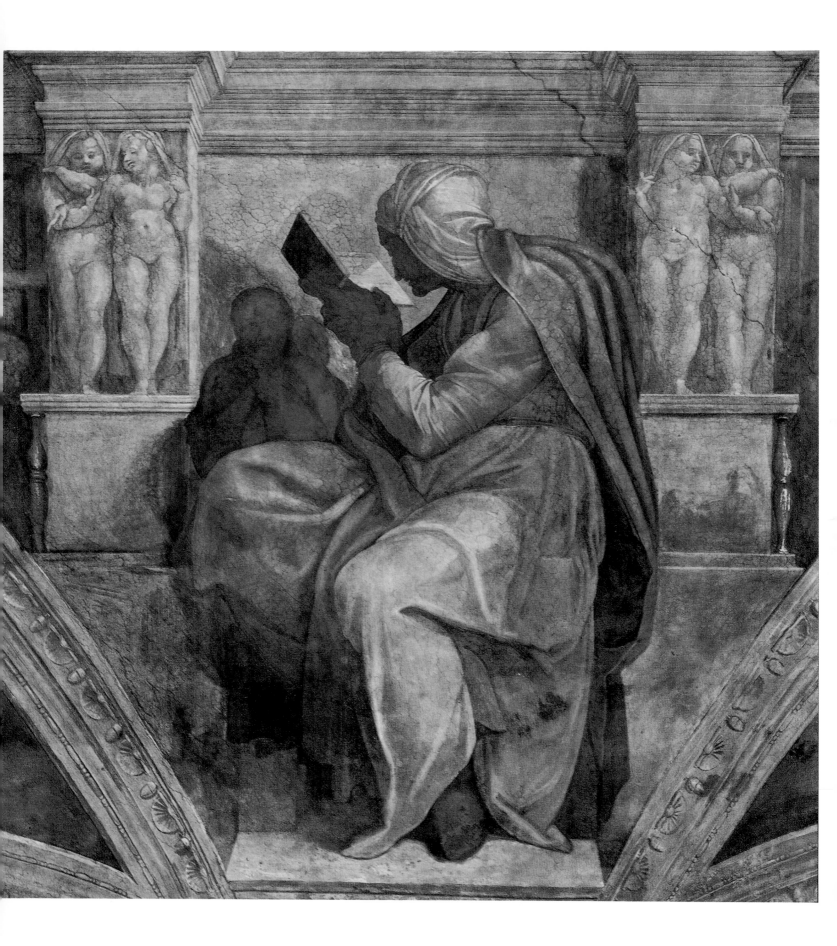

DANIEL

Fresco, 1511

Sistine Ceiling, Vatican, Rome

The youth and freshness of the boyish Daniel contrasts with the immense age of his counterpart, Persica, across the space of the Chapel. According to Filippo Barbieri, the great importance of Daniel was his prophecy of the stone, cut without hands, that fell from the mountain and broke the idol with the feet of clay, and then became in turn a great mountain to fill all the earth. This prophecy, universally repeated in the Middle Ages and the Renaissance, was held to signify the Virgin Birth of Christ without mortal intervention, the destruction of paganism, and the miraculous growth of Christianity to fill the whole world. Daniel sits directly below the *Congregation of the Waters* (page 93), foreshadowing the congregation of all mankind in the Church.

Another of Daniel's famous prophecies of the coming of Christ was the passage in which he said to "the man clothed in linen, which was upon the waters of the river, How long shall it be to the end of these wonders? And I heard the man clothed in linen . . . when he held up his right hand and his left hand to heaven, and sware by him that liveth forever that it shall be for time and times and a half" Michelangelo has placed Daniel below the scene in which the Lord, dressed apparently in linen, floats over the waters, lifting up His right hand and His left hand to heaven.

The importance of Daniel in Christian theology lies beyond any single passage or group of passages. Like all the other prophets in the sanctuary, he was believed to have foretold Christ in his own life and actions. The den of lions in which he was sealed at the King's order was the tomb sealed over Christ in obedience to the Father's will, and his release the Resurrection. In the book of Daniel was inserted the Song of the Three Holy Children, so magnificent a hymn to the Creator that, although rejected from the King James version of the Bible, it nonetheless remained in Anglican ritual in the canticles *Benedictus es, Domine*, and *Benedicite, omnia opera Domini*. The line "Blessed art thou that beholdest the depths and dwellest between the Cherubim" would seem to refer to the appearance of the Lord in the *Congregation of the Waters*, looking into the depths and flanked by two cherubim.

Of all the prophets on the Ceiling, Daniel is the only one shown writing. One of the attendant *putti* upholds a huge book, its lower edge balanced on the prophet's knee so that he may see its contents and transcribe them into a smaller volume on a little reading desk at his right. In the language of allusion and suggestion adopted for the imagery of the Sistine Ceiling, this is probably a reference to the smaller Song of the Holy Children contained with the larger Book of Daniel.

The prophet's head is turned in the direction of the *Creation of Sun, Moon, and Plants* (page 95; fig. 29). Masses of chestnut-colored hair rise like flames from the head of this prophet of the fiery furnace, uniting him in appearance with the new revelation of the Deity creating the blazing luminaries of heaven.

The effects of foreshortening and the broad, expressive movement of form and color are even more powerful in Daniel than in Persica. The head was badly disfigured by discolored varnish (applied later), but the tunic still glows with brilliant blue lighted by pale blue. Yellow-gold picks out the borders and the button of the tunic and illuminates the green lining of the fringed mantle over the powerful knees. Yet the outside of the mantle is rose, so that one reads across the whole mass of drapery a rich succession of rose, green, gold, and blue.

The wonderfully foreshortened forearm supports a hanging hand strikingly similar, in its loosely pendent thumb and forefinger, to the left hand of God in the *Creation of Adam* (page 83).

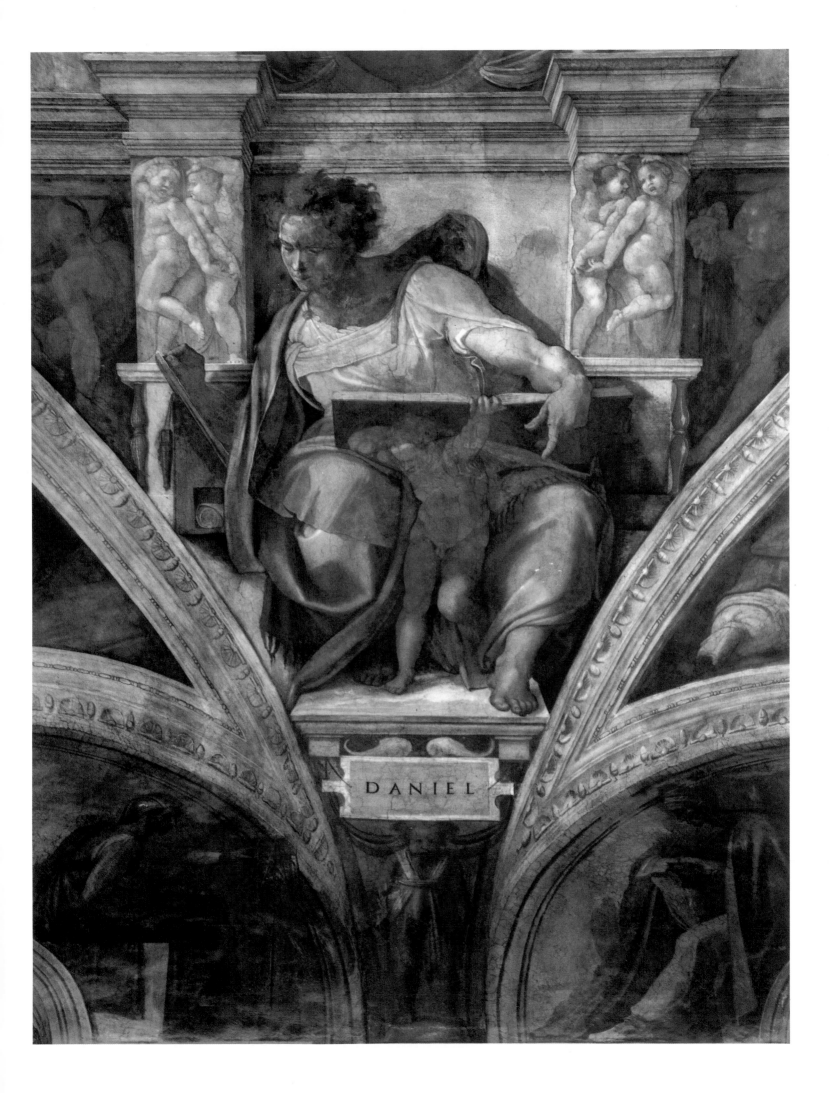

DANIEL

THE CONGREGATION OF THE WATERS

Fresco, 1511

Sistine Ceiling, Vatican, Rome

Since no life is visible in the expanse of waters below the floating figure of the Deity, it is unlikely that the fifth day of Creation is represented, when the Lord created all the moving creatures in the water and the air. Clearly Michelangelo was not required to illustrate the text of Genesis exactly; the creation of the firmament (second day) and of the animals (sixth day) are nowhere depicted. In all probability the scene represents the moment on the third day in which the Lord said "Let the waters under the heaven be gathered together into one place," and called them the Seas. St. Ambrose believed this act foretold the congregation of all peoples in the Church, which would explain the expression of priestly benignity now given to God, the sacerdotal gesture of the two lifted hands as in the Canon of the Mass, and the two angels who uplift his cloak as the acolytes hold up the chasuble of the celebrant.

For the first time the artist has arranged his figures so that they abandon the foreground plane entirely. As occasionally in the early Renaissance—but never so dramatically—the figure of the Lord is entirely foreshortened, entering the scene toward the observer, His arms outstretched, His head and chest seen from above, His legs disappearing in the mantle drawn about Him. So extreme is the foreshortening, in fact, that the right arm is, as Vasari put it, inscribed within a square, yet seems to project to its full length.

Along with the ever-increasing breadth and openness of the forms, which at once seem to invade and to be penetrated by space, to gain volume and to lose weight as compared with the earlier sections of the Ceiling, the brushwork proceeds at a sharply accelerated tempo. Broad movements of a large, soft brush suggest pictorial surfaces dissolved in light, particularly in the misty streams of hair and beard. Yet the contour continues to function with the greatest power, isolating the masses in perfect harmony with the gliding surfaces and silvery colors, dominated by the lilac of the Lord's mantle and the blue and gray of sky and sea.

As the great revelations of God's power and glory succeed each other, always in circular form, one is compellingly reminded of Ezekiel's vision of the four wheels revolving in Heaven, within each of which dwelt the Lord Himself.

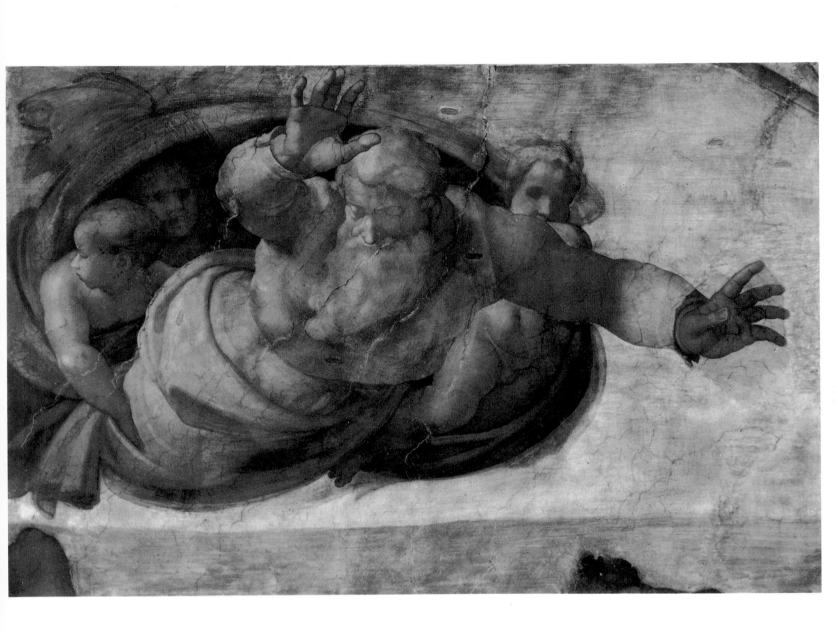

THE CREATION OF SUN, MOON, AND PLANTS
(detail)

Fresco, 1511

Sistine Ceiling, Vatican, Rome

In a vast, cruciform gesture, the Lord, sweeping through the heavens attended by four angelic figures, points—and the sun and moon spring into being (fig. 29). According to the account in Genesis this event occurred on the fourth day. Michelangelo has shown the Lord from the back, at the left, stretching forth His hand on the third day to call plant life from the earth.

St. Ambrose had seen in the creation of the sun to rule by day and the moon by night a mystic foreshadowing of Christ and the Church. The wideflung arms, culminating in the sun and moon, remind one that sun and moon were darkened at the Crucifixion, and are often represented in medieval and even Renaissance art at either side of the arms of Christ. When Christ yielded up the ghost, according to St. Matthew, "the veil of the temple was rent in twain." Michelangelo's composition is dominated by a conspicuous rip between the two heaven-mantles of the Creator, neither of which surrounds His whole being in the broad, full circles of the two earlier Creation scenes but end in ragged edges as if torn. There are other visual suggestions of the sacrifice of Christ. Under God's right arm a kneeling nude angel repeats the pose of the kneeling son of Noah in the *Sacrifice of Noah* (page 73)— but looks upward at the Lord instead of away from the victim. Under God's left arm a clothed figure repeats the gesture of Noah's wife and of Adam in the *Fall of Man* (page 77)— but looks upward at the Lord. Surely this is the brand plucked from the burning.

At the left, one looks in vain among the conspicuous ferns, grasses, and other leafy plants growing up at the Lord's command, for a single tree capable of "yielding fruit after its kind," until the eye falls on the leaves and fruit of the Rovere tree that invades the field at the lower left from under the arm of one of the nudes outside the scene, but is read in an almost continuous line with the plants inside the scene. Similarly, from above the scene, looming so large as to compete with the major elements in the composition, a kind of burden wrapped in cloth emerges from beneath the elbow of one of the most powerful of the nudes, and seems to descend upon the Lord's broad shoulders. One thinks instinctively of Isaiah's dark verses, "Surely he hath borne our griefs and carried our sorrows . . . the Lord hath laid on him the iniquity of us all." In the Creation of Plants as in the Creation of Sun and Moon, the sacrificial death of Christ is foretold, this time visibly through the mystic tree and its burden.

After its predecessors, the violence of the *Creation of Sun, Moon, and Plants* comes as a sudden shock. Not only the awesome expression of the Lord's countenance, but the terrible force of the great volumes, the fierce involvement of the ragged edges, the eruptive intensity of the foreshortenings, combine to raise the message to an astonishing plane of grandeur. The sun and moon whirl, but half out of the space of the picture. The Lord hurtles toward us in space, but then as swiftly moves away again. All the masses are now foreshortened according to the new and final style, and those left entirely in shadow are as full and round and massive as those illuminated by the sun.

In Michelangelo's image, God Himself can suffer. His tragic expression reflects premonition of the impending sacrifice of the Incarnate Word. Vast sweeps of the brush indicate torrents of beard and hair, from which a few wisps escape and dissolve into air. But at the very end of the day's work, apparently the artist decided to cut the soft surfaces of the hair irregularly into blocks by seven or eight huge black strokes, as if previously they had been flowing too smoothly, too much like the dreamy, shimmering hair and beard of the Lord in the *Congregation of the Waters.*

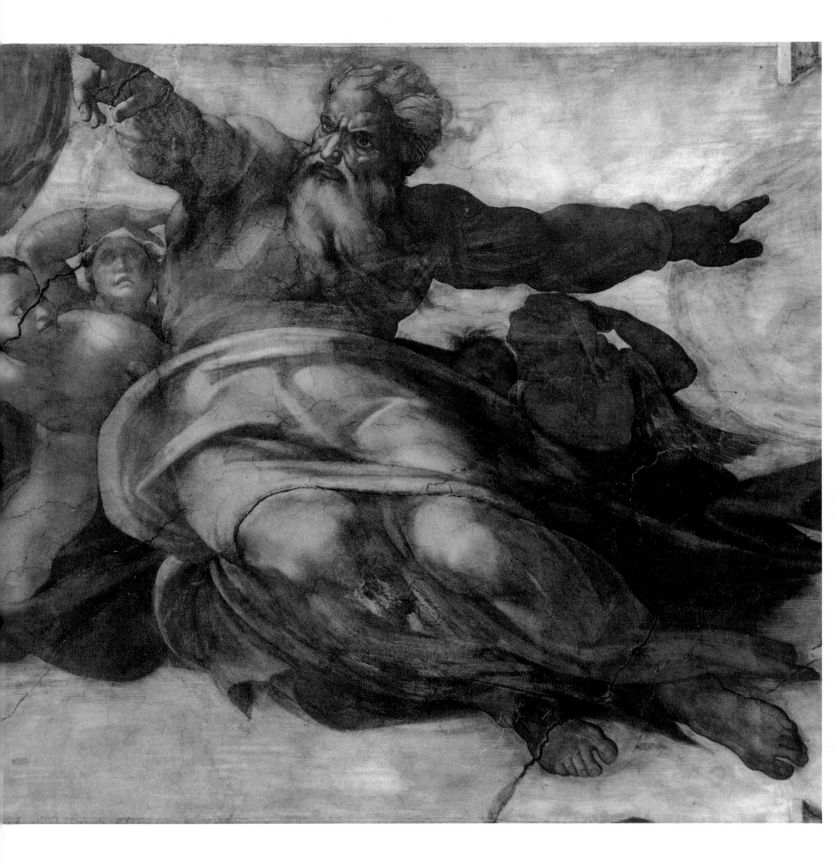

JEREMIAH

Fresco, 1511

Sistine Ceiling, Vatican, Rome

The aged Jeremiah, one of the most crushing images of melancholy and desolation ever painted, looks down from his throne at that of the Pope. Like Daniel, Jeremiah experienced the Passion in his own body, for he was derided by the priests and elders, taken captive, beaten, cast into prison, from which his miraculous deliverance foretells the Resurrection. In this respect he was also compared with St. Peter, the first Pope, and perhaps for this reason Jeremiah was placed over the throne of Pope Julius II, Peter's successor, who had been cardinal of the church of San Pietro in Vincoli. The *Creation of Plants*, with its Rovere tree, and the *Burning Bush* of Botticelli, painted for Julius' uncle Sixtus IV, also of the Rovere family, are respectively above and below Jeremiah, to whom the Lord foretold that He would "raise unto David a righteous Branch In his days shall Judah be saved and Israel shall dwell safely." The passage given by Barbieri for Jeremiah was the Lord's question, "Jeremiah, what dost thou see? And I said, I see a rod keeping vigil." These were prophecies of Christ and the Crucifixion, in the same arboreal imagery universal throughout the Ceiling.

Beside him on his throne is visible a little scroll with the word "*Alef*," the first letter of the Hebrew alphabet, which refers to the book of Lamentations, in each of whose five books the individual verses are lettered in Hebrew, even in the Vulgate. Lost in bitterness, his head sunk on his hand, he gazes downward, meditating, doubtless, on the destruction of Jerusalem, that great city. Instead of *putti*, mourning women flank him on either side, probably personifications of the kingdoms of Israel and Judah. In Barbieri's little book may be read under Jeremiah's picture, "Turn again, O virgin of Israel, turn again to these thy cities . . . for the Lord hath created a new thing in the earth, A woman shall compass a man." The mourning maidens may well be called upon to turn again, for Michelangelo has averted their heads from the altar.

The broad, loose forms of the last section of the Ceiling combine with the soft yellow and lilac coloring of the garments to produce a strange feeling of collapse. The huge masses seem to be melting, like overhanging snowbanks on a spring day. All the lines pull downward, whether of beard or of drapery, or of the useless left hand. "For these things I weep," said the prophet; "Mine eye, mine eye runneth down with water, because the comforter that should relieve my soul is far from me: my children are desolate, because the enemy prevaileth." It may not be entirely a coincidence that this image of despair presided above the throne of Julius II when, on August 14, 1511, awaiting what everyone thought would be the inevitable descent of the French on Rome, the Pope consecrated the Sistine Ceiling.

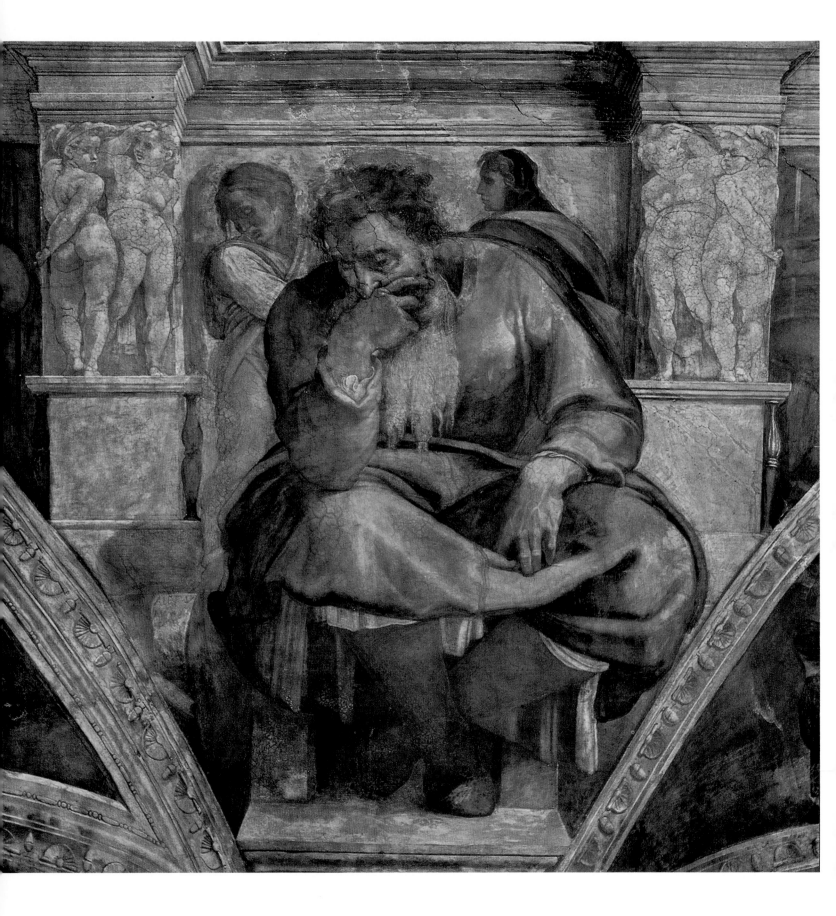

THE LIBYAN SIBYL

Fresco, 1511

Sistine Ceiling, Vatican, Rome

Stripped of her outer garments, which lie behind her against the back of her throne, the last and most regal of the sibyls turns in a superb *contrapposto* movement to close her book and replace it on its desk while she looks downward at the altar, ready to step from her throne. Scroll under arm, one of her attendant *putti* points back toward her as both children depart. She has no need of book or scroll; her whole being is absorbed in the ultimate reality on the altar whose light irradiates her Hellenic features.

According to Barbieri, Libyca had prophesied: "Behold, the day shall come and shall illuminate the condensed shadows, and the lips of men shall be silent: and they shall see the King of the Living. A virgin, the mistress of the nations, shall hold him in her lap, and shall reign in mercy; and the womb of his mother shall be the image of all." Below her luminous features and silent lips the virgin-born King of the Living is daily seen on His altar, in the tabernacle-womb of Ecclesia, mistress of the nations, image of all. Above her head, across the primal deep, floats God Himself, dividing the light from the darkness (fig. 30).

One of the finest surviving nude studies for the Sistine Ceiling, the beautiful red chalk drawing in the Metropolitan Museum (fig. 31) shows clearly that Libyca, like all the female figures on the Ceiling, was done from a male model. However, in the final painting Michelangelo has softened the harsh rack of male bone and muscle with a soft veil of adipose tissue. The study at the lower left-hand corner, in which the face is repeated, is apparently an attempt to envisage the kind of transition that would be necessary to transform male into female. He has also analyzed again and again with great care the structure of the crucial foot and hand that bear such enormous weights, living symbols of the little brackets upon which the whole vast structure of the Ceiling apparently rests. These vital fulcrums are sharpened in the final fresco and brilliantly illuminated, as all the masses of book, drapery, and body are brought to bear on them. Against these sharp points the turned-up edge of the petticoat moves over the left knee in a broken curve of immense power, against which mighty theme are played a series of broken chords in the lower edge of the fold.

The vast symphonic structure of Michelangelo's color is especially well seen in this illustration, ranging from the deep, rich tonalities of the spandrels and lunettes, intensifying the natural shadow of their positions, through the bright garments to the gray-white of the simulated marble. The figure is dominated by an orange-lavender dialectic of throbbing intensity. The bodice is orange, with white highlights and reddish shadows; the rose lining is turned up to reveal a lavender shift, always the color of divinity on the Ceiling, punctuated by hanging gray scarves. The border and the belt of the bodice are gray with gold-yellow buttons. The outer dress before which Libyca sits is a splendid green, with yellow-gold borders and sleeves, to harmonize with the green of the book cover and the cloth over the lectern. Around her beautifully plaited yellow-gold hair, whose color is related to the orange of her bodice, lavender scarves are bound.

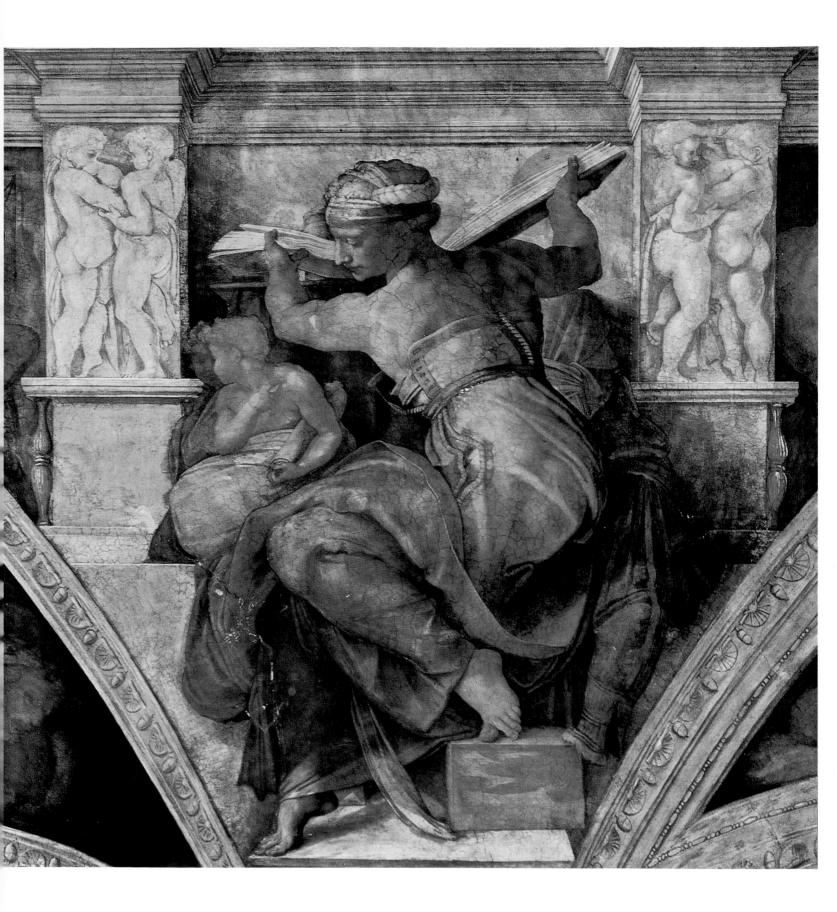

JONAH

Fresco, 1511

Sistine Ceiling, Vatican, Rome

This agitated youth, so expanded as to overflow his throne, is placed above the altar—the first figure in the entire Ceiling to strike the eye of an observer entering the Chapel. *Jonah*, alone among the twelve prophets and sibyls, looks upward, as if he could see, beyond the painted marble frame, the *Separation of Light from Darkness* (fig. 30).

Our own point of view shifts, and with Jonah we look upward at the first day of Genesis, directly into heaven as through a skylight; we, like Jonah, see the Creator from below, moving beyond the frame, in the same direction as the ribs of the vault, not only separating the light from the darkness but upholding like Atlas the weight of the heavens. As one would expect, the light is on the side of the altar (the Second Person of the Trinity is always identified with light: "In Him was life and the life was the light of men"); the darkness, on the side toward the beginning of the Ceiling. The mystic identification of Christ with the first light is proposed by Cardinal Vigerio, in a majestic dialogue across the millennia between Moses and John, the first chapter of Genesis that Michelangelo is ostensibly illustrating and the first chapter of John, read at the end of every Mass (see pages 32–33).

Jonah truly belongs in this position, above the altar on which Christ is daily sacrificed and resurrected, and the Church with Him, because Jonah is the prophet of the Resurrection: ". . . there shall no sign be given . . . but the sign of the prophet Jonas: for as Jonas was three days and nights in the whale's belly; so shall the Son of man be three days and nights in the heart of the earth." The whale, however, reduced in size for convenience at this juncture, is still an awesome creature with his great staring eyes. Michelangelo has been to the fish market again (see page 12). Together with the violent pose of Jonah, the sweeping curves of his cloak, and the storm blowing in the background, the gruesome shape conveys a tremendous feeling of the terror of death. Not unexpectedly the "sign of Jonah" (the gourd vine of the King James version is an ivy in the Vulgate, symbol of triumph) is easily identified visually with the Rovere tree in its frequent appearances elsewhere in the Chapel. In fact the Rovere tree was once visible on the shield right below Jonah's feet, until it was removed in 1534 to make way for the *Last Judgment*. The ivy leaves are so shaped as to suggest oak foliage and even acorns.

The deeply tanned sailor is dressed in characteristic Renaissance undergarments of green jerkin and white breech-clout that would seem out of keeping with his exalted position in the Chapel but appropriate enough for the storm-tossed mariner coughed up by the whale. Such underclothing is also understandable for a fisherman on the thwart of a boat. Peter was called Simon *Bar Jonah* (son of Jonah), and after the Resurrection, Christ dwells on this name when He directs Peter to "Cast the net on the right side of the ship, and ye shall find. They cast, therefore, and were not able to draw it for the multitude of fishes." Jonah twists to his *right*, and his gesture is that of one who draws a heavy net. One of the attendant figures behind him also seems to be pulling. Below this very point Michelangelo later painted the fulfillment of the prophecy, the multitude of faithful drawn up to heaven in the *Last Judgment*, some physically by means of a rosary (page 111).

With its prophetic suggestions of death, resurrection, and the presentation of souls to the overshadowing Lord, this glorious figure sums up the whole symbolic program and artistic intention of the Ceiling. It is no wonder that now, instead of the inverted pyramids of the other prophets and sibyls balanced on their apexes to conform with the arches, Michelangelo has created a broadly based structure which leads in a spasm of muscular effort and a sudden cry of fulfillment entirely past the realm of the Sistine Chapel and into that of heaven itself.

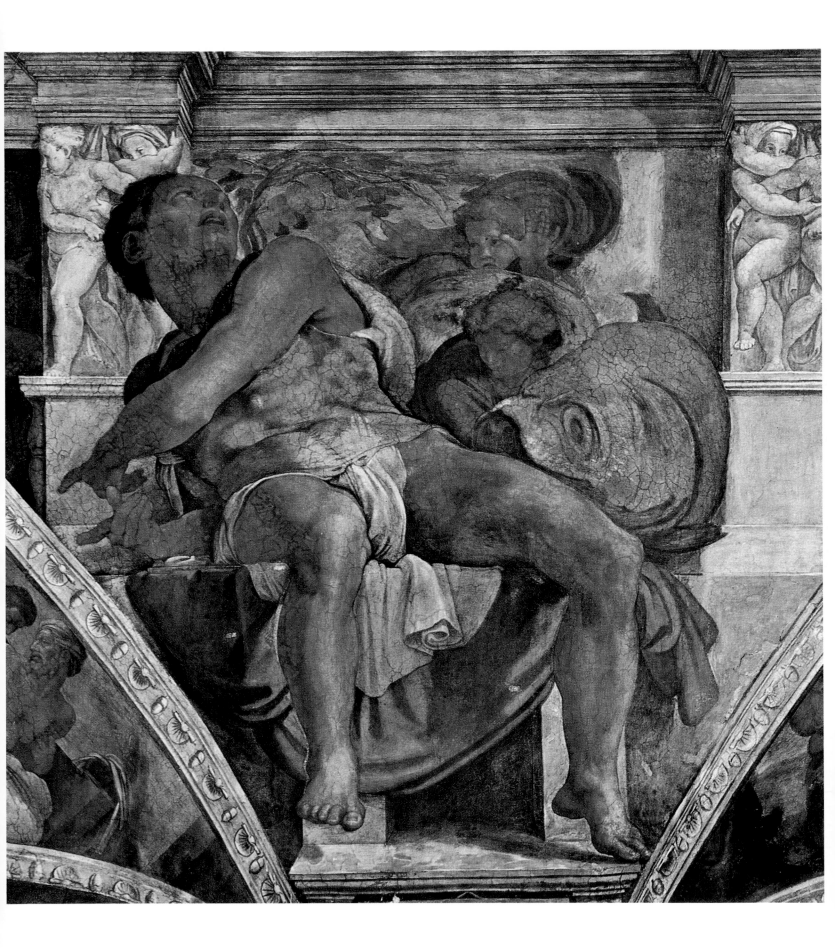

THE BRAZEN SERPENT

Fresco, 1511

Sistine Ceiling, Vatican, Rome

In the spandrel below and to the right of Jonah appears the *Brazen Serpent*, a scene of a complexity and turbulence that is astounding after the broad, clear-cut harmonies of the central scenes of the Ceiling. Michelangelo's newly found foreshortenings are here pushed to their limits, so that all but two or three figures are seen either from above or from below.

The corresponding spandrel to the left of Jonah is filled by a scene that has fewer fore-shortenings but is no less violent in its drama or abrupt in its spatial relationships (fig. 32). The story of Esther and Mordecai and the story of how Moses by the Lord's command saved the Israelites in the wilderness from the fiery serpents are both examples of divine intervention for the Chosen People, and complement the first spandrels (pages 59, 61). Although a comparison of the first and second pairs of spandrels shows the gigantic strides Michelangelo's style had taken in less than three years, the subjects were clearly intended to fit into the same calculated program. According to medieval theologians, Esther was a type of Mary, Mordecai foreshadowed Christ, and Ahasuerus, God the Father, while Haman was Satan himself. Michelangelo was clearly informed about this tradition, and has given Ahasuerus the legs of the Lord from the *Creation of Sun, Moon, and Plants* (fig. 29) and His life-giving arm from the *Creation of Adam* at the very moment when the King decreed that Esther's people shall be saved. But why is Haman crucified in this strange manner, instead of being hanged from the gallows fifty cubits high on which he intended to hang Mordecai (fig. 32)? The same medieval symbolic tradition, culminating in Dante, held that Haman's gallows was really a cross, a kind of antitype of the cross of Christ, and that it was illuminated by St. Paul's statement that Christ had blotted out the handwriting which was against us, "nailing it to his cross"—a kind of crucifixion of evil. Buried with Him, says St. Paul, we are also risen with Him, and the crucified enemy looks despairingly upward from his instrument of torment to *Jonah* (page 101), prophet of the Resurrection. Haman is represented twice, for he also may be seen at the left at the meal with Ahasuerus, when Esther revealed his treacherous scheme. There he reacts with the guilty gesture of Adam in the Expulsion (page 77), shielding from his eyes his own appearance on the cross.

Through the words of Christ Himself, the Brazen Serpent prefigures the Crucifixion: "Even as Moses lifted up the brazen serpent in the wilderness, so shall the Son of man be lifted up." At the left of Michelangelo's spandrel the young Moses lifts a woman's hand to the thaumaturgic image in a manner strikingly reminiscent of the hand of Adam lifted toward the life-giving Creator. On the side toward *Jonah* and toward the Rovere tree, then below his throne, the Israelites are healed; elsewhere they have not beheld the serpent of brass, and they writhe in an unbelievable tangle of arms and legs and pain-racked bodies.

The color is appropriately thunderous, built on the flesh tones (gray in the shadows, pearly in the lights), green, lavender, rose, and orange. Lavender shadows at the upper left move to the rose tunic of Moses, then his iridescent knee with its pink highlight, green middle tone, and red-orange shadows, all contrasting with the stony gray and the lavender shadows of the woman's garments. The dreadful serpents whose coils involve legs, arms, and torsos, are all a vivid green, against the gold of the Brazen Serpent. To continue the fantastic color range, the massive torso heaving toward us in the center of the spandrel is clothed in a bright orange doublet with pink highlights, a lavender shoulder, and a sea-green sleeve with lavender shadows, while the adjoining figure, seen from the back, has a lavender-gray undergarment and a doublet shifting from rose to orange. Against a ground mottled with sea green and golden gray, the legs at the extreme right are modeled in warm, rosy flesh tones, with unexpected greenish shadows.

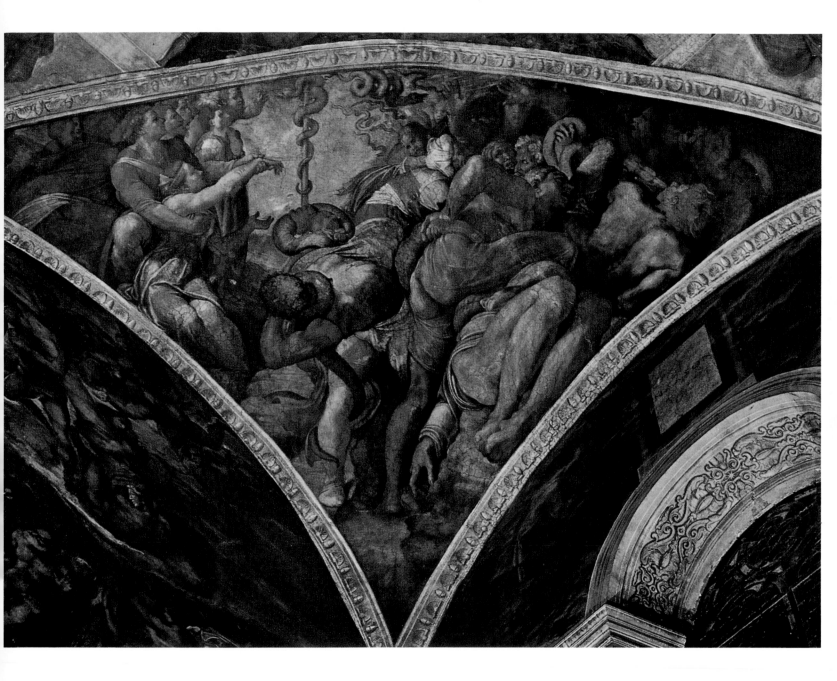

NUDE YOUTHS ABOVE EZEKIEL

Fresco, 1509–10

Sistine Ceiling, Vatican, Rome

Glorying in their beauty and prowess, the twenty nude youths seem at first sight somewhat out of place in a Christian chapel, the more so in that most of their poses are drawn from pagan models well known to the Renaissance. There is, however, a long tradition for nudity in Christian art: all human souls are naked before God. Consequently in representations of the Last Judgment souls are frequently shown as naked children or adolescents. It was been suggested that Michelangelo's youths embody still another tradition in Christian thought, that of the soul as an athlete, victorious in his race; and several, though by no means all, wear around their heads the fillets of victors.

It should not be forgotten, however, that despite their sometimes violent poses the youths perform a specific function in the structure of the Ceiling. They uphold enormous garlands of oak leaves and acorns—now unbound, now wrapped in cloth, now spilling from cornucopias—symbols of the Rovere family and of the doctrine of the Tree of Life. They also assist in upholding, by means of scarf-like bands of cloth, the ten bronze medallions which, upright above the thrones like hosts in monstrances, are responsible for shortening five of the nine narrative scenes in the center of the Ceiling. Garlands are, in ancient art, the characteristic decoration for sacrificial scenes. Rams' skulls, the leavings of sacrificial rites and thus the decoration of both pagan and Hebrew altars, are placed around the Ceiling at twelve crucial points, to poise the vast frame on the points of the vaulting compartments and the corner spandrels (see page 55). The sacrifice symbolized by the entire program of the Ceiling, and appropriate to its exalted position in the Christian world, is the sacrifice of Christ, foretold by the prophets and sibyls through the nine scenes from Genesis, carried in the very bodies of the forty generations of Christ's ancestry in the lunettes and vault compartments (see page 107) and performed upon the altar by the Vicar of Christ on earth. Each of the ten medallions is pierced by five slits, through which the bands are inserted. The body of Christ was pierced by five wounds, and the bands recall strongly the bands in which His body was carried in the *Entombment* (fig. 14). In the Middle Ages and the Renaissance the Host used for the communion of the celebrant at Mass was a large, sculptured medallion, adorned by means of molds engraved into the baking irons, with images not only of the Crucifixion and the Resurrection, but of other subjects with eucharistic overtones. The stories used by Michelangelo, insofar as they were completed, relate to the sacrifice of Christ. The most striking example is the pair of medallions that flank the *Separation of Light from Darkness* (fig. 30), representing the Sacrifice of Isaac, age-old type of the Crucifixion, and the Ascension of Elijah, type of the Resurrection.

Michelangelo's marvelous beings participate in the deepest sense in the sacrificial purpose of the Ceiling, alternating between the joy of communion and the deep preceding fear (*"Dominus, non sum dignus . . ."*). Sometimes they turn in terror from the scene they flank, sometimes they gaze into it with awe and reverence. "The Lord hath laid on him the iniquity of us all," said Isaiah of the Messiah to come; next to the *Separation of Light from Darkness* one of the nudes carries his garland like a gigantic burden which weighs him down, casting his face in shadow. Radiant in rose and gray flesh tones, the full-bodied, graceful, almost feminine youth to the right above Ezekiel looks deep into the *Creation of Eve* (fig. 27), which foreshadows the creation of the Church, while with one hand he holds the shining golden band reverently over his head like a veil, and with the other pulls at another band, emulating the gesture by which the Lord draws Eve from Adam's side.

Whether or not the nudes can ever be fully "explained," they do suggest the verse from St. John said countless thousands of times below them at the close of every Mass, "But as many as received him, to them gave he power to become the sons of God. . . ."

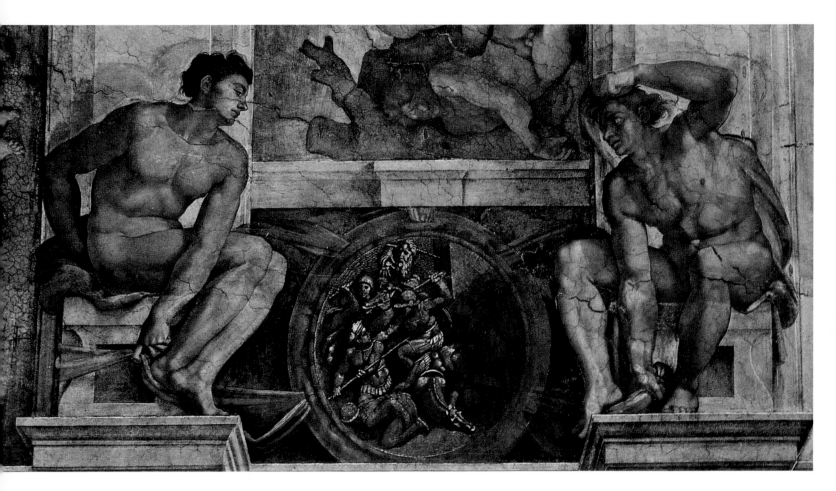

ABIUD AND ELIAKIM

Fresco, 1511–12

Sistine Ceiling, Vatican, Rome

Around the Chapel, in the sixteen lunettes and the eight vaulting compartments, run the forty generations of the ancestry of Christ according to St. Matthew's Gospel. Originally this ancestral tree began in the two lunettes below *Jonah*, separated by the papal arms bearing the Rovere tree. In the first lunette Abraham pointed to the Rovere tree, permitting no doubt about the connection, and Isaac carried wood for his own sacrifice, like Noah's son in the *Sacrifice of Noah* (page 73). From them the ancestry branched out to alternate sides of the Chapel. The ancestors are named on tablets, but these tablets appear only in the lunettes, making it difficult to relate the names and figures. A name may refer to a child or an adult, but the inhabitants of any lunette or compartment form a real family group even when the child transmitting the ancestry of Christ is yet unborn. The names are unevenly distributed; some tablets bear one, some two or three, and the first had four.

While the ancestors of Christ include many well-known figures, others are very nearly unknown save for Matthew's list. But each name means something, and their Latin meanings were collected and interpreted by the great ninth-century theologian Hrabanus Maurus. Cardinal Vigerio must have known his *Commentary on Matthew*, for Hrabanus' meanings almost invariably corroborate the prophetic message of the scenes directly above in the Ceiling, acting time after time as a counterproof for their interpretation. Clearly the names were juggled to create this system, and since Hrabanus connects several different texts with each name, the possibility of success was greatly increased.

In this instance, Zorobabel appears in the compartment just above *Abiud and Eliakim*. His name means "master of Babylon," or "master of confusion." To Hrabanus, Babylon signifies this world, confused by idolatry and error, and doomed to destruction excepting those who trust God. Not unexpectedly, Zorobabel appears next to the *Deluge*. Abiud (right) means "he is my father," and here he is shown looking at his father. Hrabanus quotes, "He shall cry to me, thou art my father, my God and the rock of my salvation." Eliakim (left), "resurrection of God," or "God lifting up," is here lifted up by his mother. Hrabanus refers to Christ revealing himself as the bread of life; "This is the will of the Father which hath sent me, that of all which he hath given me I should lose nothing, but should raise it up again at the last day." Both Abiud and Eliakim refer to salvation in Christ's mystical body, symbolized by the Ark. Color throughout the ancestor series is more subdued than in the Ceiling, but the basic palette and meanings are the same. The gray-lavender cloak of Abiud's father recalls that of the Creator; the cinnamon-red and gold tones of Eliakim and his mother appear throughout the crowd about to be overwhelmed.

There are other arresting images: *Joram* (fig. 37), below the *Creation of Adam*, an allegory of the Incarnation, means "where is the high One," and Hrabanus quotes St. John, "No man hath ascended into heaven, but he that came down from heaven, even the Son of Man." Most graphic of all is Hrabanus' text from the Psalms: "Who is like unto the Lord our God. . . . He maketh the barren woman to keep house, and to be a joyful mother of children," thus explaining the old woman besieged by her unexpected children.

Ruth (fig. 38) clasps the sleeping Obed in her arms, his swaddling clothes suggesting grave wrappings. Obed ("serving") has the text, "who, being in the form of God . . . took upon himself the form of a servant . . . he humbled himself, and became obedient unto death, even the death of the cross." Ruth's husband, Boaz (fig. 39), a bent old man, gazes at the caricature of his head on the staff he holds. His name means "in him is wood," or "in fortitude." Wood is *robur*, close to Rovere: not only is the lunette below the *Creation of Sun, Moon, and Plants*, foretelling the Cross, but above Botticelli's *Burning Bush* and the papal throne. Perhaps Michelangelo was caricaturing his terrible patron.

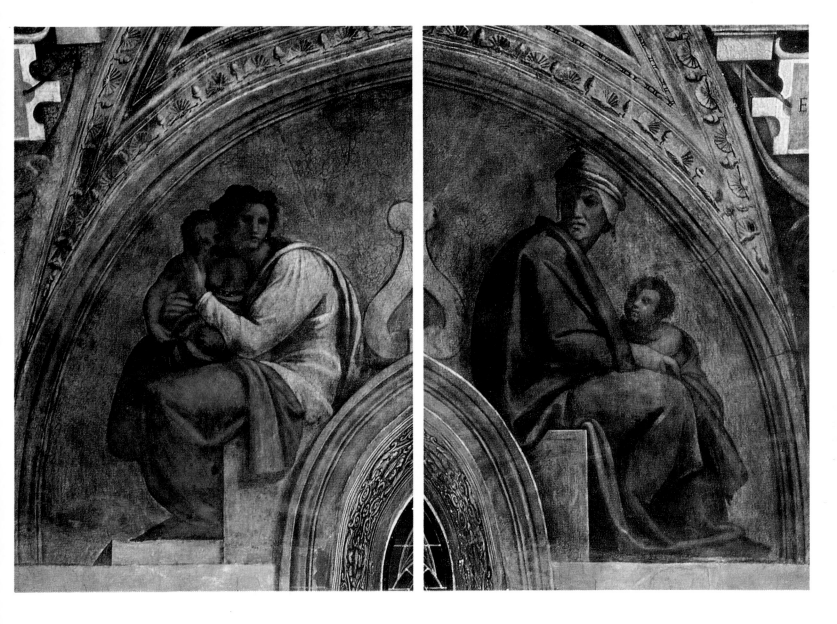

THE LAST JUDGMENT
(detail, Dead Rising from Their Graves)

Fresco, 1541

Sistine Chapel, Vatican, Rome

The gloom and terror of the *Last Judgment* come as a tremendous shock after the beauty of the Sistine Ceiling. The change is symptomatic of the transformation which had come over Rome itself after the dreadful events of the Sack of Rome in 1527 and its aftermath, from which the center of Christendom did not recover for many years (Frontispiece).

The space directly above the altar is reserved for the mouth of Hell, into which the celebrant of the Mass frequently could look as he performed the sacred ritual. To the left of Hell Mouth extends what little of earth has not yet been dissolved (see page 41), and from its barren ground, reminiscent of the earth on which Adam lies in the *Creation of Adam* (page 83), the dead crawl out of their graves. Some are well preserved, some skeletons, in conformity with a tradition appearing in monumental form in Signorelli's great *Last Judgment* series in the Cathedral at Orvieto, which Michelangelo must have studied with much interest. (Fortunately all artists representing the Last Judgment have spared us intermediate stages of decomposition.)

The dead show no joy in their resurrection or in the recognition of those they knew during their lifetimes on earth, only dread of the *Dies Irae* taking place around and above them. Some are still dazed, others hopeless; some look upward in awe and wonder. Torsos, backs, legs, and arms, powerfully foreshortened, are scattered through the foreground. The rough, brutal anatomical masses show none of the harmony so irresistible in the great scenes of the Ceiling. Rather do they remind one of the harsh power of the last two spandrels, the Crucifixion of Haman (fig. 32) and the *Brazen Serpent* (page 103), and the powerful exaggerations so expressive in the *Giorno* in the Medici Chapel (fig. 43). Horrified faces, knotted muscles, and clutching hands greet the awakening of doomsday.

Here and there the resurrected dead, their arms outstretched, start to soar upward as if drawn by some magnetic force. Next to Hell Mouth takes place a violent struggle associated with a long tradition in medieval representations of the Last Judgment—the battle between angels and demons over individual souls. One of the dead, almost erect, is lifted under the armpits by a compassionate angel while a demon, barely visible, tries to drag him into Hell Mouth by means of ropes wound around his ankles. Another, upside down, is grasped by two angels under the knees while a demon with ram's horns drags him downward by the hair. Above float the souls already called upward toward the throne of Christ. None of the dead, however, can move by his own volition; all are totally subject to divine or infernal forces. In the lower left section the deadly parallelism of long drapery folds and skeletal ribs suggests the writhing of worms.

Throughout the *Last Judgment*, the dominant color is that of human flesh against the slaty blue sky, with only a few touches of brilliant drapery to echo faintly the splendors of the Sistine Ceiling. The dead rising from their graves still preserve the colors of the earth— dun, ocher, drab. A few patches of red appear in the angels' cloaks. The whole section, moreover, has darkened considerably from the smoke of the candles at the altar.

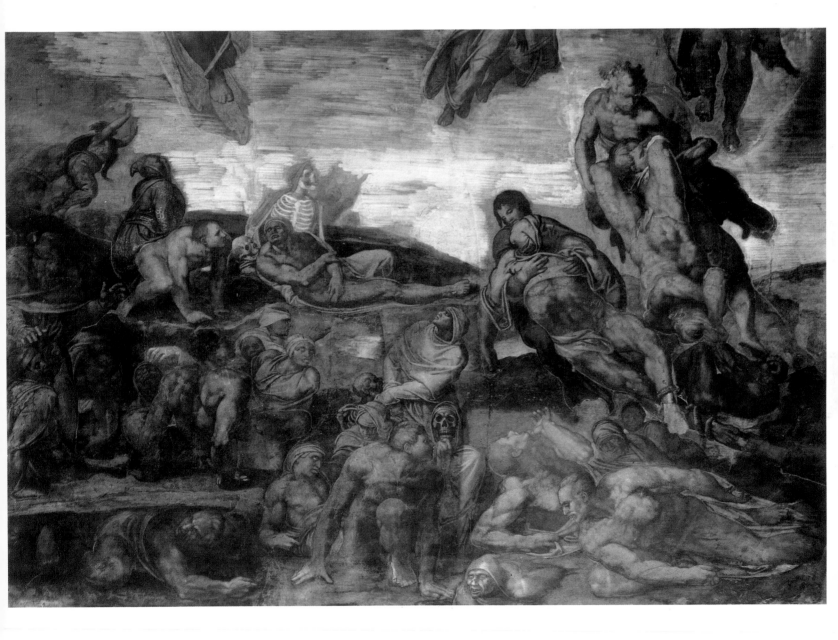

THE LAST JUDGMENT
(detail, Souls Ascending to Heaven)

Fresco, 1540

Sistine Chapel, Vatican, Rome

Michelangelo's angels are generally wingless, which is not as surprising as it might seem, since in the Old Testament angels are frequently mistaken for men. Wings, like halos, would have got badly in Michelangelo's way, and he usually omitted both so as to concentrate on the human body, always his primary concern. Only their greater power and their startling beauty distinguish the angels from ordinary mortals—characteristically enough for the creations of an artist who felt that physical beauty was a manifestation of the divine.

Souls float upward, the women always clothed, the men generally nude, and at crucial points compassionate angels help them into heaven. Compared with the harsh modeling and abrupt forms of the dead who have just risen from their graves, all the figures in this central register show a harmony and grace unexpected in bodies so bulky. This grace seems to derive from the quality of their motion rather than from the static arrangement of forms and lines more common in the Ceiling. The floating movement that pervades mortals and angels alike communicates to their surfaces and contours a soft and fluid pulsation completely new in the treatment of the nude human figure. Their magical grace survives even the irritating bits of drapery applied to cover offending portions and calm the fears of the papal court.

Some of the figures are haunting in the extreme. The man on the far left, with his arms over his head, recalls the strange combination of physical strength and spiritual yearning so intense in the later nudes of the Sistine Ceiling, those closest to and most drawn by the ultimate mystery of the first day of Creation. Another swims upward through the gloom, helped by the hands that a female figure has placed under his arms, his right hand and foot moving aimlessly, his eyes gazing upward with a fixed stare, overcome by the awesome event.

One of the most splendid figures in the whole *Last Judgment* is the herculean nude angel who lifts two souls by means of a gigantic pink coral rosary to which they cling as to a rope; the group gives dramatic witness to the efficiency of this traditional Catholic prayer device, especially appropriate in a chapel dedicated to the Immaculate Conception of the Virgin Mary, who is venerated in the decades of the rosary. The pose of this beautiful, full-bodied figure recalls the nude youth above Ezekiel (page 105) on the Sistine Ceiling, bending forward to pull (with the other arm, in this case) at the band upholding one of the bronze medallions. As is so frequent in the *Last Judgment*, the pose is far more compact, making the entire figure seem compressed into a block.

The two mortals hauled into Heaven by the rosary are apparently Negroes; this may refer to the worldwide missionary attempts of the Counter Reformation Church, paralleling the continuous spread of discovery, exploration, and, alas, conquest of Asian, African, and American territory in the sixteenth century.

In general the existence of the figures is restricted to the foreground plane, but some seem to move at another parallel level some few yards deeper in the background. While the coloring is, as usual, dominated by the grayish brown of the figures with their darker shadows, the drapery tones sometimes appear as solid areas of strong lavender, blue, or cinnamon red, but only occasionally in the *couleurs changeants* so common in the drapery of the Ceiling.

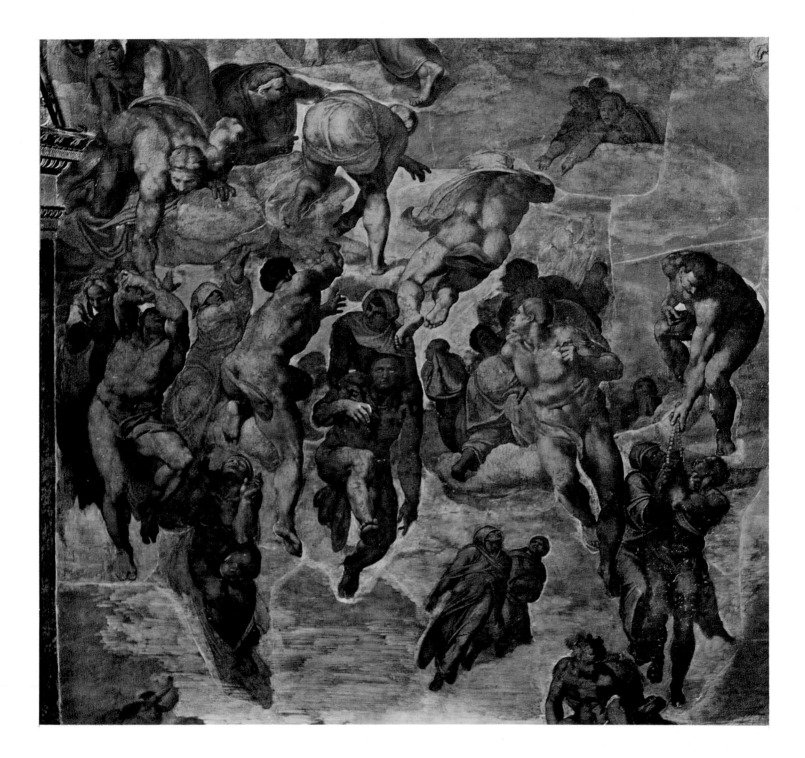

THE LAST JUDGMENT
(detail, the Elect)

Fresco, 1536–38

Sistine Chapel, Vatican, Rome

Around the awesome Judge the elect are "gathered from the four winds, from one end of heaven to the other." Crowds of figures extend rank on rank back in depth until only heads can be made out. Some of those in the foreground can be clearly identified, such as St. Lawrence and St. Bartholomew, placed below Christ because on the feast day of St. Lawrence the first Mass was said in the Chapel and on that of St. Bartholomew, Pope Sixtus IV himself for the first time celebrated there. St. Andrew with his X-shaped cross stands at the right, next to the Virgin, then St. John the Baptist. The Junoesque woman nude to the waist, her arm protecting a supplicant woman embracing her knees, is probably Ecclesia, the personification of the Church; her exposed breasts show the abundance of the spiritual milk with which she nourishes mankind; her pose, the protection of the Universal Church. So many figures are difficult or impossible to identify in the *Last Judgment* as to suggest that Michelangelo was not given a program as detailed as that for the Ceiling.

A tremendous wave of excitement runs through this crowd of giants, half again taller than the figures in the register just below them. The intensity of the moment is increased by the tornadic pressure of the great cloud weighing down upon their heads, in which float heroic angels bearing the Cross (fig. 49) and the crown of thorns. Generally in representations of the Last Judgment these symbols of Christ's Passion are held below His throne, but Michelangelo's new and dynamic interpretation of the text demanded this more vivid treatment. Also, he was faced by the awkward shape of the wall, once it had been cleared of all paintings, including his own two lunettes representing the first seven generations of the ancestry of Christ; the angels holding these instruments of the Passion (the column, ladder, and sponge on a reed appear in the right lunette, fig. 51) made an excellent solution. Michelangelo took considerable pains to harmonize them with the spandrels in the Ceiling, so that the Cross would appear parallel to the cross of Haman (fig. 32) and the column with the rod on which the Brazen Serpent is entwined (page 103).

Both lunettes are compositions of the greatest beauty, derived from the rich interaction of the swooping, heaving figures, moving counter to each other in enormous curves around the diagonals of Cross and column. The head of the powerful young angel who throws one leg around the Cross to steady it as it hurtles through the air is barely sketched in (fig. 50), yet the sense of volume is overwhelming. In contradiction to the careful sculptural modeling of the foreground heads (fig. 53), in the background Michelangelo seems to have wanted to return to the soft, loose manner invented by Masaccio in the frescoes of the Brancacci Chapel more than a century before, at the very dawn of the Renaissance. Sometimes the heads show the drastic power of his vision at its most terrifying, as for example the ravaged old woman behind Ecclesia (fig. 54), her face crumpled into masses of flesh hardly distinguishable from the folds of the veil over her head.

In this upper portion of the fresco the clouds are faintly rosy against a bluer sky. Above the head of St. John the Baptist (fig. 53) stands a figure wearing a beautiful blue garment with plum-colored shadows, a combination that may be traced all the way back to Giotto in the Arena Chapel. Almost invariably, St. John the Baptist, the great precursor, appears near the throne of the Judge, since it is through the sacrament of Baptism that Christians gain their title to salvation (fig. 53). Usually he is seated on Christ's left, flanking the Virgin on His right. Here John may have been displaced because of the special importance of St. Peter in the Sistine Chapel, the private chapel of the Popes, successors of St. Peter.

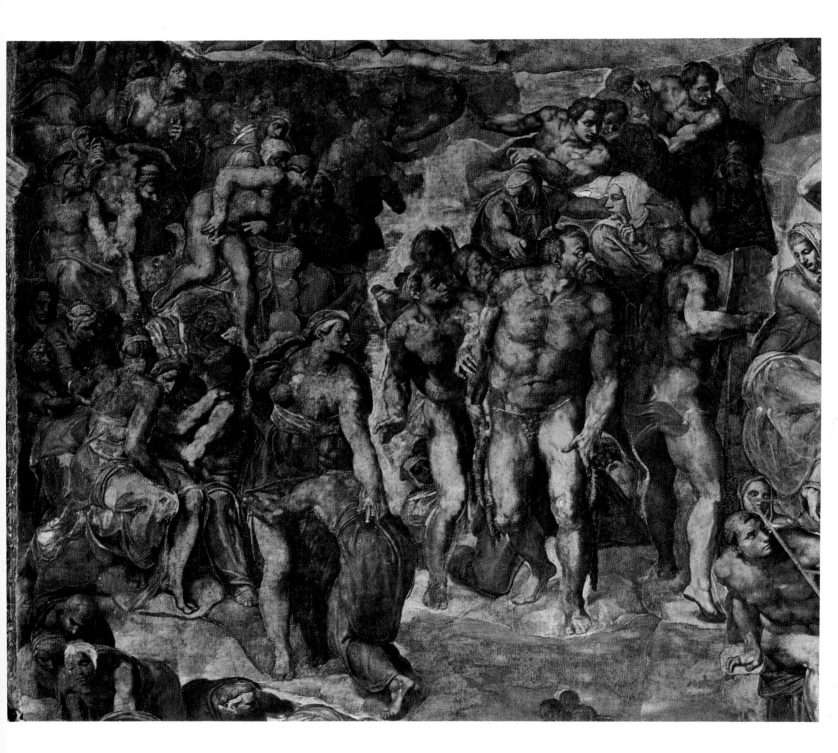

THE LAST JUDGMENT (detail, Christ)

Fresco, 1536–38

Sistine Chapel, Vatican, Rome

At the apex of the ascending movement in the vast composition, in the zone of the fresco best lighted by the windows of the Chapel and directly below the prophet *Jonah* (page 101) with all his prophetic adumbrations of the resurrected Christ, stands the Judge, Whose tempestuous arrival has sent the universe into such cataclysmic motion. In medieval representations of the Last Judgment, Christ was usually shown nude to the waist, in order to exhibit the wound of the spear in His side along with the nail holes in His hands and feet. As if to recall the Crucifixion and the Resurrection more strongly, Michelangelo has shown the legs naked as well, clothing the body only in the traditional mantle, which envelops Christ's loins in somewhat the same manner as the loincloth He is generally shown wearing on the Cross. Only in one or two instances prior to Michelangelo is He shown in this manner. Michelangelo has also painted Christ without the customary beard. He is beardless in Michelangelo's own drawings for the Resurrection (fig.47), and occasionally in fifteenth-century paintings of the Resurrection as well, notably that by Andrea del Castagno in the convent of Sant'Apollonia in Florence.

Although Christ's attention is largely occupied with the terrible gesture of damnation—the right hand held on high—it has been shown that His left hand is extended very gently, as if to summon the blessed up toward Him, according to the medieval formula. Instead of the traditional halo and almond-shaped glory, a soft radiance extends outward from the mighty figure, into Whose side the Virgin shrinks. In the Casa Buonarroti drawing (fig. 48) she throws herself before the throne of her Son, to plead for mortals. Now she almost identifies herself with Him, turning gently to look downward at mankind. The position of her head and hands repeats almost exactly those of Eve in the *Fall of Man* (page 77) as if to remind the observer that she is the second Eve, as Christ is the second Adam. In her role as intercessor with her almighty Son she seems to take upon herself the guilt of all mankind, even as the martyrs offer the symbols of their martyrdom around and below His cloudy throne.

Today the dark and unclassical Christ-figure is frightening, but not entirely in the sense intended by Michelangelo. A great deal of very clumsy and tedious hatching is visible on the chest and across the neck, which is nothing like Michelangelo's brushwork elsewhere in the fresco, and must have been added during one of the numerous campaigns of repainting in the sixteenth century, when so many of the nudes were bowdlerized. In spite of these disfigurements, the power of Michelangelo's conception is still present in the pose of the figure, and the arms, the legs, and the lower portion of the torso are authentic and inimitable. Before the movement of the surfaces across chest and neck was slowed down by the retouchings, the entire figure must have been sublimely beautiful, in terms of the new and more massive canon of beauty prevalent throughout the angelic figures in the fresco. Conferring the function of mercy on His mother with whose very essence He seems to identify Himself, Michelangelo's Judge is far from being as implacable as is frequently and too easily supposed. It is not merely with condemnation, but with justice that the fresco is concerned. It should be noted that even the uplifted right hand is deliberately intended to recall that of the Creator in the *Congregation of the Waters* (page 93) which prefigures the congregation of mankind in the Church, as if to fulfill the quiet power foretold in that image.

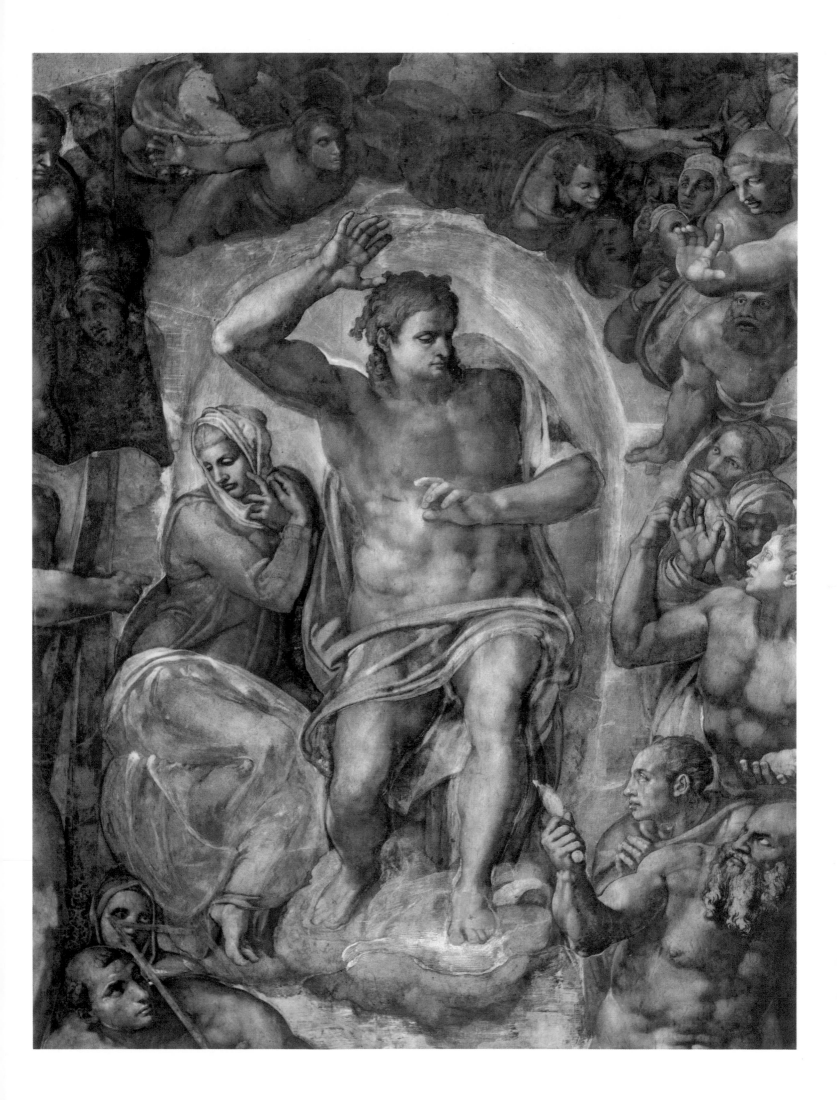

THE LAST JUDGMENT (detail, St. Peter)

Fresco, 1538–40

Sistine Chapel, Vatican, Rome

As titanic as his counterpart, St. John the Baptist, St. Peter starts forward at Christ's left to present to Him the colossal keys of Heaven; like all the saints in this group immediately surrounding Christ, he seems to have no will of his own but rather to be swept by anxiety as by a storm, activated only by the terrible force radiating from the Judge. Peter's mighty left arm recalls the powerful left arms of *The Cumaean Sibyl* (page 79; fig. 26) and of *Moses* (fig. 40), and likewise symbolizes the power of the Church. One of his keys is gold, the other silver, still the colors of the Vatican flag. Against his richly tanned skin and the slaty blue of the sky with its rusty clouds, Peter's soft golden cloak provides a welcome note of delicacy and tenderness, similar to the touches of color introduced throughout the fresco in order to relieve the endless expanse of struggling muscles and barren sky. As usual, unfortunately, the simple, brutal rhythm of Peter's stance was spoiled by an absurd extension of his cloak made to whisk about his loins in order to quiet some of the clerical protests.

Some of Michelangelo's most glorious figures spiral through the cloud above St. Peter's head (fig. 51), carrying the column at which Christ was scourged, the ladder that ascended the Cross, the reed tipped with the sponge soaked in vinegar. The mighty group enters the picture as the Lord spoke to Job—out of the whirlwind. Placed directly below the spandrel showing the salvation of the Israelites through the Brazen Serpent lifted up by Moses in the wilderness (page 103), the column carries a suggestion of the great theophanies of Exodus, the pillar of smoke by day and of fire by night in which the Lord's presence was made known. The figure curving around the base of the column appears for the first time in the drawing of the *Brazen Serpent* (fig. 44)—probably intended for the never-executed frescoes of the Medici Chapel—and was lifted bodily in the early nineteenth century by Delacroix for use in his *Bark of Dante.*

This amazing group is built systematically on diagonal straight accents (the column, the ladder, certain vertical and recumbent figures) against which the curving figures play a continuous polyphony. One of the most brilliantly conceived of these is the angel holding the center of the column and looking upward as he strides through the air (fig. 52). The enormous bulks of such figures and their softly pulsating contours differ sharply from the more harmonious masses and melodious outlines of the nudes on the Ceiling, but they show that Michelangelo in his sixties has lost none of his command over the human figure, and none of his insight into the beauty of form.

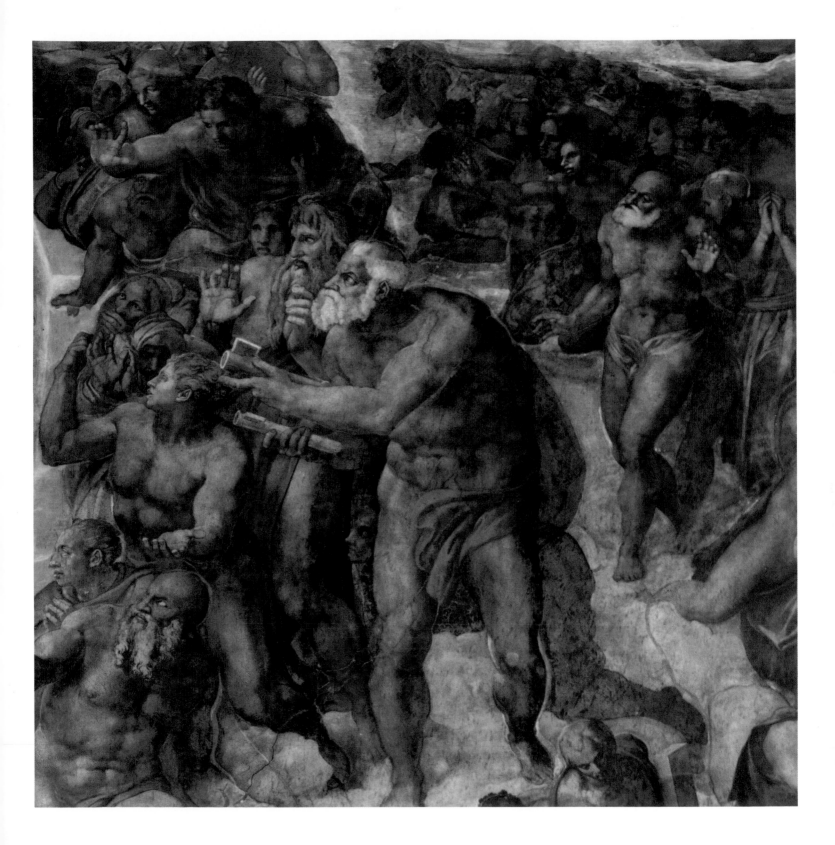

THE LAST JUDGMENT (detail, Martyrs)

Fresco, 1536–38

Sistine Chapel, Vatican, Rome

On cloud banks to the left of the Judge are grouped the martyrs, many identifiable by the symbols of their martyrdom which they extend as if to show Christ that they, like Him, suffered the Passion in their bodies. The Apostle St. Simon Zelotes shoves forward an enormous saw; a youth, possibly St. Philip, carries a cross; St. Blaise brandishes his curry-combs; St. Catherine holds a huge fragment of her toothed wheel; St. Sebastian climbs out of a cloud grasping his arrows (fig. 55). Above him a powerful nude heaving a cross onto his shoulders has been variously identified as St. Simon of Cyrene, who aided Christ in carrying the Cross, and as St. Dismas, the penitent thief who was crucified with Him. Below Christ appear St. Lawrence, holding the gridiron on which he was roasted, and St. Bartholomew dangling his skin in his hand, both associated with the original dedication of the Chapel under Sixtus IV (see page 112). Old copies of the fresco show that originally even St. Catherine was completely nude.

It is clear enough where Michelangelo places himself, for the fearfully distorted face of the empty skin, swinging hideously before the Almighty, is a self-portrait (fig. 56). Just how recent is our present knowledge of so many aspects of the master's art and life may be gauged by the fact that this vivid and indisputable self-portrait was not recognized as such until 1925, and that, through a mistaken sense of propriety, important documents in Michelangelo's own handwriting in the Archivio Buonarroti in Florence are still kept not only from publication but even from examination by scholars. The shameless sycophant and satirist Pietro Aretino, self-styled "scourge of princes," who plagued Michelangelo unmercifully during the painting of the *Last Judgment*, both to get drawings from him and to influence his treatment of the subject, is represented as St. Bartholomew holding the artist's skin. This attack, typical of the artist's grim humor, is so devastating that Aretino's later letter attacking the *Last Judgment* is a real revenge. But there is more than humor in this self-image, which provides a frightening ray of light into the artist's inner nature, corroded by a self-pity so intense as to become an affliction. The wealthy master who could refuse sovereigns and drive the representatives of monarchs from his door sees himself as a martyr before the throne of Christ.

As throughout the heavenly regions of the *Last Judgment*, these figures with their swelling masses and softly throbbing contours, incredibly dense and compact, and at once soft and strong, show to the full the new ideal of form developed by the artist in this strange era, when the High Renaissance was only a memory. One of the most beautiful of all is St. Sebastian (fig. 55), holding triumphantly the arrows that pierced but did not kill him. Note that there are five arrows, the same as the number of the wounds in Christ's body.

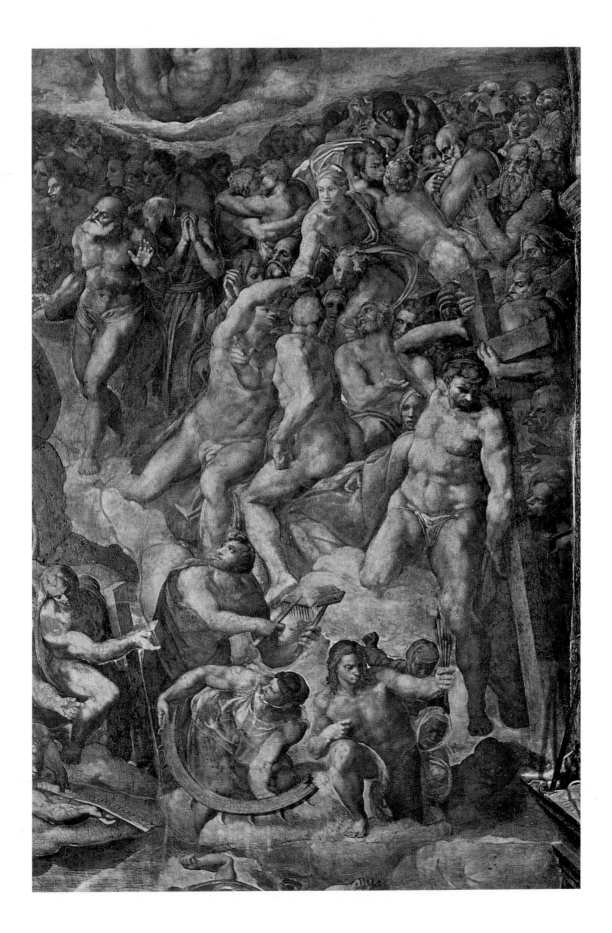

THE LAST JUDGMENT (detail, the Last Trumpet)

Fresco, 1540

Sistine Chapel, Vatican, Rome

The mighty group of angelic figures hovering on a cloud above the altar announces the end of all things. Michelangelo has conveyed, entirely by means of the human figure (for it is not in his nature to indulge in pyrotechnic displays), the terror of such biblical moments as the revelation on Sinai amid "thunders and lightnings, and a thick cloud upon the mount, and the voice of the trumpet exceeding loud so that all the people trembled." Seven of the angels blow trumpets, as noted by Vasari, to illustrate the Book of Revelations with its seven angels that blow their trumpets before the Lord, thus heralding the end of the world in seven frightful catastrophes. At the left, an angel carries a book presumably with the names of the elect; it is small. At the right, above Charon's bark with its tragic human freight, the book of the damned is so huge that it requires the services of two angels.

The group recalls an earlier phase of Michelangelo's art, the lost cartoon for the *Battle of Cascina* (fig. 15) with its trumpeting soldier, his cheeks puffed out with the air to produce the thrilling sound. Of the angelic figures, only the one holding the little book is displayed in his entirety. Old copies of the painting before it was censored show that he was completely nude. The green cloak behind him is original, but the blue drapery that enwraps his legs is repaint. All the other angels are visible merely as inflated faces, gigantic arms and legs. Particularly frightening is the angel second from the left in the top row (fig. 59), with his strange, light eyes rolling in a darkened face, and his huge, pulsating shoulders and arms.

The trumpets are all of gold, save for the exquisite silver one at the left—blue gray with white highlights and brown shadows. The extensive damage visible in this section of the fresco was caused by the rubbing of the huge canopy, when the papal throne was located there for special occasions.

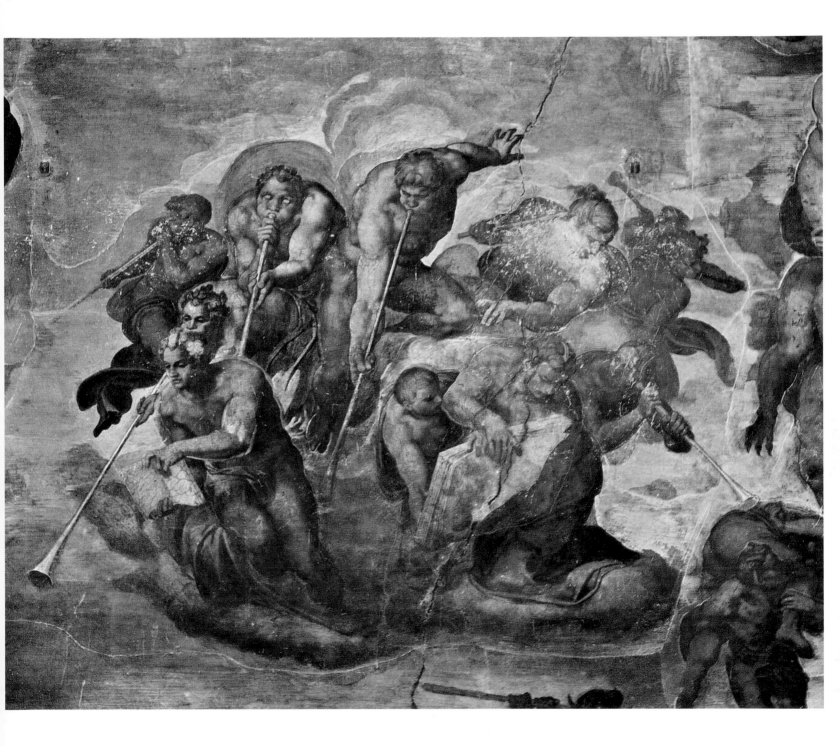

THE LAST JUDGMENT (detail, Charon's bark)

Fresco, 1541

Sistine Chapel, Vatican, Rome

We have come full circle, and followed the dread revolution to its inevitable close. Charon, dark ferryman of the River Styx, brings his terrified boatload to their doom, according to the words of Michelangelo's "famigliarissimo Dante," as Vasari calls him:

> Charon, the demon, with eyes like embers,
> Signing to them gathers them together:
> Beats with his oar anyone who tarries.

Hounded, horror-struck, the damned pile forward in the shadow, from which they emerge into the glow of Hell's fires—only the glow, for Michelangelo does not paint a single flame. Despairing, some leap toward the crowded coast of Hell; others are dragged by demons who have sunk boathooks into them. No other torments are shown.

The demons all have powerful human bodies, but some show the legs and claws of wild animals (fig. 57); horns or bats' ears sprout from their bald skulls. One, in the foreground, wears his hair so cut as to suggest the appearance of an American Indian, detailed accounts of whom had surely reached Rome by this time. But Michelangelo, even in Hell, keeps deforming horrors and monstrosities to the absolute minimum. The contrast between the tangled mass of helpless bodies, crushed into violent and discordant angles, and the sublime perfection of the whirling curves and glorious, free bodies in the celestial regions of the fresco, says all this supremely human artist needs to say about Hell and Heaven. But this, too, is a function of divine will. The mighty wings on which Charon's boat moves over the dark tide, also drawn from Dante, terminate in pinions of a soft lavender-gray —throughout the Sistine Ceiling the color of the mantle of God.

Over the door leading into the papal palace stands a ghastly figure, profoundly significant for Michelangelo's attitude toward man and his Maker. It is Minos, king of Hell (fig. 58), provided by Dante with a serpent's tail which this infernal desk clerk wound about himself the same number of times as the circle of Hell to which each new guest was to be consigned. It seems that when the fresco was three-quarters complete in 1540 and the scaffolding was taken down, before it was restored for the final stage of painting, Pope Paul III inspected the work in the company of the artist and the papal chamberlain, Biagio da Cesena; the latter expressed the view that the work was improper for such a place, and worthy only of a tavern or a bathhouse on account of the inordinate display of nudity and genitals. Michelangelo got his revenge by painting this potentate as Minos, directly over the door by which he customarily entered and left the Chapel. The chamberlain appealed to the Pope to have the insult removed, but the canny Paul III replied, "If the painter had located you in Purgatory, I would have made every effort to content you, but since he has placed you in Hell, it is useless for you to turn to me, for there *nulla est redemptio.*"

Like the self-portrait in the empty skin held in Pietro Aretino's hands (fig. 56), this is not just an example of Michelangelo's grim humor and personal spite. For the devastating caricature, with its ass's ears and snide expression, is a timeless embodiment of the leering Mrs. Grundys of this world. Only here has Michelangelo referred to the medieval tradition that the damned were to be tormented in those parts by which they had most sinned, for he has directed the head of Minos' gnawing serpent toward this official's own genitals. Perhaps we can best understand the blinding purity of Michelangelo's vision of the total human being by his own words, written while he was painting the Sistine Ceiling:

> "He who made all things made every part."

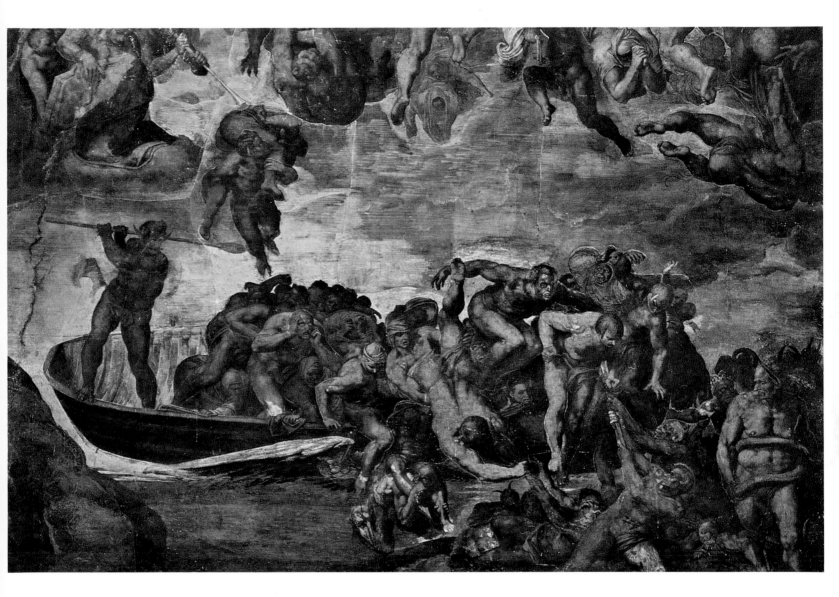

THE CONVERSION OF SAINT PAUL (detail, St. Paul)

Fresco, 1542–45

Pauline Chapel, Vatican, Rome

The frescoes in the Pauline Chapel represent Michelangelo's swan song as a monumental painter. Repeated illness frequently forced him to lay down his brushes for months at a time. Yet within each fresco the style is so consistent that we would never suspect the interruptions. Even the compositional differences between the two scenes can be explained more in the light of their internal necessities than of any alteration in the artist's powers. By its very nature the *Conversion of Saint Paul* (fig. 60) is centrifugal and explosive; the *Crucifixion of Saint Peter* (fig. 62), centripetal and compact.

One would have expected the artist to choose similar subjects for both frescoes, so that two martyrdoms would face each other, or else the two most important scenes from the lives of these two princes of the Apostles. And in fact Vasari in the first edition of his *Lives*, 1550, speaks of a Delivery of the Keys to St. Peter instead of the Crucifixion actually painted. The feast of the Conversion of St. Paul, January 25, was one of the most important of the year to Pope Paul III, who doubtless selected that name for himself for the best of personal reasons. Intensity of inner conviction, indeed conversion wrought by miraculous divine intervention, played a central role in the transformation of the Church that was the primary purpose of the Counter Reformation, and was represented again and again in the later sixteenth and seventeenth centuries. The Acts of the Apostles tells the story with unforgettable directness:

> And suddenly there shined round about him a light from heaven:
>> And he fell to the earth, and heard a voice saying unto him, Saul,
> Saul, why persecutest thou me?

Then follows the narration of the astonished companions who heard the voice but saw no man; of Saul's blindness; and of his helplessness in Damascus before his name was changed to Paul. Following a long medieval and Renaissance tradition, Michelangelo has presented Saul fallen from his horse which rears in terror, held by a struggling servant. But the soft path of yellowish light moving from the heavenly apparition to the agonized mortal has little to do either with the golden rays of the early representations or with the vast luminary displays so common in the Baroque period. It is seen only by Saul, and is not the source of the light in the painting.

Christ appears in Heaven at the upper left (fig. 61), sharply foreshortened according to Florentine Renaissance tradition as He moves downward and outward, pointing toward Saul with His right hand, to Damascus with His left. About Him the angelic host is divided into five cohorts, like the five wounds in His body. No longer do they twist and turn as in the *Last Judgment;* a kind of para-military discipline has forced them to conform to the block shape always underlying Michelangelo's forms, and imposed also on the soldiers and the bystanders. Under the compulsion of supernatural authority, Michelangelo's free humanity has now renounced the principle of individual will. The devastation this compulsion has wrought is depicted in the face of the persecutor, soon to become the Apostle.

This unexpectedly old face, with its echoes of the blind Homer and the dying Laocoön, has been described as a spiritual self-portrait of Michelangelo. Certainly the emotion corresponds to that which rocks the anguished sonnets in which the aged artist communicates his doubts and fears and longings, and his all-consuming spiritual need.

In the distance, beyond heaving landscape masses looking more than ever like those around Michelangelo's birthplace, the blocky walls and saucer-domes of Damascus can be discerned—the artist's one sally into the realm of orientalia, that yet looks very Renaissance-like and quite of a piece with the massiveness of his late architectural designs.

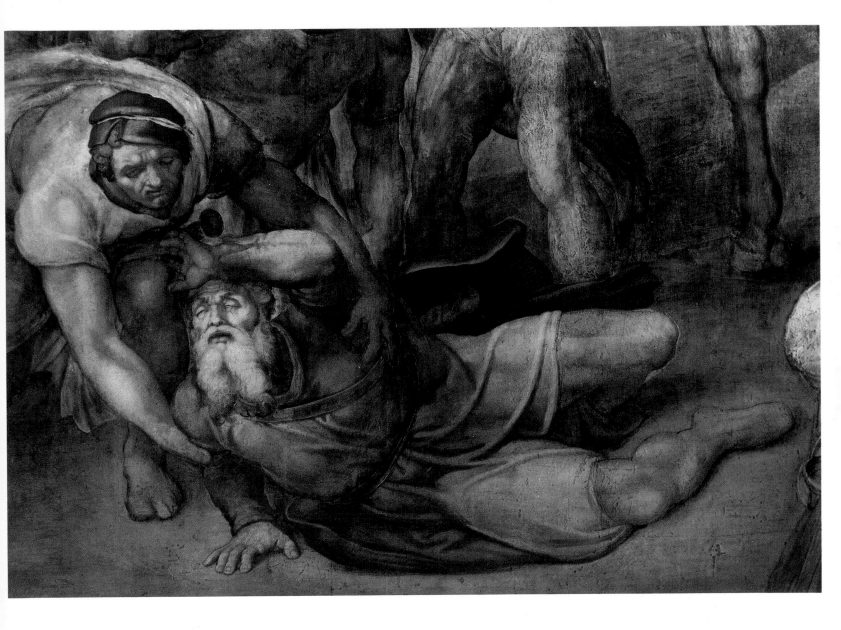

THE CRUCIFIXION OF SAINT PETER (detail)

Fresco, 1545–50

Pauline Chapel, Vatican, Rome

Sentenced to death by crucifixion, St. Peter asked only that, in reverence for the Crucifixion of Christ, his cross be reversed. This upside-down position always gave artists a good deal of trouble, and it is fair to state that, prior to Michelangelo, the subject had never received satisfactory monumental treatment. The old man's marvelous invention was the notion to treat the intractable scene as an elevation of Peter's cross, and thereby avoid all the otherwise inescapable absurdities. The artist was thus enabled to produce a composition of overwhelming simplicity and power (fig. 62)—a kind of colossal box, with the cross moving diagonally from corner to corner, diagonally in space, in plan, and in elevation. Such superbly simple solutions were to produce the majesty of Michelangelo's last great architectural projects.

As has frequently been noted, he stripped the incident of its customary topographical setting; it takes place not in Rome, but anywhere. If there is any suggestion of setting, it is that of Michelangelo's native, revisited Apennines. The ritual universality of the composition is enhanced by the curious stasis of so many of the poses. Few figures are shown in action. Many face us, some even look at us (figs. 63, 64). Many have their backs fully turned. Contrapposto has disappeared almost completely. So have hatred, anger, and all emotions save awe and fear. Some of the most gigantic figures seem to be shrinking into themselves. As in a passion play, in which all the actors are townsfolk, there is little distinction between executioner and martyr, pagan and Christian. The universal becomes strangely intimate and personal. The inner world of the late religious drawings has begun to open toward us.

At first sight the composition, from which all perspective seems to have been withdrawn, reminds us of the densely packed reliefs of Nicola Pisano in the thirteenth century, or even of the Roman sarcophagi Nicola used as models. Yet the very ground level has dissolved, and figures emerge from nowhere, cut off at the waist by the frame, so that the space moves disconcertingly forward to include us, as do so many of the glances including that of St. Peter himself. The effect, reinforced by the lowering clouds, is that the whole scene is mysteriously floating, and that what is happening is a dream rather than reality. Yet the figures are as powerfully painted as the great nudes in the *Last Judgment*, if somewhat less subtly modeled. The shadows are less pronounced, but the contours stronger, and the color more intense even than that seen in the *Conversion of Saint Paul* (page 125), suggesting the concentrated glow of stained glass. Tunics and doublets carry the massive hues from brilliant green to intense, sweet red to gold-bronze to slightly grayed blue, against the green and clear, sky blue of the hills.

One of Michelangelo's few extant cartoons, a fragment showing the three soldiers at the lower left, is preserved in the Museo di Capodimonte in Naples.

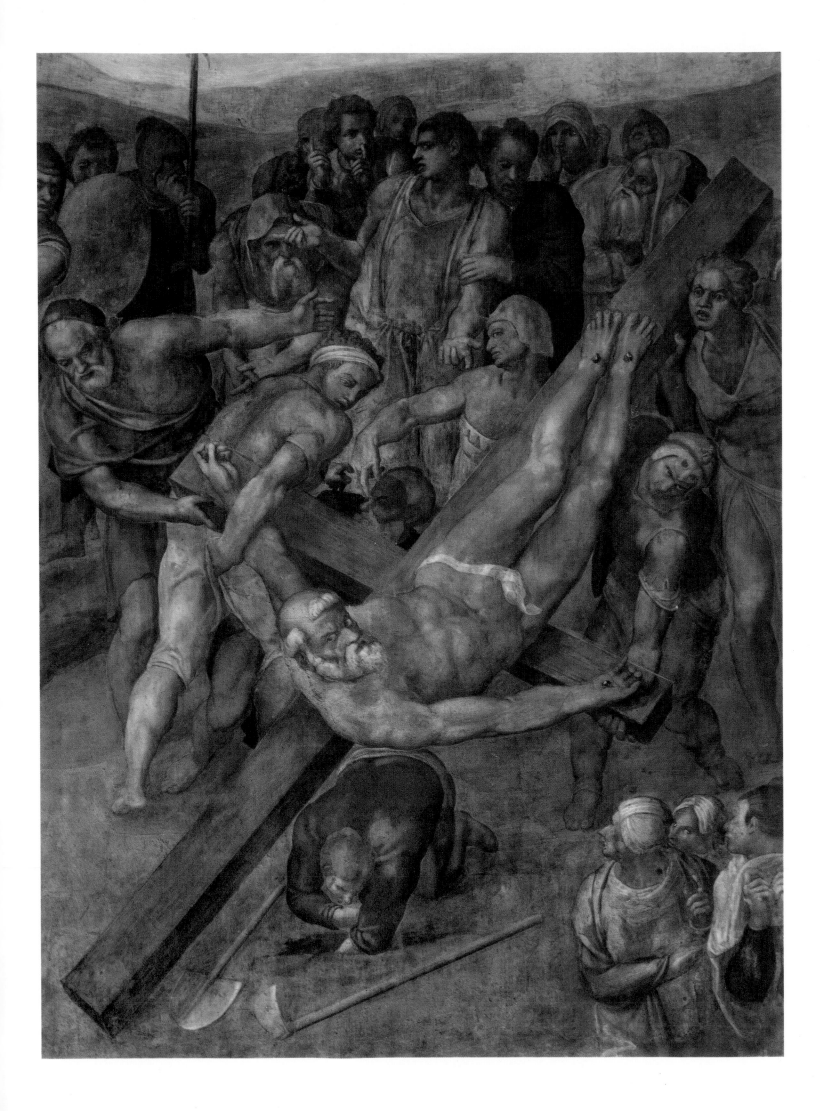

PHOTOGRAPHIC CREDITS

Alinari, Florence: Frontispiece, 1, 9, 11–13, 18, 21, 23–30, 32–39, 41–43, 48–64, 69, 70; Gabinetto Fotografico Nazionale, Rome: 10, 40; Gabinetto Fotografico, Uffizi: 16, 68.